WITH BORROWED EYES

LANDSCAPE | LANDSCHAFT | SHAN SHUI

WITH BORROWED EYES

LANDSCAPE | LANDSCHAFT | SHAN SHUI

With texts by Ulrike Münter and Michael Ostheimer

SAMMLUNG WEMHÖNER

KERBER

WHAT IS LANDSCAPE?

What is landscape? These days, this is a question that can really get us into the same kind of predicament that Augustine once found himself in when asked about time: 'If no one asks me, I know; if I wish to explain it to one that asketh, I know not.'[1] The unquestioning certainty that we generally display in the everyday use of the word 'landscape' gives way to doubt when someone insists that we reflect upon it or give an account of how we engage with it. Suddenly it becomes clear that what is meant is anything other than obvious. 'From the subject of painting and the concept of the genre in art history by way of literature's space of mood, reflection and action to the object of the cultural and geographic sciences, from the field of activity of landscape architects to the destination of tourists, the word "landscape" refers to [a] wealth of realities almost too large to grasp, seen from very different perspectives and approaches.'[2]

Over the course of the modern era, a highly idealised and aestheticised perception of nature shaped our understanding of landscape. According to the philosopher Joachim Ritter in his famous essay on the aesthetics of landscape,[3] when modern subjects encounters landscape, they experience the wholeness of nature, which was disregarded by modern science. According to Ritter, the divide between humankind and nature resulting from the technological domination of nature is the prerequisite for being able to reconcile oneself aesthetically with the lost 'whole nature'. In the late 20th century, this classical concept of landscape, fostered largely by landscape painting, landscape aesthetics and garden design, came under fire. For one thing, it is based on a bygone need for a wholeness of nature, which today can no longer be logically assumed; for another, aesthetic interest is focussing on a form of nature that has not existed for a long time.[4]

The natural conditions for natural landscapes and their spatial expansion were seriously threatened at a global level in the late 20th century by environmental pollution and urbanisation. The number of cultural landscapes was constantly increasing; pristine, untouched nature is now a rarity. At the same time, there was a tremendous renewal of interest in the phenomenon of landscape in social, artistic and scientific circles. The threat faced by the material basis of landscape led to a veritable renaissance in how landscape was viewed.[5] This contemporary appreciation prompted an updating of the concept of landscape on two fronts: representational and methodological. On the one hand, a broader perspective revealed physical manifestations of the industrial society in a diverse range of landscape types – from industrial landscapes to transportation landscapes and slag heap and waste landscapes.[6] On the other hand, in the course of an energetic international discussion, landscape was no longer simply regarded as a physical and objective object, but rather as an individual construct generated in the web of meaning of certain eras, cultures and social conventions.[7]

Compared to the science-based understanding of geographical space or territorial units (such as rural districts or federal states), the concept of landscape is based on human perception. Different environments only become landscapes if they are characterised as such from the point of view of the person in the impression of (primarily visual, but in principle multi-sensory) perception. It means that different people also have different ideas and perceptions of landscape. The Indian author Amitav Ghosh illustrates this connection perfectly in his novel *The Hungry Tide* in which his protagonist, who is travelling through the islands in the Ganges-Brahmaputra Delta, ruminates:

1 Saint Augustine, *The Confessions of Saint Augustine*, Edward B. Pusey (trans.), Oak Harbor, WA, 1999, online at http://www.documentacatholicaomnia.eu/03d/0354-0430,_Augustinus,_Confessionum_Libri_Tredecim-Pusey_Transaltion,_EN.pdf (last accessed 05.09.2019).

2 Brigitte Wormbs, 'What is landscape supposed to mean here?', in Donata Valentien (ed.), *Return of Landscape*, Berlin, 2010, pp. 52–61, p. 53.

3 Joachim Ritter, *Landschaft. Zur Funktion des Ästhetischen in der modernen Gesellschaft*, Münster, 1963.

4 See Martin Seel, *Eine Ästhetik der Natur*, Frankfurt am Main, 1991, pp. 225–230.

5 See Hansjörg Küster, *Die Entdeckung der Landschaft. Einführung in eine neue Wissenschaft*, Munich, 2012.

6 See Brigitte Franzen and Stefanie Krebs (eds.), *Landschaftstheorie. Texte der Cultural Landscape Studies*, Cologne, 2005.

7 Olaf Kühne, *Landschaftstheorie und Landschaftspraxis. Eine Einführung aus sozialkonstruktivistischer Perspektive*, Wiesbaden, 2013.

'And now, indeed, everything began to look new, unexpected, full of surprises. I had a book in my hands to while away the time, and it occurred to me that in a way a landscape is not unlike a book – a compilation of pages that overlap without any two ever being the same. People open the book according to their taste and training, their memories and desires: for a geologist the compilation opens at one page, for a boatman at another, and still another for a ship's pilot, a painter and so on. On occasion these pages are ruled with lines that are invisible to some people, while being for others as real, as charged and as volatile as high-voltage cables.[8]

The phenomenon of landscape is thus an individually constructed, intellectual artefact. The area of space captured by the gaze is structured by the specific perception of the subject's emotional sensibility and intellectual world view and is invariably seen from a certain perspective. Visual perception, knowledge and imagination are intimately intertwined.

The title of this publication, *With Borrowed Eyes*, refers precisely to this inseparable intertwining of visual perception and interpretation. It aims to show that every form of landscape is based on a specific concept that viewers update when they see an area of space. We only manage to identify a landscape when we connect the visual perception of the space with a certain concept of landscape. In other words, without a specific concept of landscape we would not be able to identify any landscapes; we thus invariably only recognise landscapes 'with borrowed eyes' as it were.

To a certain extent, the 'borrowed eyes' are a variant of those 'green glasses' referred to by Heinrich von Kleist as a metaphor for eyes to explain to his fiancée Wilhelmine von Zenge how Kant's theory of knowledge represented a radical change towards the subjective. Immanuel Kant's philosophy renegotiated the dialectic of reason and nature. If the divine mind had previously acted as sole legislator, the subjective human mind now took on this role vis-a-vis nature. As a result, nature was constrained by humankind:

If all people had green glasses for eyes, they would have to judge that the objects they see through them ARE green and they would never be able to determine whether their eyes showed them the things as they are or whether they added some property which does not belong to the thing, but to the eye. And so it is with understanding. We cannot determine whether that which we call truth really is truth, or whether it only appears to be.[9]

The existing scope of landscape can be summarised as follows: the subject perceives a certain environment, while the judging mind provides the notion of landscape for this current perception on the basis of an internalised concept. As this occurs again and again each time an environment is perceived, it could be said that we constantly metaphorically 'borrow' the current version of the concept of landscape from the mind. Our understanding of landscape is thus 'in flux' over the course of a lifetime; depending on the 'borrowed eyes', we constantly see landscapes in a new or different light.

Michael Ostheimer

8 Amitav Ghosh, *The Hungry Tide*, Boston/New York, 2005, p. 186

9 Heinrich von Kleist, letter to Wilhelmine von Zenge of 22 March 1801, quoted at http://hcc. humanities.uci.edu/archive/Student/archives/ s03Kleist1.htm (last accessed 08/09/2019).

LANDSCAPE FORMS IN THE WEMHÖNER COLLECTION:

EAST-WEST LANDSCAPES | TEMPORAL LANDSCAPES | ARTIFICIAL LANDSCAPES

PERCEIVED SPACE OR AESTHETICISING SPATIAL MODELLING

Landscape can be perceived directly, as the space captured by the gaze, or indirectly, as a mediated form of aestheticising spatial modelling. And yet, it is difficult to distinguish between the two modes of appearance, as the history of landscape painting has already shown.[1] For more than 200 years, the use of the word 'landscape' has veered from referring to a reflection of what has been found to a modelling projection. The Grimm brothers' German dictionary defines the word landscape firstly as a 'region, land complex in relation to its position and natural characteristics [...] considering the impression that such a region makes on the eye', while the second meaning of the word describes what comes to light when the impression is reflected upon: 'the artistic representation of such a region'.[2] The dictionary entry echoes the difficulty that both the empirical landscape experience and the aestheticising depiction of landscape are based on a subjective representation. Landscapes are phenomena that are found *and* made. The aestheticising depiction of landscape only makes explicit the potential that is implicitly updated in every real landscape experience. The concept of landscape oscillates between *aisthesis* and aesthetics, irrespective of whether the landscape is viewed in reality, imagined or visually portrayed.

ARTISTS AND COLLECTORS: INTERPLAY OF TWO UNDERSTANDINGS OF LANDSCAPE

While the relationship between the material landscape and the artistic depiction of the landscape may be close, only the viewers' concept of landscape is mobilised when they encounter a material area of space; when they encounter a depiction of landscape, on the other hand, at least two concepts of landscape collide: that of the producer and that of the recipient. In this case, the encounter is enhanced by the presence of a third party: the collector. *With Borrowed Eyes* therefore undertakes to create a dialogue between the landscape concepts of three different actors. The artists' understanding of landscape, which is articulated in their works, combines with that of the collector, which is reflected in his collecting activity, and this combination is offered to the reader. In this regard, three types of landscape feature in the Wemhöner Collection: east-west landscapes, temporal landscapes and artificial landscapes.

EAST-WEST LANDSCAPES

The most striking feature of the landscape-related art in the Wemhöner Collection is its geographical context, namely the interrelatedness between East and West, or to be more precise, between China and the 'Western' world.[3] On the one hand, numerous works by Chinese artists informed by the Chinese landscape tradition deal with Western landscapes or a Western understanding of landscape. On the other hand, many Western artists coming from a Western landscape tradition and looking in the opposite direction turn to Chinese landscapes or engage with a concept of landscape that has been informed by the Chinese tradition.

This aesthetic interplay between East and West in the Wemhöner Collection alludes to the life-long project of French philosopher and sinologist François Jullien (b. 1951), who constructively compares the different cultural manifestations that characterise China and the West. According to Jullien, intelligent cultural dialogue does not develop if one

1 See Norbert Schneider, *Geschichte der Landschaftsmalerei. Vom Spätmittelalter bis zur Romantik*, Darmstadt, 1999.

2 Jacob Grimm and Wilhelm Grimm, *Deutsches Wörterbuch*, Vol. 12, Munich 1984 (photomechanical reprint of the first edition, 1885), p. 131 (translated by Ann Marie Bohan).

3 For more on the concept of the West, see Heinrich August Winkler, *Geschichte des Westens*, 4 volumes, Munich, 2016.

simply focuses on the ostensible generality of the cultures and downplays the differences. Instead, the differences between the cultures must first of all be revealed. Jullien calls his proposition for a European-Chinese cultural dialogue on equal terms a 'technique of detour'. It involves attempting, by means of a 'detour through China', to set aside the categories of thought and action strategies accepted in Western culture or at least to see them in a new light.[4] Jullien unpicks the knowledge systems that are intrinsic to culture-bound ways of thinking by instigating encounters between Europe and China and showcasing contrasting effects in such a way 'that they leave their traces on one another, reflect one another and illuminate one another.'[5] He thus intends to return to the concept of dialogue its inherent original meaning: a counterpart to various discursive forms of coherence. Jullien therefore emphasises the contradictory and redefines the concept of comparison, as for him there is no *tertium comparationis* that would be determined by the Own. It is a mutual illumination and comprehension of intelligible resources between Europe and China, whereby in principle it does not matter whether one has one's starting point in Europe and initially directs one's gaze towards China or begins in China and looks towards the West.

Jullien emphasises the different terms that are coined for the word 'landscape', and incorporates the associated traditions in China and in the West as follows:

> The word 'paysage', which comes from painting, is [...] a European word (*paesaggio*, *paisaje*, but also *Landschaft*, *landscape* ... the Russian equivalent works in a similar way). It describes the 'land' that is transformed into a 'landscape', whereas the landscape for its part is a *resource*. China, the other great culture of landscape, opens up a gap in relation to this semantic content; reference is made there to 'mountain-water', *shan shui*; it is the connection between the high and the low (or between the immobile and the mobile, between the shapeless and that which has a shape, etc.). The Chinese add another resource: a resource that is equally coherent, equally strong, which we in Europe have not yet conceptualised or have only imagined. We thus have a very different starting point for contemplating what we call 'landscape'.[6]

Based on this difference between China and the West in relation to landscape as a cultural resource, depictions of landscape attempt in the cultural dialogue to overcome the limitations of the self-reference and to effectively fill the cultural gap.

TEMPORAL LANDSCAPES

'Landscape is not a permanent given thing, but rather the product of social interaction with nature. As sedimented history and a current political issue, however, its complexity is scarcely comprehended.'[7] In addition to their spatial dimension, therefore, landscapes also have a temporal dimension. As the product of natural material and human activity, landscape is in a state of continuous transformation. In the course of processes of social change, landscapes undergo a dual transformation: one in the material world and another in our minds in terms of what we ascribe to particular landscapes and how we construct them. Accordingly, the social power structures affect the constitution of landscapes in two ways:

In the Anthropocene, humanity is informed by a post-creationist and post-naturalist belief, according to which nature is no longer regarded as unavailable creation that must be preserved. Given the finite nature

4 See Francois Jullien, *Detour and Access: Strategies of Meaning in China and Greece*, New York, 2004.

5 François Jullien, 'Unterwegs. Strategie und Risiken der Arbeit François Julliens', in 'Der Umweg über China' Festival (ed), *Kontroverse über China. Sino-Philosophie*. Berlin, 2008, pp. 77–122, here p. 95 (translated by Ann Marie Bohan).

6 François Jullien, *Es gibt keine kulturelle Identität. Wir verteidigen die Ressourcen einer Kultur*, Berlin, 2017, p. 60 (translated by Ann Marie Bohan).

7 Brigitte Wormbs, *Über den Umgang mit der Natur. Landschaft zwischen Illusion und Ideal*, Frankfurt am Main, 1978, p. 8 (translated by Ann Marie Bohan).

of the earth's natural resources – oil, gas, coal, uranium – people's lifestyles are at risk to a hitherto unknown extent. Climate change and changes in the earth's living environment are key issues and challenges that visual artists need to respond to in a productive way: for example, by linking together different time periods in their depiction of landscapes. A temporalising perspective may, on the one hand, communicate historical examples or threatening scenarios in terms of our relationship to nature; on the other hand, the use of creative visions of the future may develop alternatives to a deep-rooted understanding of landscape. It frees the way for innovations in an understanding of landscape or even, in radical terms, for artificial landscapes.

ARTIFICIAL LANDSCAPES

Artificial landscapes are the limit of two developments that mutually reinforce one another: the digital technology that emerged in the late 20th century and the modern-art practice of abstraction. Even if landscape has always tended towards abstraction, since around 1800 subjective access has had to grapple with the fact that, on the one hand, there is no longer any *terra incognita* and, on the other hand, that landscapes retreat from direct access. 'The result is its forced aestheticisation, its transformation into an inner experiential space and, in art practice, its increasingly abstract manifestation.'[8]

As digital imaging techniques have evolved, the analogue representation of the photographic motif has been superseded. In the case of landscape photography, this meant that photographs could no longer be compared with a prior space-time figuration: the computer-based processing of the photographic image expanded the scope of representation to include artistic entities that transcend the objectivity of the historical space to include artificial landscapes.

INNOVATIVE LANDSCAPE AESTHETICS AND CULTURAL DIALOGUE BETWEEN CHINA AND THE WEST

In 2010, in the light of the 'catastrophic effects of technological dominance over and exploitation of natural resources', the Akademie der Künste (Academy of Arts) in Berlin staged an exhibition entitled *Return of Landscape*. The exhibition posed the question of how art institutions in Germany could productively address 'a key issue facing humanity', namely 'the systematic destruction of the human environment'.[9] And in 2011, the Kunstmuseum Luzern combined works of Chinese contemporary art from the Sigg Collection on the subject of landscape with selected examples of *shan shui* painting, which had been practised in China for the last 1,500 years (*shan shui* is a Chinese term meaning 'mountain-water'). An accompanying publication entitled explained how the exhibition undertook to 'bridge the gap between the cultures' by representing an 'artistic viewpoint' that 'runs counter to the main requirements of Western art, such as the dictate of constant innovation'.[10]

This publication links to these two exhibitions by combining and continuing their intentions (presentation of positions of innovative landscape aesthetics and cultural dialogue between China and the West in relation to the theme of 'landscape') and by developing the scope of the theme based on three trends in the contemporary artistic depiction of landscape: east-west landscapes, temporal landscapes and artificial landscapes.

Michael Ostheimer

8 Werner Busch, 'Vorwort', in Werner Busch and Oliver Jehle (eds.), *Vermessen. Landschaft und Ungegenständlichkeit*, Zurich/Berlin, 2007, p. 7.

9 Klaus Staeck and Johannes Odenthal, 'Preface', in Donata Valentien (ed.), *Return of Landscape*, Berlin 2010, pp. 68, here p. 6

10 Peter Fischer, 'Foreword', in Peter Fischer (ed.), *Shanshui. Poetry without Sound? Landscape in Chinese Contemporary Art*, exh. cat. Kunstmuseum Luzern, Ostfildern, 2011, p. 7.

WITH BORROWED EYES

A WEST-EAST APPROACH TO THE PHENOMENON OF LANDSCAPE IN ART

It is true that Europe has only recently become aware of landscape. It cropped up in Renaissance painting. [...] In China, however, landscape-thought dawned more than a thousand years earlier and thereafter developed without interruption within the lettered class.[1]

François Jullien

As far back as his 2003 book-length essay *The Great Image has No Form*, the French philosopher and sinologist François Jullien was already focused on Chinese landscape painting in his studies. His 'detour via China'[2] was not in any way a spiritual retreat into the exotic Other, but rather a journey to mark the boundaries between the Own and the Other. Jullien qualifies Western assumptions – for example, the definition of emptiness as scarcity or a lack of something, of 'no(t) more' or 'not yet' – by setting them side by side with a conceptual alternative, in this case the Chinese *kong bai*, i.e. emptiness as potential.

In the Chinese perspective, emptiness is not, as one might suppose, something vague or nonexistent. It is dynamic and active. Linked with the idea of vital breaths and with the principle of the alternation of yin and yang, it is the preeminent site of transformation, the place where fullness can attain its whole measure.[3]

This is how the writer, poet and calligrapher François Cheng describes the fundamental importance of emptiness in Chinese cosmology, ethics, calligraphy and art.

In their writings, Jullien and Cheng, both recognised authorities on the Chinese philosophy of art, trace the characteristics of traditional calligraphy and the meditative approach that underpins it. Classical scholars were already practising this form of meditation away from the palaces and the hustle and bustle of everyday life in precisely the natural environment that we see in traditional scrolls. Landscape delineated in black brushstrokes on rice paper has been a feature of Chinese art right from the beginning. Jullien refers to evidence of 'landscape-thought in China from the 5th century.'[4] In Western art, the representation of the person had priority right up to the 18th century, and nature scenes tended to be considered as decorative backdrops for theater stages or in paintings. The scribes and painters in China, on the other hand, dedicated themselves to nature untouched as possible by humans, to the grandeur of mountain ranges, the great expanse of sky and the flow of the water more than 1,000 years before that.

The reason for this lapse in time in relation to the difference in focus is the Christian story of creation. According to this doctrine, humankind was above animals and nature, which played only a useful or subservient role. In Chinese popular belief, in Buddhism and Taoism, however, this hierarchy does not exist. All elements of the cosmos – stones, plants, animals or humans – are in a constant reciprocal relationship, which is reflected in the comparison made between mountains, clouds and water and parts of the human body. Jullien talks about 'the same physical tension' seen in humans and nature, and invokes classical Chinese cultural concepts which Jullien calls 'name tables'. In these, analogies are made between rocks and bones, forests and clothes, plants and hair, waterways and veins; clouds and wafts of mist are likened to facial expressions and the haze and the little clouds are seen as atmosphere.[5]

This special role played by landscape painting continues into contemporary art even if the artistic forms of expression do not always

1 François Jullien, *Living off Landscape: or the Unthought-of in Reason*, London, 2018, p. 11.
2 See Jullien, Francois, *Detour and access: Strategies of meaning in China and Greece*, New York, 2004.
3 François Cheng, *Empty and Full: the Language of Chinese Painting*, Michael H. Kohn (trans.), Boston & London, 1994, p. 36.
4 Jullien 2002 (see note 1) (translation by Ann Marie Bohan).
5 Jullien, 2018 (see note 1).

immediately reveal the bond with tradition. For example, the series of photographs entitled *To Add One Meter to an Anonymous Mountain* (1995), staged by Zuoxiao Zuzhous (b. 1970) and a number of other artists, unexpectedly prompts an association with a traditional Chinese landscape. However, in classical nature scenes, humans are depicted as de-individualised figures in miniature format. By adding a metre in height to the summit of a mountain through the pile of naked bodies, the artist collective expresses the stipulation that, in the 21st century, it is not only the greatness of nature that should be honoured as a subject of art but also the human being as an individual. A conceptual revival of the historic genre, therefore, which the more conservative viewer may well find to be more of a provocation than a bond between the generations.

'One particular image runs through the thought of ancient China, both irrigating it and linking it together: the image of water',[6] writes Jullien in *A Treatise on Efficacy: Between Western and Chinese Thinking*. According to Lao-Tzu (4th or 3rd century BCE), the founder of Taoism, the dynamic nature of water and its capacity for transformation symbolise the characteristics of a successful life. Water is key to Chinese landscape painting in many respects: the haze that settles over lakes and rivers; the rounded summits of soaring hump-backed mountains plunged into dense fog. The composition of the cosmos changes timelessly and without any recognisable boundaries between the elements, and with it humankind, whose role according to Lao-Tzu is to live in peaceful unity with itself and nature. 'What we call landscape draws its consistency from the correlation of mountains and waters. The mountain, it is said, deploys the course of the water, and the water *animates* the mass of the mountain.'[7]

Once the question of whom Jullien means by 'we' is raised, it is clear how strongly he identifies with the strategies of Chinese thought, without losing sight of his cultural distance in the course of his argument. His 'detour via China', ongoing over several years, allowed him to internalise knowledge about the 'other culture' to such an extent that he can take on both perspectives. In this case, however, he is looking through the eyes of a Chinese viewer, for whom landscape means *shan shui* (mountain-water).

The life's work of Long Chin San (1892–1995) illustrates how masterfully Chinese artists deal with traditional heritage – particularly when they are very familiar with the art of other countries. Long Chin San rapidly gained recognition both in China and abroad as a pioneer of Chinese photography and the first photojournalist in his native country. He was made a Member of the Royal Photographic Society of Great Britain in 1937. In 1980, the Photographic Society of America named him as one of the most important photographers in the world. Long Chin San did not see any contradiction between state-of-the-art technology and tradition, as his following statement shows: 'Photography is an international language, and I've decided to use this most powerful of international languages to introduce and present to the entire world China's natural beauty, its richness of culture, its virtuous ethics.'[8] He used composite photography to ensure he complied with the guiding principles of Chinese landscape painting, i.e. the classical composition and the synergy of elements, in the medium of photography. William Notman (1826–1891) developed the composite method in the 1870s. Yet while the Scottish-Canadian photographer and businessman used a combination of several negatives for his portraits and stagings of fantastical scenes, the Chinese artist was interested in perfecting nature.

6 François Jullien, *A Treatise on Efficacy: Between Western and Chinese Thinking*, Janet Lloyd (trans.), Honolulu, 2004.

7 Jullien, 2018 (see note 1), p. 32.

8 Sotheby's, 'Photographer Long Chin-San's Monumental Retrospective', in *Sotheby's*, 13.03.2017, https://www.sothebys.com/en/articles/photographer-long-chin-sans-monumental-retrospective (last accessed on 23.08.2019).

According to Long Chin San: 'We are often disappointed to find a good piece of scenery spoilt by an unneeded tree or ruined by an excrescent bit of rock. [...] but with the advent of composite pictures such disappointment can at last be remedied: we can now eliminate what is not wanted and add in what is lacking.' He emphatically refutes the accusation that classical Chinese painters would paint 'from imagination'. What differentiates them from Western artists is 'that they paint what they have seen instead of what they are seeing'.[9] 'Eventually man has invented what he calls art, and art is said to improve nature.'[10] Long Chin San then goes on to briefly summarise the essential features of a traditional landscape composition. The line of vision and the horizon should form an angle of roughly 45 degrees. The mountains, water-ways and sky should be arranged in such a way that the painting is divided into a foreground, middle ground and background. Clouds and fog are of fundamental importance to 'temper the atmosphere' and 'render more variety to the design' and to ensure the characteristic mood of the ensemble. These pragmatic instructions inherently sound considerably more poetic in the classical Chinese poems. Nor do Long Chin San's photomontages reveal that they follow clearly formulated specifications.

What does the Chinese viewer see in a composed, ink-painted mountain-water scene? What does the Western viewer see? What connection does he or she make with the landscape experience conveyed in the image and with the 'real' nature that he or she sees? What are the implications of a more or less pronounced familiarity with the classical Chinese landscape aesthetic for the respective recipient of a landscape impression? The explicit and generalised answer is not of primary interest here, but rather the awareness of an existing alternative to one's own perception. Once this step has been taken, it seems reasonable to enquire about the other body of knowledge. This exploration is akin to 'trading eyes' or adopting a type of temporary Janus-like approach. Is it possible to see with eyes that access knowledge shaped by a different culture? If so, what traces are left behind by this venture? Does one subsequently return to one's own horizon of seeing, or perhaps even acquire the ability to permanently see in a different way, i.e. at least in two different ways, one and the same image, one and the same landscape?

The publication *With Borrowed Eyes. Landscape, Landschaft, shan shui* approaches this experiment from a variety of perspectives. In some instances, the philosophical and art-historical discourse will help us in the interpretation of the image. In others, the work will serve as a visualised argument on the subject. Looking in an open and unbiased way and having an interest in the 'technique of detour'[11] were important prerequisites for all participants when it came to the concept of this book.

Ulrike Münter

9 Long Chin San, *Techniques in Composite Picture-Making*, Taipei, 1958, n.p.
10 Ibid., n.p.
11 Jullien 2004 (see footnote 2).

EAST-WEST LANDSCAPES

ZUOXIAO ZUZHOU

Body Landscape

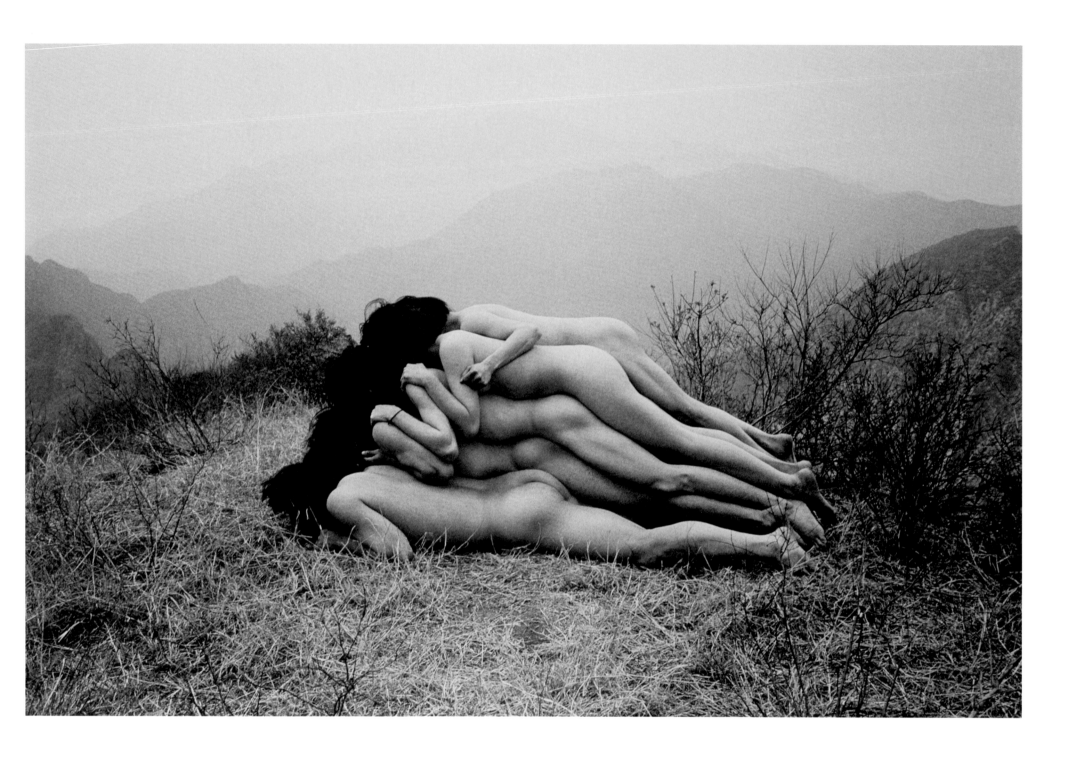

↗ **To Add One Meter to an Anonymous Mountain**, 1995
Silver gelatine print
120 × 160 cm

From a Western perspective, the performance documentation *To Add One Meter to an Anonymous Mountain* (1995), which is available in various editions and formats and as both black-and-white and colour photographs, is an unusually conciliatory work of the Chinese avant-garde. One of the artists involved was Zuoxiao Zuzhou, whose real name is Wu Hongjin (b. 1970) and who is better known these days as a rock singer. Although the series of photographs appeared in several exhibitions inside and outside China, no consideration was given to the fact that the formation of naked bodies as part of a mountain impression is an almost literal enactment of a principle of Chinese landscape painting.

Harald Szeemann was the main instigator who helped to bring Chinese contemporary art to international attention in 1999. As curator of the 48th Venice Biennale, he exhibited works by twenty Chinese artists, among them the performance photograph *To Add One Meter to an Anonymous Mountain*. Its genesis is particularly impressive in that it does not fit the stereotype of the spectacular, inherent in the art of the post-Mao era. Thus, on 11 May 1995, eight male artists (Cang Xin, Gao Yang, Ma Liuming, Ma Zhongren, Wang Shihua, Zhang Huan, Zhu Ming and Zuoxiao Zuzhou), two female artists (Duan Yingmei and Zhang Binbin), together with two land surveyors, the art critic Kong Bu and the photographer Lu Nan made their way to the Miaofeng mountain near Beijing. Working to a very detailed schedule, the group climbed to the top, removed their clothing and lay down, one of top of the other, to form a pyramid shape. This intervention raised the summit of the mountain to more than 87 metres, approximately one metre higher than it was before.[1]

The charged atmosphere of the free Chinese art scene of those years can only be felt in a very removed way in *To Add One Meter to an Anonymous Mountain*. The young men and women hold on to each other's shoulders, their hair

1 After the performance, each of the participating artists received a black-and-white negative; some also received a colour negative. A total of more than ten different editions was produced. As the subsequent hype about Chinese contemporary art could not be predicted at the time of the action, the dispute over the creative authorship of the photographs ensued after some delay. It is still not resolved. I would like to thank Sabine Wang (Beijing) for the consultation with Zuoxiao Zuzhou on the genesis of *To Add One Meter to an Anonymous Mountain*.

2 Zhang Huan, quoted in Kong Bu, 'Zhang Huan in Beijing' in: *Zhang Huan: Altered States*, exh. cat., Asia Society Museum, New York, Milan, 2007, online: http://www.zhanghuan.com/wzMF/info_74.aspx?itemid=1144 (last accessed on 18.04.2019).

3 François Jullien, *Living off Landscape: or the Unthought-of in Reason*, London, 2018.
4 Ibid., quote from Tang Zhiqi.

covers their faces. Their nudity does not expose them, inasmuch as we only see their bodies in profile. There is nothing to indicate the inner turmoil felt by the artists, their precarious living conditions or the daily threats they faced from the authorities.

Many artists had left the country following the traumatising experience of the brutal suppression of the democracy movement in the spring of 1989. Those who stayed retreated from the public eye. In 1993, one of the locations to which they retreated was a collection of empty buildings in a derelict migrant workers' residential 'village' in the eastern outskirts of Beijing. Performance artists, photographers, musicians and art critics were drawn there. They named the resulting artistic community the Beijing East Village in homage to the hip East Village in Manhattan. The colony was particularly famous for the experimental nature of the actions that took place there. The artists tested their limits of endurance and those of their audience in the experiments that they conducted. The staging of one's own body – and in particular the naked body, hitherto taboo in China – became a recurring theme, as retrospective exhibitions illustrate. A special role is assigned to the photograph *To Add One Meter to an Anonymous Mountain* in this regard: while artists in other performances deliberately and in full view of the audience inflict injuries on themselves or place themselves in other, almost unbearable situations, *To Add One Meter to an Anonymous Mountain* exudes serenity and calm.

In a symbiotic overview, the bodies acquiesce harmoniously to the natural surroundings. Other hill formations can be discerned in the mist behind the Miaofeng mountain. The resulting shades of grey lead into the depths of the pictorial space. Zhang Huan, who came up with the idea of the performance, refers to an old Chinese proverb that inspired him to increase the height of a mountain using the human body: 'behind a mountain lie other mountains'. 'It is about humility,' he says, explaining his understanding of these lines. 'Climb this mountain and you will find an even bigger mountain in front of you. It's about changing the natural state of things, about the idea of possibilities.'[2] Zhang Huan's statement articulates the idealism, the resilience but also the occasional feelings of resignation of that artist generation, whose protagonists had to ignore prevailing social conventions in order to explore uncharted artistic territory.

The use of calligraphy by the proponents of the Chinese avant-garde also makes it clear to the Western viewer how deeply the artists feel connected to the cultural heritage of their homeland. The direct reference to traditional landscape painting is well-developed territory from an art-historical perspective, and *To Add One Meter to an Anonymous Mountain* is explicitly named in this context, given that the natural surroundings, featuring the mist-covered mountains, quite clearly correspond with this topos. It is all the more surprising then that none of the commentary relating to this series of photographs makes reference to the analogy formulated between the individual natural elements of a landscape and the human body. The 'constitutive being of a mountain' included the rocks as 'bones', the forests as 'clothing', the foliage as 'little hairs and head hair', the waterways as 'veins', the clouds and wafts of mist as 'facial expression' and the haze and the little clouds as 'atmosphere': this is how the French philosopher and sinologist François Jullien summarises the communicative and emotional tension between humankind and landscape.[3] He quotes the Chinese artist Tang Zhiqi (1579–1651), according to whom 'the "nature" of the mountain (and that of the water)' corresponds to human nature.[4] With the sound of the Chinese classical artist in mind, the performance *To Add One Meter to an Anonymous Mountain* is like a poem that the participating artists are writing with their bodies. **U.M.**

JOSEF HOFLEHNER

Placeless and Timeless

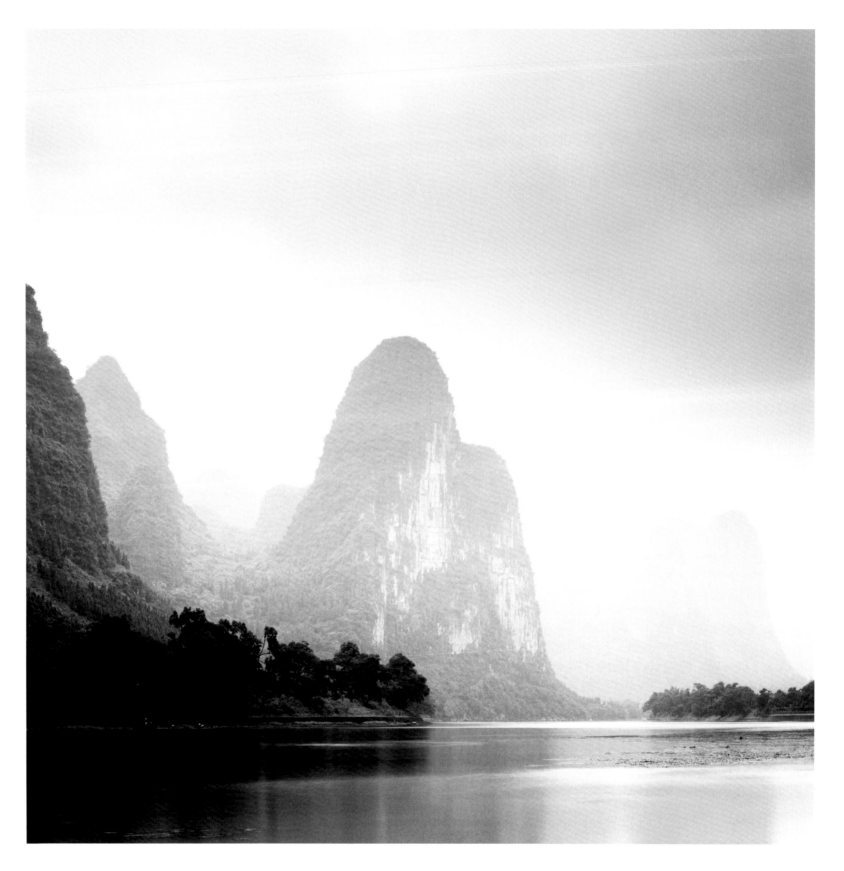

↗ **Li River, Study 8**, 2008
Barite print
30 × 30 cm

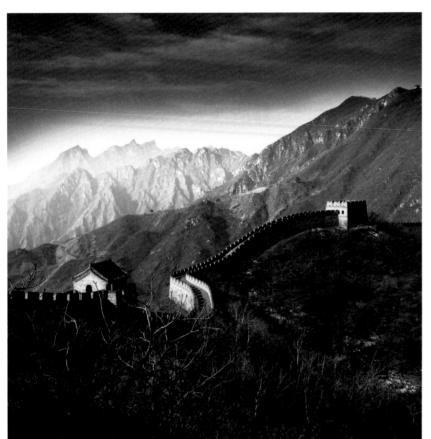

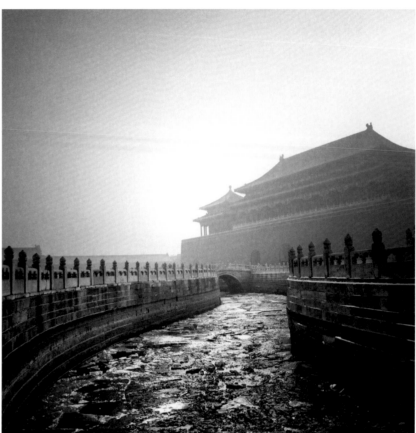

← **The Great Wall, Study 3**, 2007
Barite print
30 × 30 cm

↙ **Forbidden City**, 2008
Barite print
30 × 30 cm

The Austrian photographer Josef Hoflehner (b. 1955) has been drawn to China on several occasions. Between 2006 and 2009, he photographed a number of landscapes there in black and white using long exposures. Critics have repeatedly compared these works to the pictorial compositions of traditional Chinese landscape painters. They are understandably referring to the meditative atmosphere in Hoflehner's photographs, which appears to be borrowed from the traditional painted works using ink on rice paper. However, this comparison does not go very far. The *shan shui* painting style that has been practised according to strict conceptual requirements since the Tang Dynasty (618–907) does not in any way strive to depict a real nature scene but instead an idealised, aesthetic synergy of mountains and waterways.

Josef Hoflehner's preference for 'empty spaces'[1] could be scarcely more radically manifested than in his photograph *South China Sea. Sanya, Hainan* (2006).[2] Dense mist fills the entire pictorial space. It could bring to mind a light installation by the American Land Art artist James Turrell, but in Hoflehner's case, the photograph that was taken on the tropical island of Hainan has not been enhanced. The artist does not even hint that Hainan is one of the most famous and popular tourist destinations in China. We see the hazy sea – but no shoreline, people swimming or ships. The greyness rising from the lower edge of the photograph to the horizon in the middle of the photograph is placeless

1 Till Bartels, 'Einmal um die Welt in Schwarz-Weiß. Josef Hoflehner Retrospektive', in: *Stern*, 24 September 2015, online: https://www.stern.de/reise/fernreisen/josef-hoflehner---retrospective-1975-2015-6458062.html (last accessed 17 April 2019).
2 Tellingly, he concludes the series of photographs in *China. Josef Hoflehner* (Wels, 2009) with this photograph.

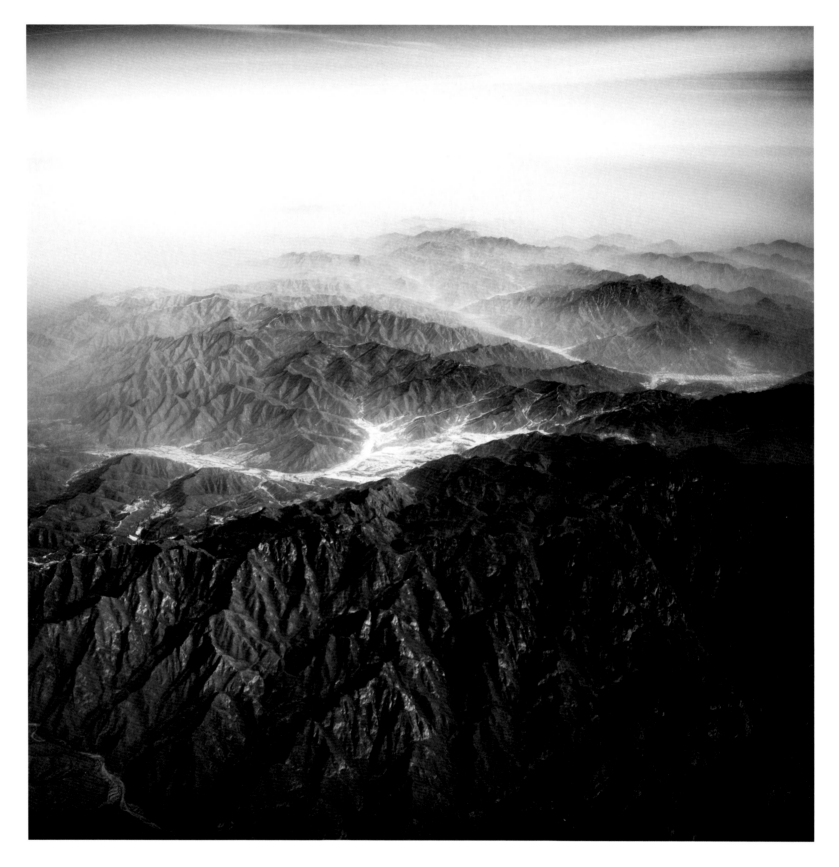

↗ **From the Above**, 2007
Barite print
30 × 30 cm

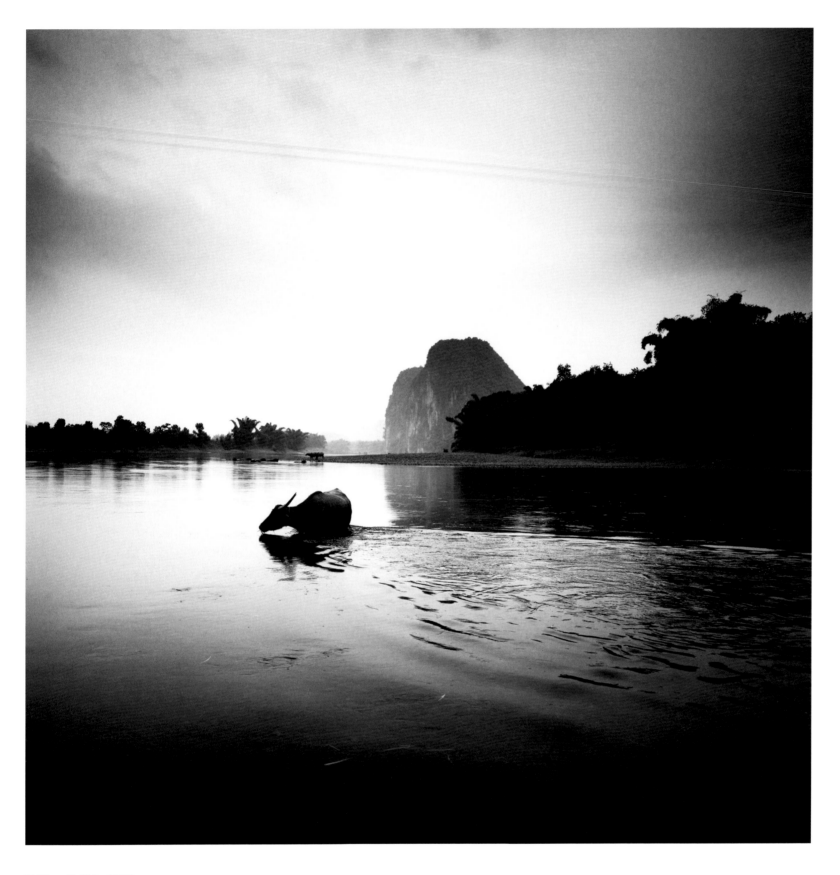

↗ **Water Buffalo**, 2006
Barite print
34 × 34 cm

and timeless. What we assume to be the sky is a monochrome, milky expanse. A photograph without any reference to the actual landscape, an abstraction of reality.

The prevalence of mist and emptiness could be interpreted as an affinity with the Chinese tradition. However, this is only partly the case, as the fixed element – the suggestion, at least, of a mountain – is missing from the subject matter he has chosen for the work. No landscape without land, but also none without water. The name of this art form – 'mountain-water painting' (*shan shui hua*) – speaks for itself. However, Hoflehner's view of the Chinese landscape is the view of a stranger. It was the 'search for new photographic challenges'[3] that brought him to China. When asked, he clarifies that he does not have a connection with Chinese landscape painting. He says that *South China Sea. Sanya, Hainan* and some of the other photographs came about due to his interest in 'seemingly desolate areas'.[4] Whether it is in the sparsely populated mountainous area surrounding the legendary river Li in the Guangxi region in south China or in the middle of Beijing, Hoflehner professes to be not very impressed by the immaterial, historic or even political connotations of the regions or places he visits. Instead, the aesthetic continuity accounts for the recognition value of his photographs – the restraint apparent in the scene, achieved using long exposures, and the fact that misty weather suits him perfectly.

Hoflehner chose a murky, overcast winter's day for his visit to the Forbidden City in Beijing. A leaden sky forms the backdrop to the imposing architecture of the former imperial palace. In *Outside of Forbidden City* (2007), the eye skims over a snow-covered expanse of water, which occupies a large part of the photograph. Sublimely unaffected by changing times, one of the four corner pavilions in the fortress wall lies between the middle ground and background of the photograph. The comparison with *Forbidden City* (2008) shows the extent of dramatic potential in Hoflehner's photographic concept. Although this is just another view of the same area, extending over 720,000 square metres, the winding course of the river with its turbulent surface and the gloomy lighting create a completely different mood. The multi-storey Hall of Supreme Harmony extends skywards, solid yet indistinct. The portrait of the 'Great Leader', Mao Zedong, hung at the entrance to the Forbidden City, is hidden in the mist.

From the Above (2007) shows the Great Wall more as a line winding its way through the breathtaking expanse of the mountain landscape than as an architectural masterpiece. While this photo was taken from a helicopter, *The Great Wall, Study 3* (2007) provides a close-up view of the section of the former rampart that has been refurbished for visitors. The beauty of the mountain landscape and its vegetation fades away in the seasonal and weather-related cloudiness.

3 Josef Hoflehner in an email to the author on 26 September 2017.

4 Michael Zollner, 'Josef Hoflehner', in: *Fotomagazin*, 12 July 2010, online: https://www.fotomagazin.de/bild/josef-hoflehner (last accessed 17 April 2019).

Although certain regions in China have been sought after as preferred locations for meditation for thousands of years, and still continue to be so, and the relationship between mountains and waterways there is considered to be ideally typical of Chinese landscape painting, nonetheless the traditional ink paintings do not show what the individual painter really saw. Instead, real nature inspires the image that the inner eye sees and that then guides the brushstroke. However, these landscapes are definitely enlivened by people. Well-placed huts with pagoda roofs protect against rain or invite one to linger; miniature-sized people stroll along narrow paths, often guiding an ox or looking pensively from a viewpoint into the expanse. Small, manned boats make their way along the waterways following the contours of the mountains. If we consider Hoflehner's photographs in such a context, it is immediately obvious that he is not intent on presenting the famous hump-backed mountains in Guilin, which are considered to be the epitome of beautiful landscape, as a place that has been made accessible for people. The misty, overcast impressions in the *Li River, Study* series (2008) depict unrealistically calm mountains and lakes. The water buffalo wading through shallow water in *Water Buffalo* (2006) looks almost archaic. Using a wide range of shades of grey, it seems as if nothing has changed here for a long, long time and will not do so either in the future. Time stands still. **U.M.**

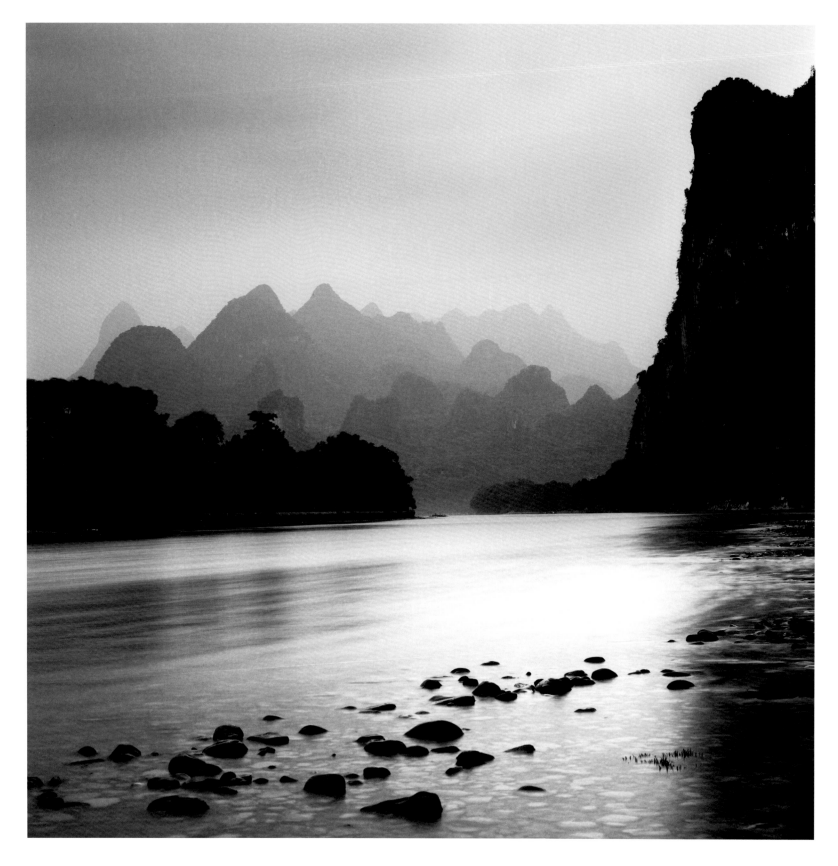

↗ **Li River, Study 4**, 2008
Barite print
100 × 100 cm

IN SOOK KIM

Not a Landscape in the Traditional Sense

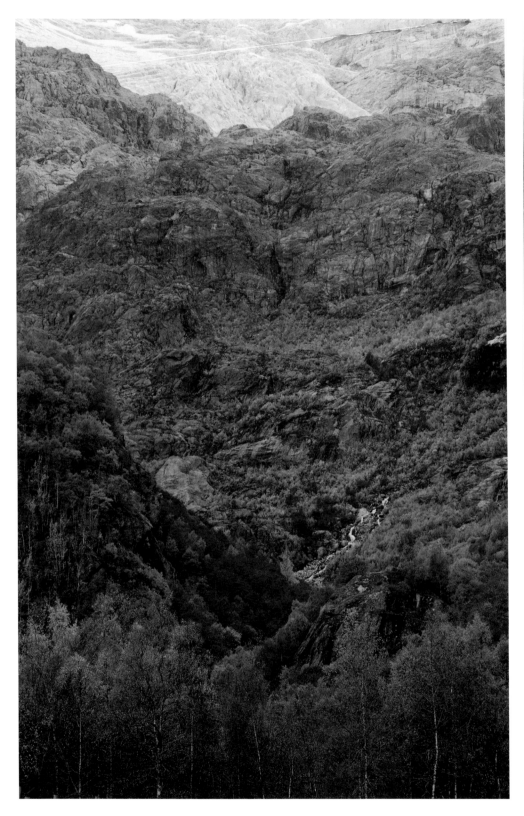

↑ **H2O – 01**, 2014
C-Print, Diasec
220 × 150 cm

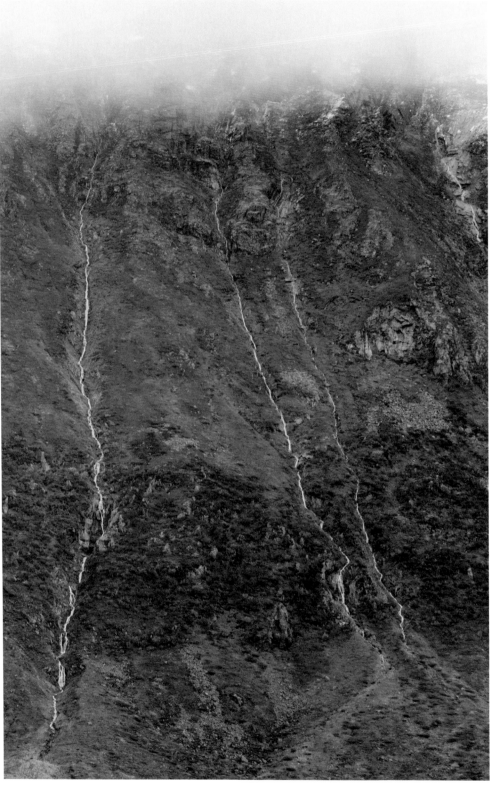

↑ **H2O – 55**, 2015
C-Print, Diasec
220 × 150 cm

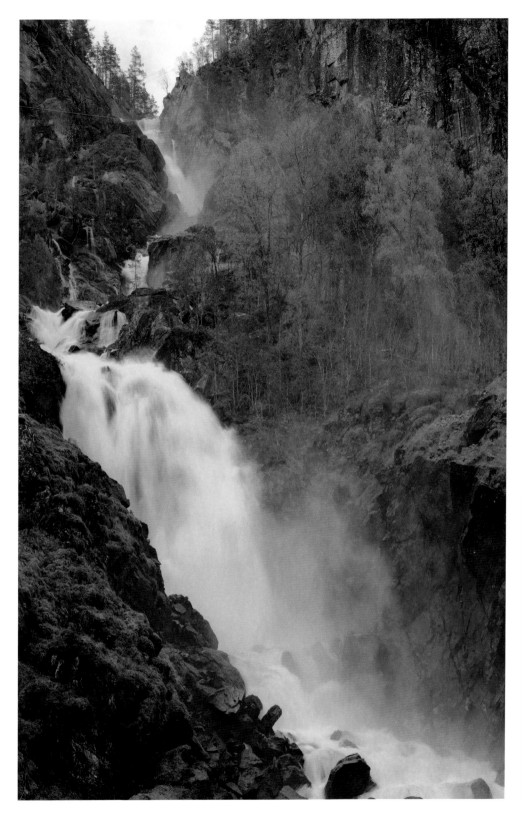

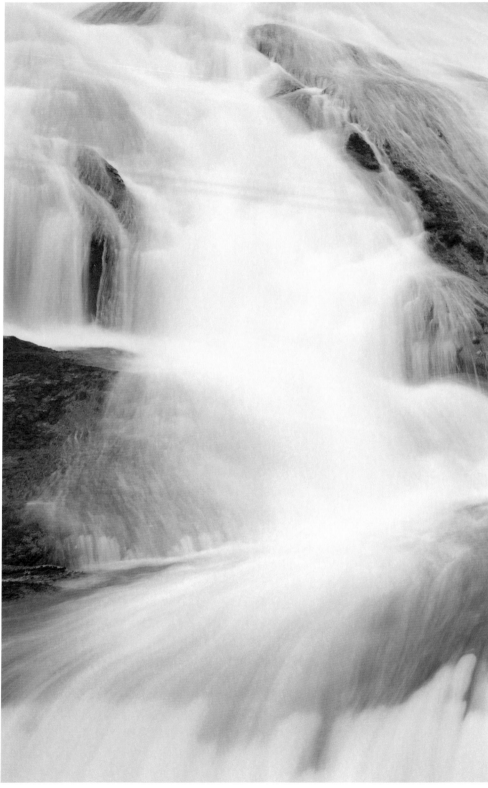

↑ **H2O – 220**, 2015
C-Print, Diasec
220 × 150 cm

↑ **H2O – 219**, 2015
C-Print, Diasec
220 × 150 cm

1 All of the quotes from In Sook Kim used here come from an email interview conducted with the author in autumn 2018.

'This must be roughly what it looked like before humanity arrived,' says the Cologne-based artist In Sook Kim (b. 1969 in Busan, South Korea), commenting on her *H2O* series of photographs, most of which were taken in Norway (2014/2015).¹ In contrast to her earlier works, in which she arranged scenes on the set and photographed them digitally, In Sook Kim used analogue sheet film for her impressions of nature 'because the contrasts are more striking and the details appear more pronounced when this technique is used.' Her images of alpine streams and waterfalls have an otherworldly quality. A velvety haze envelopes the mountain ranges, and there is nothing violent even about the wildly roaring waterfalls.

In Sook Kim came to international attention mainly as a result of her view of the Radisson Blu Media Harbour Hotel in Düsseldorf. In a work entitled *Saturday Night* (2007), she focuses on the isolation, not only of older people, which is symptomatic of life in the city. In the anonymity of such a transitory place, the strategies developed by the people temporarily living there to withstand the silence of solitude usually remain hidden. However, the illuminated windows in the series of photographs grant the viewer unobstructed insights into the rooms, which themselves become a kind of backdrop to a stage. The tableaux show men and women in front of their television or computer, drinking alcohol or showing signs of drug consumption. The close-up shot *Saturday Night Room 509* highlights a more generalised phenomenon, namely the discrepancy that exists between one's position in society, or rather that of the authority associated with the position, and the person behind it. We see a pilot in uniform, a resigned look on his face, slumped slightly forward as he sits on the edge of his bed. *Saturday Night Room 606* undoubtedly depicts the most drastic situation: in this work, a young Asian woman is on the point of taking her own life. A Saturday evening in the hotel of a strange city becomes the antithesis of what is auspiciously described as 'home'. At every level, In Sook Kim's work is a none-too-flattering testament to the restlessness that is characteristic of the hustle and bustle of big-city life. The aim of a successful life – as suggested to the metropolitan resident – is to be flexible and available at all times. The price of such 'success' is often a lack of inner stability or even existential crisis.

The fact that In Sook Kim leaves the city behind her a few years after the *Saturday Night* series and photographs landscapes apparently untouched by humans for the *H2O* works may initially appear to be a radical change of course. She recounts in the interview how most of the photographs were taken in Norway. However, her travels also brought her to Asia and other parts of Northern Europe. 'In Norway, I was fascinated by the unspoilt nature.' Compared to the Asian landscape, the northern mountain regions appeared to her to be more 'masculine'. Responding to the Chinese tradition of landscape painting, which had a profound influence on the Japanese and Korean depic-

tion of nature in art, In Sook Kim admits that '*shan shui* [has] certainly woven its way unconsciously into [my] DNA.' 'Essentially it is a drawing with countless graduations. When I look at something, I first see the lines: my perception abstracts what is seen into a line drawing.' In Sook Kim thus considers the *H2O* photographs 'not as landscapes in the traditional sense'. During her travels she did not seek out the 'beauty of nature' but rather 'the abstract element in nature'. It is here at the latest that the indeterminate and disconcerted effect of her mountain-and-water painting is explained. She achieves this effect through interventions relating to colour, light, contrast and cropping. Landscape in art is assigned the status of a visual experience transferred into a photo.

In contrast to In Sook Kim's set photographs, which deal with 'social issues' and the significance of 'interpersonal connections', *H2O* moves to places where the person is absent, hasn't been there yet or is no longer there. The mountains and the waterways achieve their imaginative potential. They create open spaces in which it is possible, by virtue of the imagination, to emerge from situations that restrict individual opportunities for development. In the uncharted territory of the aesthetic, they perhaps open up alternative living models. The solid mountains, the powerfully flowing water, the bleak landscape and the streams of water delicately winding their way through the stones offer an energetically comforting environment. U.M.

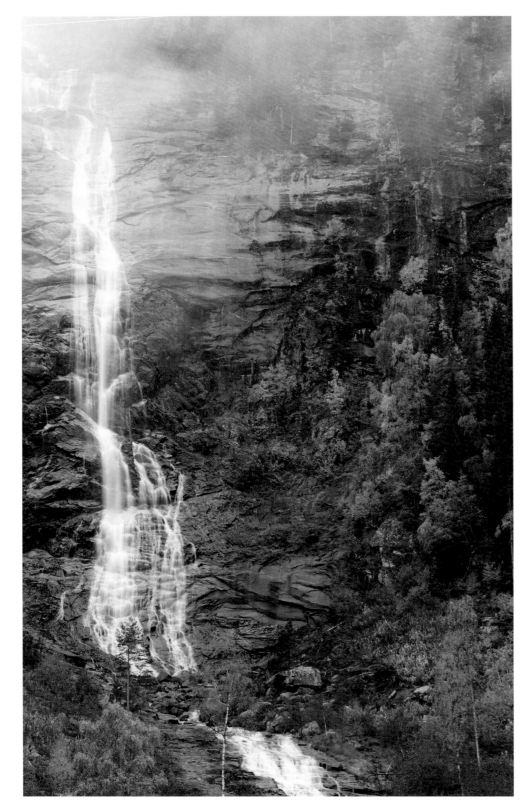

↑ **H2O – 36**, 2015
C-Print, Diasec
220 × 150 cm

↑ **H2O – 24**, 2015
C-Print, Diasec
220 × 150 cm

JIANG PENGYI

Joined with All-That-Is

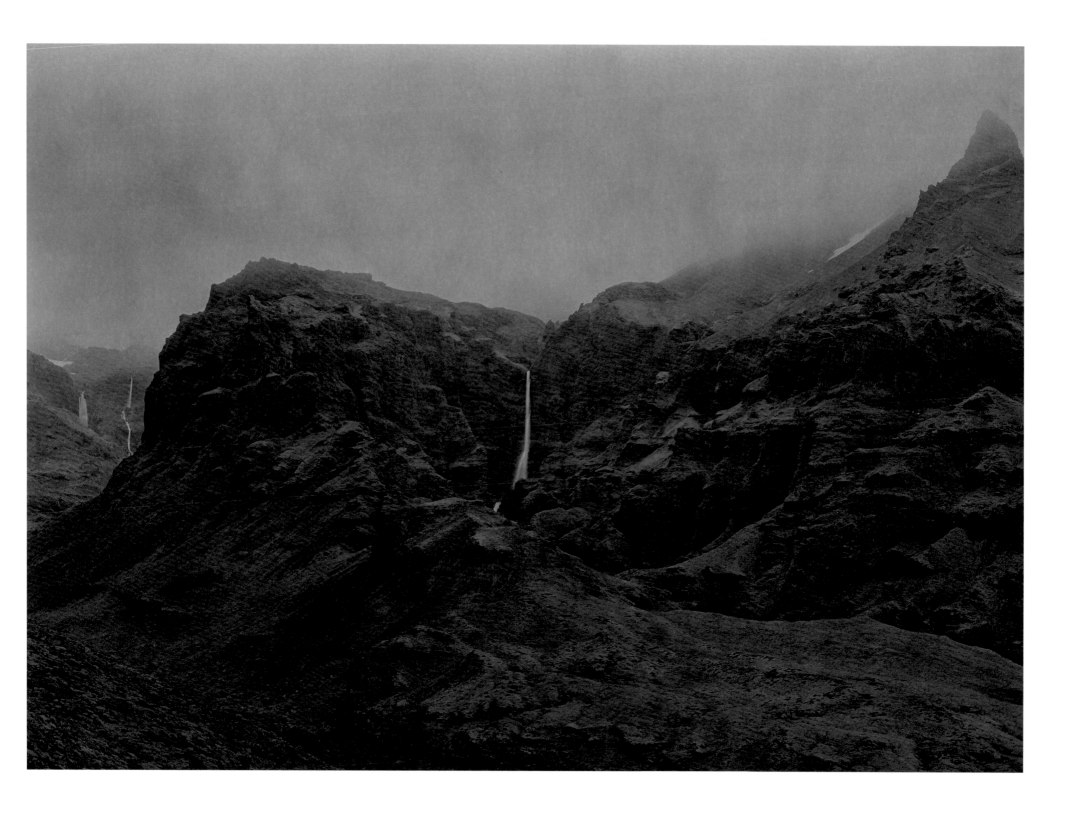

↗ **Grace No. 1**, 2014
Archival inkjet print
160 × 227 cm

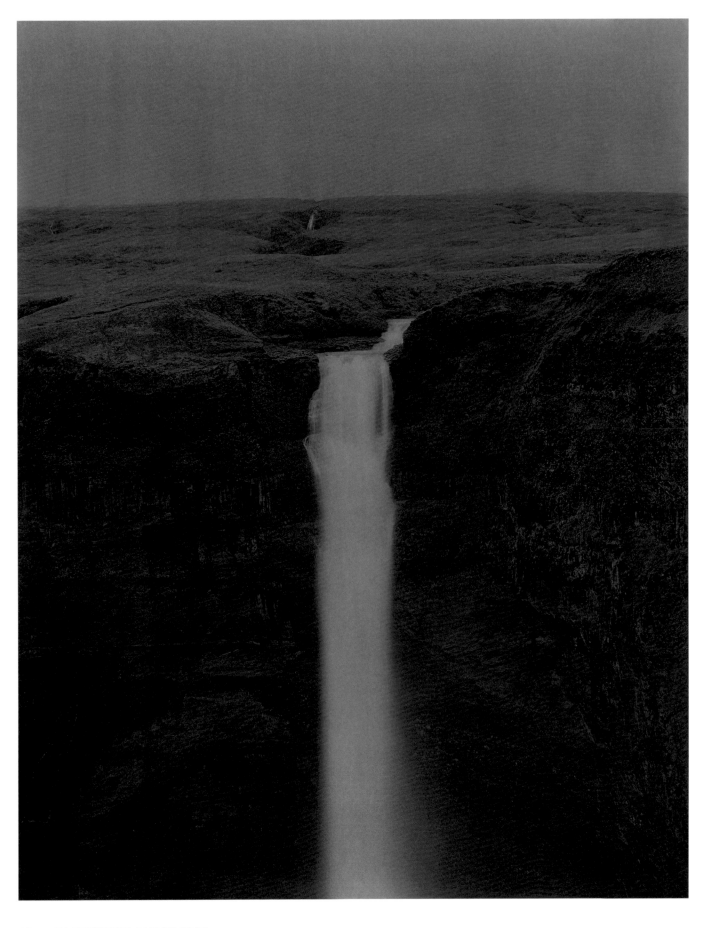

↖ **Grace No. 2**, 2014
Archival inkjet print
150 × 118 cm

1 Jiang Pengyi in June 2018. I would like to thank Sequin Ou at the Galerie ShanghART, Shanghai for the translation of the author's email interview.

2 Guō Xī, The Lofty Message of Forest and Streams, quoted in Mae Anna Pang, 'Zhu Da: the mad monk painter', in *Art Bulletin of Victoria*, No. 25, Melbourne, 25 June 2014, available at https://www.ngv.vic.gov.au/essay/zhu-da-the-mad-monk-painter/ (last accessed 27 May 2019).

3 See François Jullien, *Living off Landscape: or the Unthought-of in Reason*, London, 2018.

'I enjoy looking at the works of Chinese landscape painters. They convey a deeper understanding of nature and human existence to me. I get a real feeling for what we call the "cosmos" when I experience a waterfall with all my senses, when I see how it makes its way through high mountains, how the atmosphere changes as a result of the weather and the seasons. I don't really see what is outside of me then. Instead, I look inward. In these moments, I feel a humble, fragile inner calm. For me, photography is the equivalent of a brush and ink to a traditional Chinese painter.'[1]

This statement by the Beijing-based artist Jiang Pengyi (b. 1977) on the subject of his series of photographs entitled *Grace* (2014–2016) makes clear, on the one hand, his affinity with classical Chinese landscape painting and, on the other hand, the freedom with which he treats the perception of nature in his art practice. The reduced black-and-white aesthetic of the photographs taken on his travels through countries in the Arctic Circle radiates timelessness. Very little has changed here in living memory, or at least so it seems. Equipped with an analogue camera, Jiang Pengyi wended his way through the mountainous areas of Norway, Sweden and Iceland. The rawness of the landscape in these countries has little in common with the rather quaint hump-backed mountains and waterways flowing through the massive outcrops of rock in his homeland. Of course there are waterfalls there too, and these feature in the ink painting of the old Chinese masters; in these paintings, however, they have flowed through a landscape of bushes and trees, curves and turns, for several hundred years, winding their way by pagoda-roofed shelters, animated by animals and people. The world as it is reflected in Chinese traditional art is an ideal type of world, a meditation made visible with the brush, a reflection on a metaphysical world nexus. *Shan shui* painting depicts creation before humankind intervened destructively in the harmony that was its key characteristic

Jiang Pengyi chooses rather inhospitable regions for the photographs in his *Grace* series. The viewer could interpret this decision as a search for an atmospheric equivalent to the current reality of life in China. The rapid pace of change, particularly in urban but also in rural areas, demands a great deal of resilience on the part of people as they go about their daily lives. The harmonious landscapes in mountain-water painting (known in Chinese as *shan shui hua*) may always have been places of magical appeal but now, against the backdrop of the existential threat of environmental pollution, they seem to be more of a lament. At the same time, the waterfalls that Jiang Pengyi focuses on and his words on the subject bring to mind passages from tracts by classical Chinese artists, which make it clear how internalised knowledge shapes his view beyond the familiar cultural space.

'Stones are the bones of heaven and earth [...]. Water is the blood of heaven and earth.'[2] These are the words, for example, of the famous Chinese landscape artist Guō Xī (1020–1090), quoted from his treatise on painting, *The Lofty Message of Forest and Streams*. This anthropomorphism of nature is not at all unusual in Chinese aesthetics. Forests are the mountain's 'clothing', plants become its 'hair' and clouds and mists are its facial expression.[3] A human organ, a character trait or an emotional state is assigned to each natural phenomenon, facilitating a particularly close connection not only between humankind and the landscape but also between humankind and the cosmos. A conversation between those who are open to nature and the surrounding creation thus does not need any great effort.

While this type of communication and the experience of the dissolution of boundaries may perhaps seem esoteric from a modern Western perspective, it is an integral part of Chinese thinking. It is also a key element of Jiang Pengyi's thinking. In a diary entry from December 2014, the artist describes waterfalls as 'turbulent white tongue[s]' that speak to him. However, this attributive de-

scription only applies to a few landscapes in the *Grace* series. In *Grace II*, for example, the mass of water tumbles over a cliff edge into the depths, giving the impression of a huge knife cutting through the rock massif. The powerful roar of this voice of nature is not difficult to imagine. In *Grace III*, on the other hand, the stream of water weaves its way like a vein through a mountain region populated by scree and flat grass sods, inviting us to forget that people and animals also live on this planet. This waterway narrates his stories with a more subdued voice.

In March 2016, Jiang Pengyi noted: 'Grace, mercy; God distributes his love to people.' According to the world view of Pantheism (*pan* from the ancient Greek for everything; *theos* from the ancient Greek for god) God's existence is revealed in untouched nature. Indeed, it contends that God and the cosmos are identical, a view to which Johann Wolfgang von Goethe and others subscribed. Goethe thus distanced himself from his radical, progressively minded contemporaries, for whom any form of spiritual approach to the world appeared suspect because it could not be proved. A glance at Greek antiquity reveals that the connection with the cosmos, which is still respected in China today as a civilised way of life, was fundamental to both the pre-Socratic philosophy of nature and to Plato's idea of a world soul. This journey into intellectual history could be continued to include the Italian early modern period (Giordano Bruno), the indigenous people of America or the Persian Sufis.

After this imaginary journey, it may be with regret that Western participants return to their own present-day cultural milieu, as the monotheist religions of Western culture declare humanity to be the pinnacle of creation and thus deny it its place in the cacophony of voices of the supposedly soulless beings of nature. Jiang Pengyi's *Grace* series of photographs eschews all ideology and surrenders to the noise of the waterfall, to which it carries those who are listening. **U.M.**

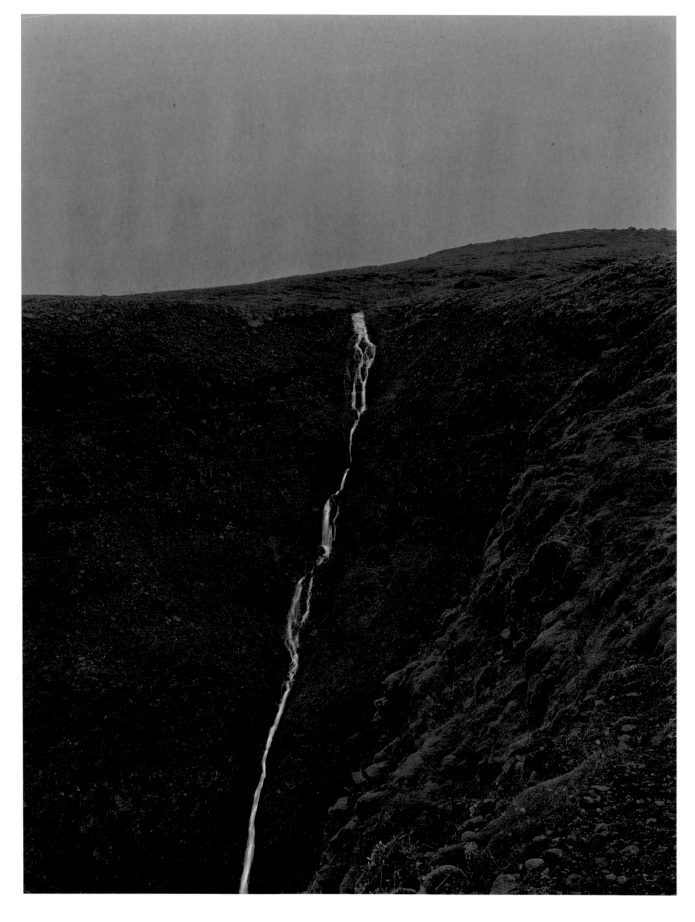

↗ **Grace No. 3**, 2014
Archival inkjet print
98 × 78 cm

ERIK SCHMIDT

'I didn't go into nature or the city to find landscapes'

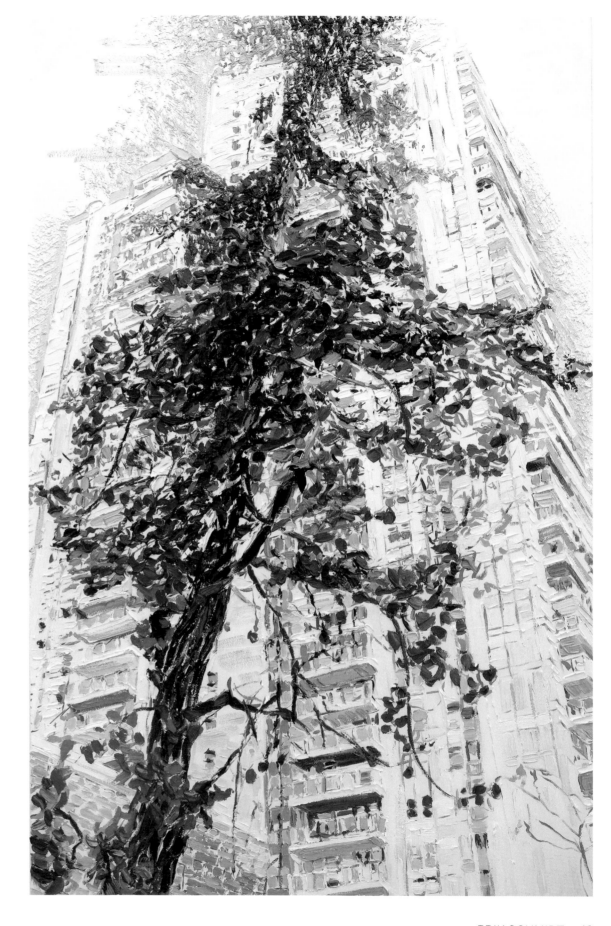

↗ **Thick Housing**, 2014
Oil on canvas
180 × 120 cm

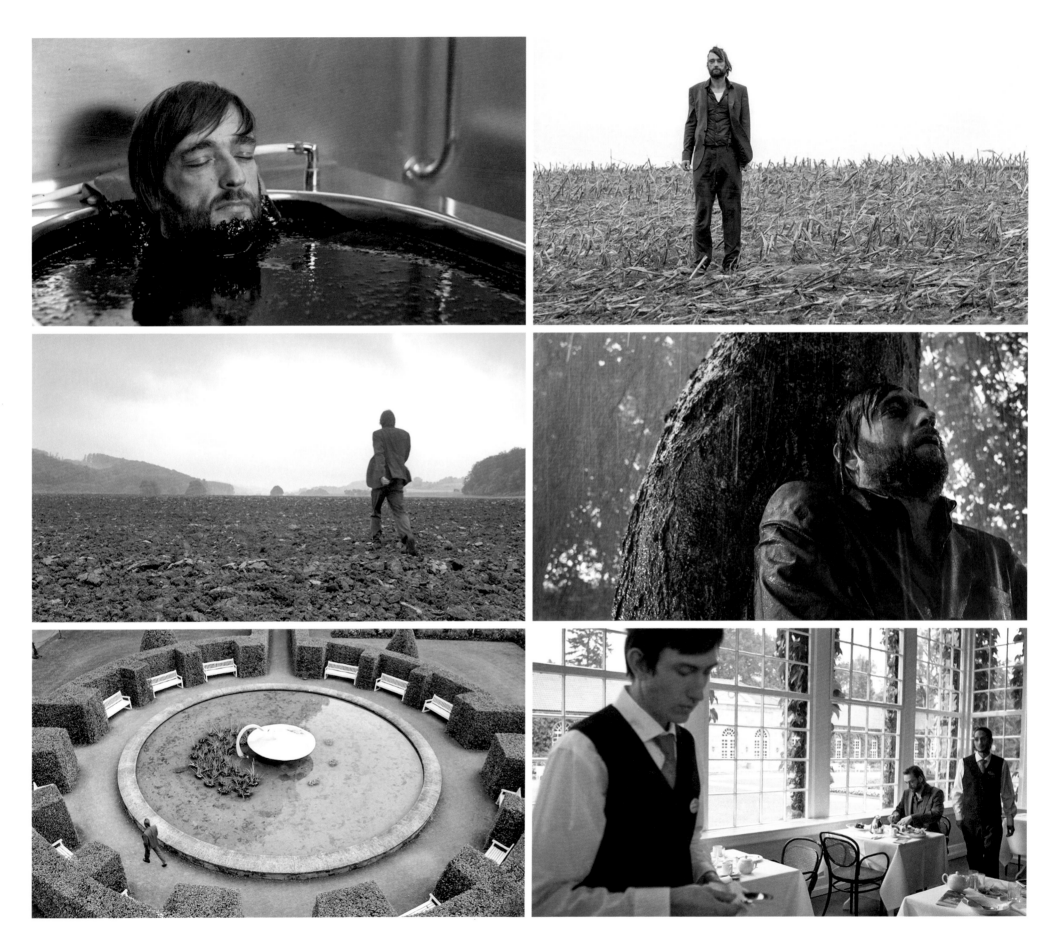

1 Erik Schmidt in conversation with the author in spring 2018 in his Berlin studio.

2 Ludwig Meidner, 'An introduction to painting big cities', English trans. in Victor H Meisel (ed.), *Voices of German Expressionism* (Englewood Cliffs, 1970), pp. 114–115; this quotation cited in Edward Timms, David Kelly (eds.), *Unreal City: Urban Experience in Modern European Literature and Art* (Manchester, 1985), p. 48.

↖ **Bogged Down**, 2010
Single-channel video
15:55 Min.

Berlin-based artist Erik Schmidt (b. 1968) is standing in his studio in Berlin's Wedding district and looking at the paintings he is currently working on.[1] The viewer's gaze is drawn upwards from a worm's-eye view. The jumble of intertwined power lines at the top of a pylon do not inspire confidence. The combinations of colours and the sensual brushstroke that Schmidt uses to translate impressions like these into his painting show that such trivial things can indeed be a source of artistic inspiration. The vaguely visible characters on the house facades below the confused clutter of cables suggest that the artist was strolling through streetscapes in Asia (*Kein Raum ohne Ordnung*, 2016) [No Space without Order]. Can we say that these paintings are landscapes?

'Let us paint what is close to us, our city world! The wild streets, the elegance of iron suspension bridges, gas tanks which hang in white-cloud mountains, the roaring colours of buses and express locomotives, the rushing telephone wires (aren't they like music?), the harlequinade of advertising pillars [...].'[2] With these anthemic words in *Anleitung zum Malen von Grossstadtbildern* (1914), the expressionist Ludwig Meidner distanced himself from the landscape painting in vogue at the time, inasmuch as he no longer considered this to be a suitable response to the changing reality of life. Instead, he extolled the aesthetic adventures of the urban space. Even back then, therefore, there was an aesthetic view of the city, according to which a certain scene – like a selected detail from a photograph – was deemed worthy of representation. Erik Schmidt's method for finding motifs in Tokyo and elsewhere resembles the actions of a stroller, who explores a place by walking around there without destination or urgency. 'It is all already there', he had said in autumn 2015 when looking back at the conditions that led to the creation of his works. 'I find my

↗ **Bogged Down**, 2010
Single-channel video
15:55 Min.

themes when I am walking and looking, in the city, in the forest; simply walking the way I did in Israel, simply looking out of the window the way I did in New York.'[3]

For Schmidt, painting without photography is unthinkable. As he says, artists in the past produced a drawing to record what they saw. For Erik Schmidt and other artists of his generation, photography has taken over this function. His works always refer to a visual experience. In *Thick Housing* (2014), for example, the rhythm of colour in the facade of a building is the inspiration for his painting. As our view follows the skyward-reaching sequence of storeys to the top, we look through the tangle of leaves in a tree standing in front of the building. The parallels with 'cable trees' in Tokyo are obvious. Schmidt calls *Kein Raum ohne Ordnung* his impression of Japan. While this description makes sense given the fact that the Japanese use every square metre of ground, it acquires an additional dimension when we look upwards where there is also no undefined space. In this work, as in other works that he has painted, light does not spread across broad expanses but is refracted through branches and leaves – or even through a tangle of cables. A heavily symbolic distance is cut into strips and other shapes. In response to the question of how the gaudy colourfulness of his paintings is to be understood (bearing in mind, however, that the film *Cut/Uncut* (2015) was also made in Tokyo and is less boisterously atmospheric, with a predominance of grey-coloured clothing and asphalt forming the main backdrop against which the action is set), Schmidt points to the invitations and flyers that he has brought with him from the Japanese capital: he is clearly influenced by manga and Pop Art, which illustrates how willing he is to distance himself from the photographs in order to incorporate impressions of his travels into his work.

Even in earlier series of works, such as *Stadt und Park* (2004–2006) [City and Park], and the paintings that he produced following his travels to Israel (*Working the Landscape*, 2008–2009), nature becomes the stage. While he was shooting *Hunting Grounds* (2006), Schmidt also painted mood landscapes in which shades of green and blue suggest the morning chill during the hunt. At the start of the film *Bogged Down* (2010), on the other hand, a man walks across a recently ploughed field. Partly forested, gently sloping hills rise to the left and right. Above, a cloud-filled sky threatens rain. We don't even need to think about the Romantic landscape painting of Caspar David Friedrich to recognise a symbolically charged scene of loneliness here.

In the closing sequence of *Cut/Uncut*, the artist leaves the city for the coast. He leaves behind all defined spheres of action – fences (*Blank*, 2014), throngs of densely packed people (*Downtown*, 2012), parkland, forests and fields. After participating in everyday Japanese life, a routine heavily shaped by rituals and rules, he plunges headlong into the sea. 'The final scene in *Cut/Uncut* shows an extreme long shot in which the crashing waves, the sandy beach and isolated walkers can be seen in the foreground. In the middle ground are some buildings and a looming chain of hills. In the background, a snow-capped Mount Fuji, partly obscured by dark clouds, is recognisable. A monumental landscape image, where the pulling effect of the one-point perspective could not be better described than in a three-line poem written by the most famous Japanese haiku poet, Matsuo Bashō (1644–1694): "Over one ridge / Do I see winter rain clouds? / Snow for Mt. Fuji."'[4] It is also entirely appropriate that Mount Fuji has been nominated by UNESCO not as a World Natural Heritage Site but as a World Cultural Heritage Site. Nature also becomes the cultural projection surface in Erik Schmidt's landscape aesthetic. **U.M.**

3 Erik Schmidt in conversation with the author in autumn 2015 in his Berlin studio.

4 Michael Ostheimer, 'Tokio-Tagebuch', in Philipp Bollmann (ed.), *Sichtspiele. Films and Video Art from the Wemhöner Collection* (Berlin, 2018), pp. XX.

↗ **Kein Raum ohne Ordnung**, 2016
Oil on canvas
190 × 140 cm

↖ **Hunting Grounds**, 2006
16-mm film, transferred onto DVD
14:00 Min.

↗ **Schnelles Verlangen**, 2010
Oil on canvas
210 × 150 cm

ISAAC JULIEN

Landscape in the Age of Global Capitalism

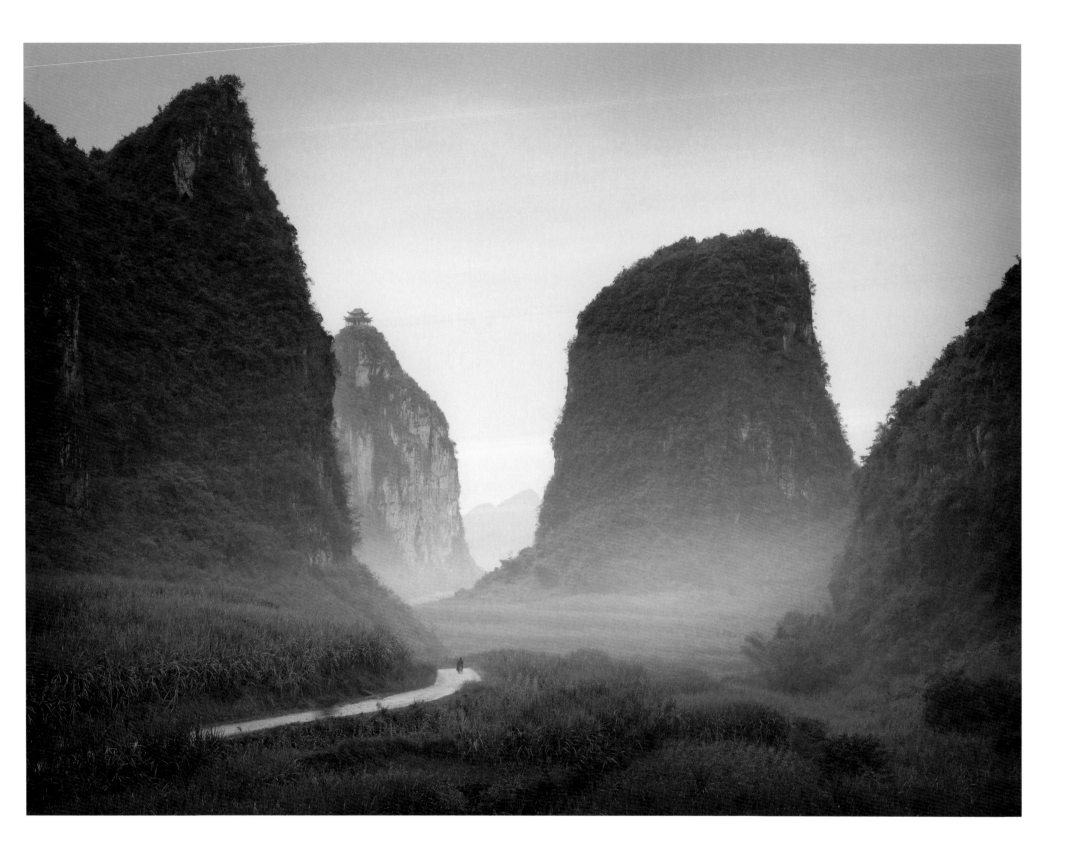

↗ **No Moon Shining (Ten Thousand Waves)**, 2010
Print on Kodak Endura Ultra
180 × 240 cm

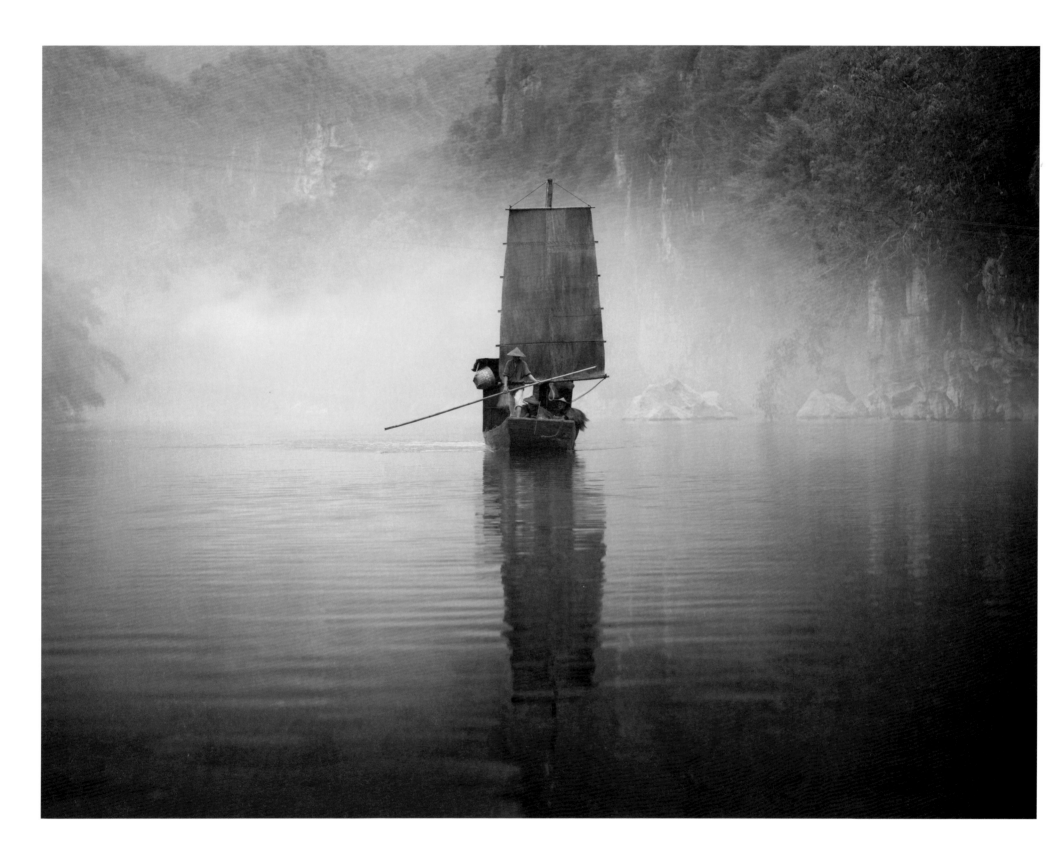

↗ **Yishan Island, Mist (Ten Thousand Waves)**, 2010
Print on Kodak Endura Ultra
180 × 240 cm

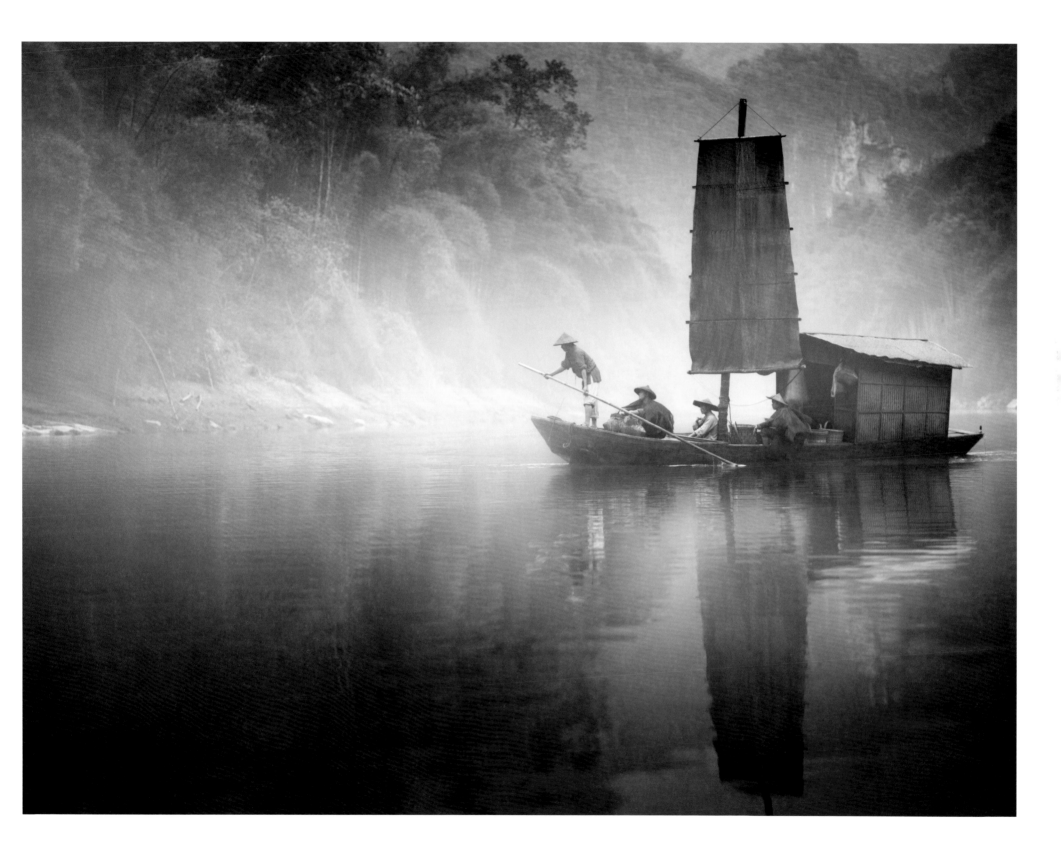

↗ **Yishan Island, Voyage (Ten Thousand Waves)**, 2010
Print on Kodak Endura Ultra
120 × 160 cm

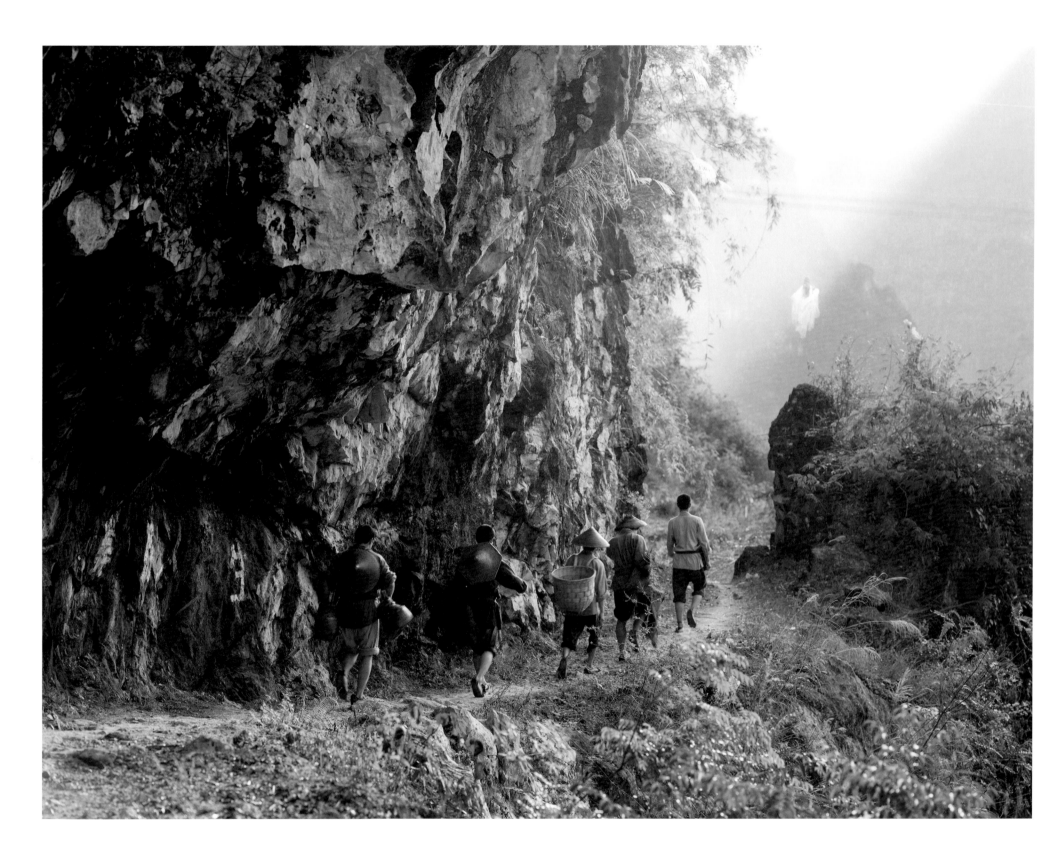

↖ Previous double page
Ten Thousand Wavese, 2010
Single-channel projection
70:12 Min.

↗ **Yishan Island, Long March (Ten Thousand Waves)**, 2010
Print on Kodak Endura Ultra
180 × 240 cm

The interaction between humankind and landscape permeates the work of British filmmaker and installation artist Isaac Julien (b. 1960). In *Ten Thousand Waves* (2010), a film that lasts almost fifty minutes, he bridges the divide between nature and culture. From the point of view of nature, his focus is on the ambivalence of water as both a life-giver and a lethal force. In terms of culture, language is the focal point: usually the basis for human communication, it can also hinder it in the case of mutual incomprehension. At the beginning of the film, archive footage is screened. From the perspective of a rescue helicopter, it depicts a storm-tossed sea and people battling high waves. This is authentic video material of the Morecambe Bay tragedy. The bay in the northwest of England, known for its fast-moving tides, hit the headlines for all the wrong reasons on the night of 5 February 2004 when a group of illegal Chinese immigrants was taken by surprise by an incoming tide. A total of twenty-three people drowned, one was rescued by the emergency services and fourteen others managed to make it alone back to shore. One of the main reasons for the delayed rescue operation was that the Chinese workers, due to their lack of English, could scarcely make themselves understood when they called the police from a mobile phone.

In contrast to these scenes, the film moves on to landscape images from Fujian, the Chinese province that was home to most of the drowned cockle-pickers. The four photographs *No Moon Shining, Yishan Island – Long March, Yishan Island – Mist and Yishan Island – Voyage*, which were created in 2010 during the filming of *Ten Thousand Waves*, show farm labourers making their way through lush green fields and meadows (these scenes were shot in the karst landscape of the Guangxi province) or fishermen at work in picturesque southern Chinese river landscapes. Legends like *The Story of Yishan Island* tell how Mazu, the local tutelary goddess of fishermen and sailors, guides fishermen, imperilled at sea, to safety.

Julien's visual world blends East and West and traditional culture with technical civilisation. But none of this could prevent the tragedy that befell the migrants in Morecambe Bay. Julien evokes dreams of a better life in a cinematic montage which combines documentary footage with fictional scenes and, in terms of the aesthetic ordering principle, converges with the multiperspectivity of Chinese landscape painting. Only the viewer's imagination can create a possible synthesis.

In the film *Playtime* (2014), the artist explores the limits of visuality at a time (2007) when the world was convulsed by a global banking and financial crisis. Can money capital be rendered visible? And if so, how can this be done? Should it be viewed from a divine-like, panoramic perspective? Or from a point

of view that is limited to individual destinies? Capital has a lot in common with time: neither can they be directly perceived, nor can they be represented visually. Like capital relations, time relations must be spatialised, translated into spatial relations in order to be palpably experienced. As a medium that determines a person's circumstances, capital acts in the background and spans the world; however, it only becomes something that can be seen and spoken about in the case of specific life stories.

Julien creates powerful images for the process of capital interlocking at a global level by interweaving a macroscopic with a microscopic perspective. This is managed, on the one hand, by illustrating the expansive power of capital flows in the guise of (urban) landscapes, for example, and, on the other hand, by tracing the individualisation of capital from the inside out in the shape of personal narratives. In the cinematic structure of *Playtime*, this means alternating between (urban) landscape images and images of the main actors. The film is set in a number of locations, among them Reykjavík and Dubai; the protagonists include an artist and a domestic worker.

In a large house not far from Reykjavík, a middle-aged artist (played by Ingvar Eggert Sigurdsson) descends a wooden staircase, apparently deep in thought. He begins talking about how, for the whole of his life, he has dreamt of having his own industrial-style home between the mountains and the sea – and how, shortly before he and his family moved in here, the financial crisis shattered this dream. In the same way that modern financial economics, whose rules permeate our contemporary world, appears as the 'spectre of capital' (Joseph Vogl), a female figure – possibly the erstwhile homeowner's (former) wife – unexpectedly appears, only to suddenly disappear again.

We are then given a bird's-eye view of a woman dressed as a maid, roaming through the dunes of a desert. In the last vignette of the film, a Filipino woman (played by Mercedes Cabral) relates how family hardship led to her hiring herself out as a maid in Dubai. Her face is reflected in the windowpane of her employers' high-rise apartment as she speaks of her loneliness and how she has lost herself abroad. Finally, she looks out from the balcony at the illuminated silhouette of night-time Dubai.

Isaac Julien stages both the desert as a superior power, far removed from civilisation, and Dubai at night as an example of urban uniformity. Taken together, they reflect one of the central points of globalisation: capital may be able to evade visual representation, but we, as humans, cannot escape it, no matter where we are. M.O.

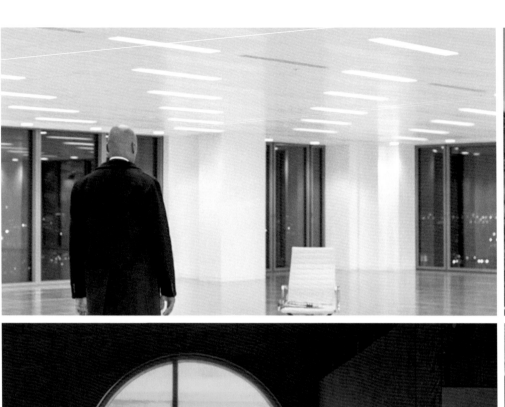
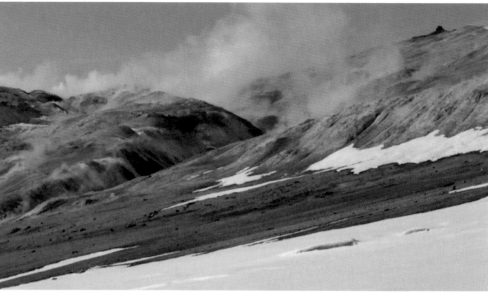
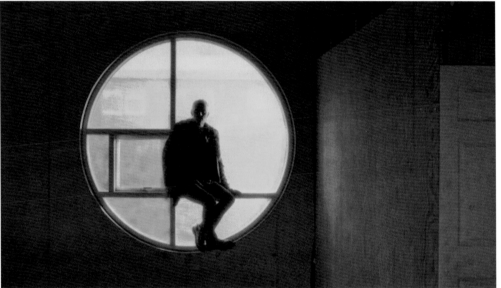

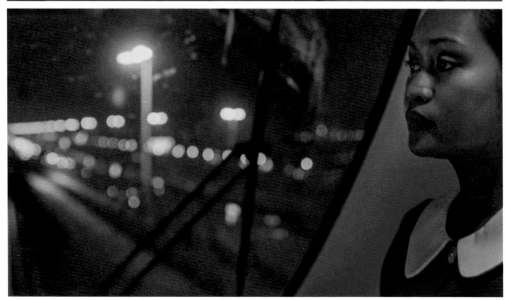
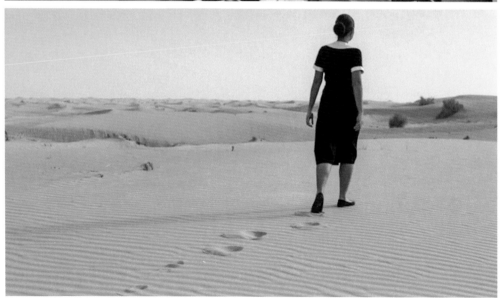

NADAV KANDER

The Tenacious Lethargy of the Yangtze

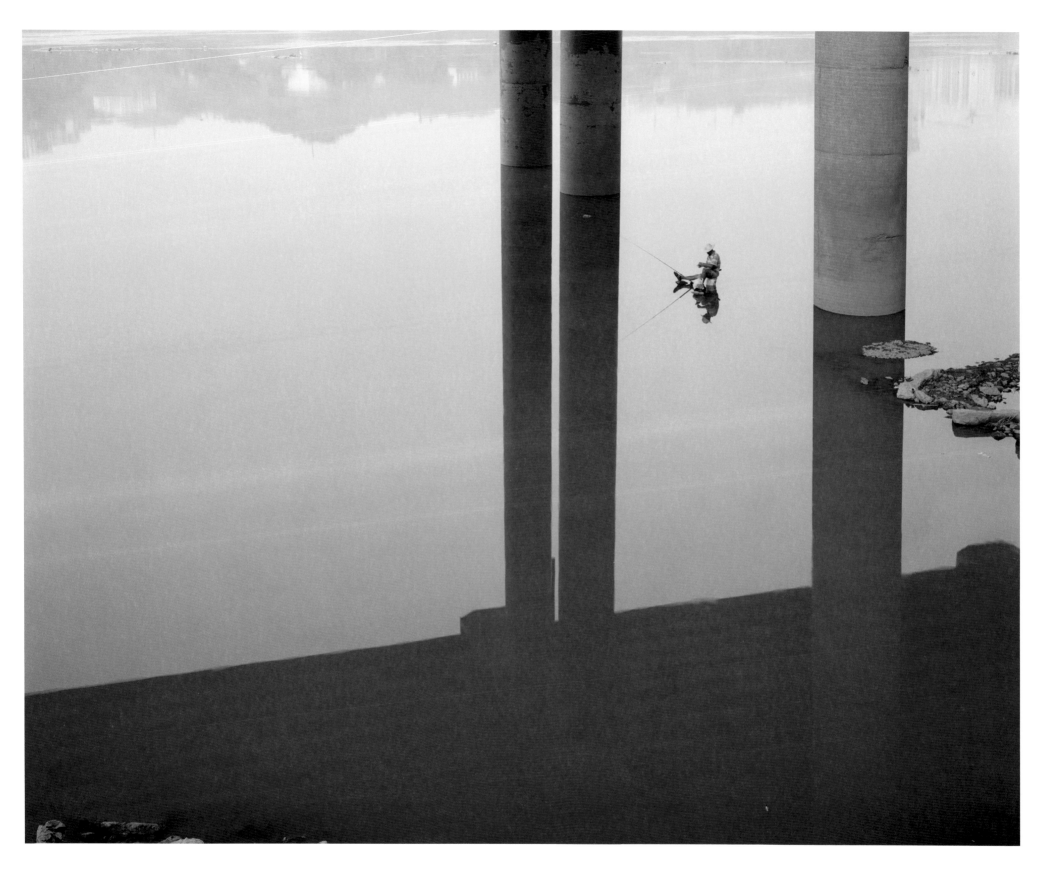

↗ Chongqing XVI, (Sunday Morning) Chongqing Municipality, 2006
C-Print
123 × 149 cm

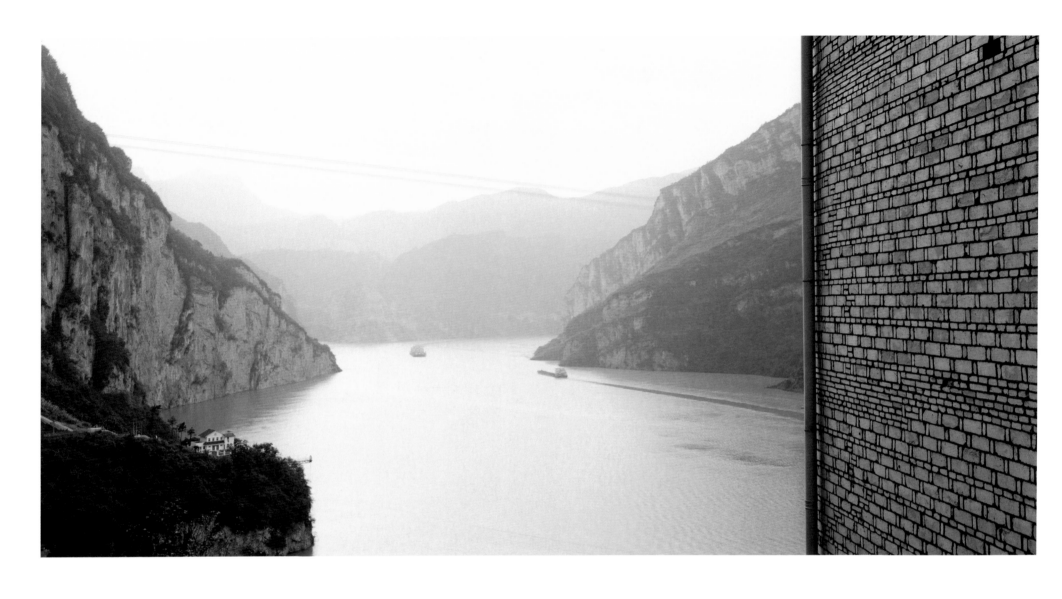

↗ **Xiling Gorge I, Hubei Province**, 2007
C-Print
123 × 172 cm

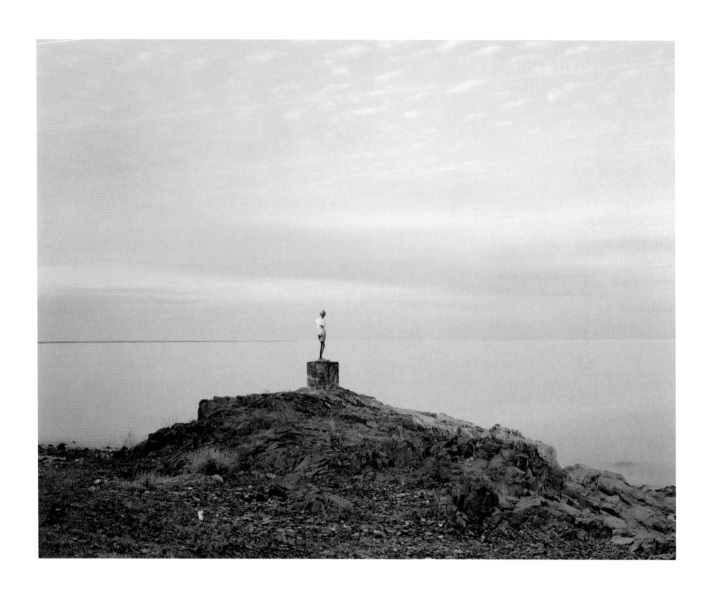

↗ **Priozersk XIV (I was told she once held an oar), Kazakhstan**, 2011
C-Print
123 × 149 cm

The military has played no small role in the career of artist Nadav Kander (b. 1961). Born in Tel Aviv, Kander grew up in South Africa. As he already had some knowledge of photography, the South African Air Force trained him as a military photographer. After these two years, Kander was sure that he wanted to be a photographer. From then on, he was driven by a search for knowledge. Even in his early days, he was inspired by Constructivism, a movement that originated in Russia, and especially by Constructivist photography. Nadav Kander was particularly influenced by American photographer Edward Weston and the Hungarian André Kertész, whose preference was for forms, shadows and lines in the everyday lifeworld.

In 2006 and 2007, Nadav Kander made multiple trips upriver on the Yangtze, from the mouth of the river at the East China Sea to its source in the Himalayas. The 'Long River' (as the word Yangtze translates in Chinese) divides the country into north and south and plays a key role historically and culturally in how the country sees itself. The *Yangtze – The Long River* series of photographs that resulted from Kander's journeys documents the large-scale, radical changes that have occurred as the river landscape has been remodelled. Major infrastructural projects aimed at modernising the country – such as the Three Gorges Dam, huge bridges and gigantic skyscrapers – are fundamentally transforming the character of the landscape. Moreover, the Yangtze is by far the most polluting river in the world, dumping the most plastic rubbish into the oceans each year. Yet Kander's series does not constitute a mere farewell to a bygone idyll. Instead, he uses his river odyssey to connect to a classical Chinese tradition. Coincidentally, the Chinese director Jia Zhangke adopted the same approach in his feature film *Still Life*, which won the Golden Lion award in Venice in 2006. For hundreds of years, artists have wandered or sailed along the Yangtze, extolling its virtues in painting and poetry as an example of the beauty of nature or reviving it as a symbol of the relentless flowing together of water and time.

Playing on this ambivalence of aesthetic attraction on the one hand and nostalgia for the past on the other, Kander uses the Yangtze as a leitmotif for the constant change taking place in China. The downside of the beauty of nature is the river's role as a vital engine for the infrastructural development of the country (transporting goods, generating electricity). All in all, the Yangtze acts as a topographical paradigm for the idea of reality flowing continuously. This idea, associated in the West with the pre-Socratic Heraclitus of Ephesus (c. 520 – c. 460 BCE) (according to Heraclitus, 'You cannot step twice into the same river.'[1]), is of key importance for China, which approaches reality less through the concepts of 'being', 'meaning' and 'truth' than through the strategies of 'process' and 'coherence'.[2] To create coherence in the processuality is also a crucial aesthetic feature of Kander's Yangtze series, about which the photographer says: 'China's progress is rapid and profound. These are photographs that can never be taken again.'[3]

Xiling Gorge 1, Hubei Province (2007) provides an insight into the region where the three gorges are located and which now forms part of the 600-kilometre-long reservoir between the dam wall in Yichang and Chongqing. The former torrent, which could have been seen here a few years ago, has become a lake-like body of water. One could think that time was standing still were it not for the traces left behind by humankind's activity in the landscape, such as the ripples left for a time on the surface of the water by the ships ploughing through the water or the section of wall at the right-hand edge of the picture which, *pars pro toto*, may represent the dam project. Unaffected by this, however, the landscape, according to Chinese tradition, draws its 'consistency from the correlation of mountains and waters: the mountain, it is said, deploys the course of the water, and the water animates the mass of the mountain.'[4] In this context, the colours themselves work together: the yellow of the brick wall that occasionally changes slightly to brown is reflected in the colour of the water; the two mountain ranges touching the horizon appear as mere shadowy outlines in muted shades of green and brown through the dense curtain of mist. If one makes the transition from the material concretion to the atmospheric or spiritual level of a landscape,[5] one could think that the muddy viscosity and the opaque numbness is symbolic of how the residents of this piece of land have been treated. If life is like a river, then it drags on lethargically here.

In *Chongqing XVI (Sunday Morning), Chongqing Municipality* (2006), a man sitting on a chair between two pillars of a bridge in the shallow waters of the Yangtze has found a suitable pastime to match this mood. The reflections of the city landscape on the surface of the water, the shadows cast by the bridge and pillars and the polluted water of the river may also testify as much to the huge threat faced by the environment. With his head tilted forward, apparently sleeping and waiting for what the future may bring, he is continuing to trust that whatever is left over by nature will make for an enjoyable morsel washed onto his fish hook. M.O.

1 Geoffrey S. Kirk, John E. Raven, Malcolm Schofield (eds.), *The Presocratic Philosophers. A Critical History with a Selection of Texts*, Cambridge, 1984.
2 See François Jullien, *Detour and Access: Strategies of Meaning in China and Greece*, Sophie Hawkes (trans.), New York, 2004.
3 Nadav Kander, 'Artist's Notes', in *Nadav Kander, Yangtze – The Long River*, Ostfildern, 2010, n.p.

4 François Jullien, Living off Landscape: or the Unthought-of in Reason, London, 2018, p. 32.

5 See also ibid.

↗ **The Polygon Nuclear Test Site XII (dust to dust), Kazakhstan**, 2011
C-Print
123 × 149 cm

YAN SHANCHUN

Dreaming a Lake

↗ **First Month of Winter #1–2**, 2018
Acrylic und mixed media on canvas diptych
Diptychon, 172 × 224 cm

↖ **West Lake in My Dream #1**, 2009
Acrylic and mixed media on canvas
212 × 152 cm

Yan Shanchun (b. 1957) belongs to the first generation of Chinese artists who graduated from art school after the Cultural Revolution. During his studies at the renowned Zhejiang Academy of Fine Arts (renamed the China Academy of Art in 1993) in his home town of Hangzhou, he chose to specialise in print-making, but never lost interest in traditional calligraphy and landscape painting. In terms of important influences from Western art, Yan Shanchun cites American abstract painting and in particular the colour field painting of Mark Rothko, which opened up new opportunities to him in the development of contemporary Chinese art. In his nebulously blurred, often large-scale paintings, the connection that he himself feels with China's classical scholars remains tangible.

In the tradition of Chinese landscape painting, the focus is not on depicting an actual scene from nature but rather on the inspiring effect of a harmoniously blended ensemble of mountains and waterways in an image or poem. Yan Shanchun's works are definitely still rooted in this balancing act between humankind and nature that has been cultivated for more than two thousand years. Except that in his paintings, rock formations and water – in the form of lakes, rivers, rapids, mist, clouds or snow – are no longer visible as such. Instead, they are visualised as a mood. In the *West Lake in my Dream* series (2009), for example, Yan Shanchun continues the assimilation of landscape, a constitutive process for Chinese landscape painting, by presenting the experience of nature as something that is dreamt rather than remembered or imagined.

Yan Shanchun still lives in Hangzhou and is permanently aware of the nearby West Lake. He perceives the seasonal changes and constellations of light with an unflagging attention to detail. The radical changes that have occurred in everyday life do not seem to deter the artist from this ritualised lifestyle. Suggestions of lines of hills and cloud formations hover in the milky white background. The surface of the water extends across the entire pictorial space; shadowy areas of darkness bring to mind pagodas and islands. Legend has it that the gently undulating shorelines of the waterways and the ideal type of mountainous landscape in the background, all of which have been captured again and again by poets and landscape artists, came into being when a pearl fell to earth and was fought over by a phoenix and a dragon. The actual origin and history is testament to perfection in landscape architecture: during the 8th century, the lake was separated from the Qiantang river, now located three kilometres away, by a sandbank, and the basin of the lake was deepened with the result that plants and animals could settle there.

The artist refers to one of the most famous sights in the West Lake area in his *Su Causeway* triptych (2008). The Su causeway was built during the Northern Song Dynasty by Su Dongpo (1037–1101), a scholar, calligrapher and poet who is revered to this day and who gave his name to the causeway. The bridge, which features eight arches, attracts throngs of visitors, particularly in spring when the flowers of the peach trees and the delicate green of the meadows bring to life the landscapes alluded to in classical Chinese poems. Yan Shan-

chun translates the admiration felt across the generations for the harmony between human art practice and nature into an atmospheric space. If it were not for the title, which assigns an associative point of reference to the abstract pictorial concept, *Su Causeway* could be taken for an informal work.

Yan Shanchun also moves between East and West in terms of his technical approach: in his painting, he superimposes layers of the ink traditionally used in landscape painting and the acrylic paint typically associated with Western painting. The thin black ink shimmers indistinctly through the wintry acrylic white. Dark patches suggest depth and heaviness; the bright veil covering these is reminiscent of mist that wafts over the landscape. In terms of aesthetic efficacy, the actual weighting of the colours is inverted: what appears to be dark and heavy is in reality a hint of dissolved charcoal, and the impression of hazy weightlessness belies the comparative solidness of the synthetic resin. If we translate the palimpsest-like overlapping to a temporal level – which is actually suggested by the history of the materials when we consider that ink has been used for thousands of years, while acrylic paint was only developed in the 1940s – then Yan Shanchun's conceptual vision is revealed. The West Lake becomes the sphere of meditation in which real temporality no longer applies. The past, the surviving, the experienced and the imagined are interwoven. Similarly, Mark Rothko's works also have their own temporality. When the viewers engage in a synergistic dialogue with the painting of both artists, they will enter spaces where they lose sight of time. U.M.

↗ **Su Causeway**, 2008
Acrylic and mixed media on canvas
179 × 357 cm

YANG KAILIANG

Inner Home

↗ **Berge hinter Berge 6**, 2014
Mixed media on canvas
200 × 280 cm

Yang Kailiang (b. 1974) attended the Shandong Art Institute in southern China before moving to Hamburg to complete a postgraduate programme. Between 2001 and 2005, he studied in Hamburg, where his professors included Norbert Schwontkowski. In most of the landscapes that he has painted since then, the line between Western and Eastern painting tradition seems to have become just as blurred as that between the subjects of his paintings and their environment. The artist now lives and works in Berlin.

Yang Kailiang's landscapes guide the viewer into the immediate reality of his life. The city park, the Outer Alster Lake and the bridges on the Elbe river, for example, are depicted on canvases up to six metres long and almost three metres high. The artist allows some time to elapse before returning to certain motifs, producing completely different pictorial compositions. Without the information in the titles, however, even long-time residents of the Hanseatic city would find it difficult to identify the specific places referenced in the works. An area painted with broad brushstrokes in light green and bright yellow sweeps through the middle of *Stadtpark 9* |City Park 9| (2007) almost abstractly, or to put it more accurately, informally. Above and below, the colour palette is reduced primarily to shades of white, grey and blue. Delicate lines form the outlines for structures that look like sunshades; a cluster of green dabs is reminiscent of a tree.

Trees and yet more trees: blurred until they are almost completely dissolved or floating in a light grey, growing from right and left into the pictorial space. In the triptych *Elbbrücken 4* |Bridges on the Elbe 4| (2008), on the other hand, Yang Kailiang has relinquished all greenery, and it looks as if he has let himself get carried away, primarily by the characteristic light of his adopted city. An iridescent expanse of greys and blues extends across a three-part landscape format, closely resembling a Chinese scroll. Cool brightness penetrates the scene in the outer section of the pictorial surface, resembling a mist-shrouded sky that has been torn open. With a perfunctory stroke, Yang Kailiang suggests a building on the opposite bank. The round arches are rendered realistically, an unusual feature of his oeuvre. The arches run through the entire composition and unmistakably signify the steel construction of the bridge mentioned in the title.

Looking at paintings like the one just mentioned, it could easily be forgotten that Yang Kailiang spent most of his life in China. But when we see *Mühlenkamp 1* (2010), we may be surprised that this work refers to a place in Germany. As with a classic Chinese pictorial composition, the viewer's gaze is initially directed through the branches of a tree. Located in the far depths of the painting, surrounded, as if in a dream, by overlapping shades of blue and grey, is a house. Although the artist worked in oil, the paint is so diluted that it resembles Chinese ink; even more specifically – he eschews the use of outlines throughout, a technique known as 'boneless painting' in traditional Chinese art. It is unclear whether the area in front of the house is a street or a body of water.

In Yang Kailiang's paintings, everything is in flux. Something that can be called reality at one moment is just a transitional stage to something else. His artistic influences are also permeable in terms of his influences from East and West. Whether he is in China or somewhere else in the world – this fact only gradually changes both the artist himself and also the way in which he captures his environment in a painting. His triptych *Westsee in Hangzhou* |West Lake in Hangzhou| (2009) makes this inner autonomy clear. Reflections of light sparkle on the surface of the water in his characteristic shades of blue and grey. Shadowy trees painted with just a few strokes loom across the hazy sky. Looking back on the last ten years, the continuities traced here suggest that Yang Kailiang has found 'an inner home'. His paintings, wherever they come from, are reflections of internalised landscapes.

U.M.

↗ **Mühlenkamp 1**, 2010
Mixed media on canvas
200 × 210 cm

DARREN ALMOND

Chronotopos

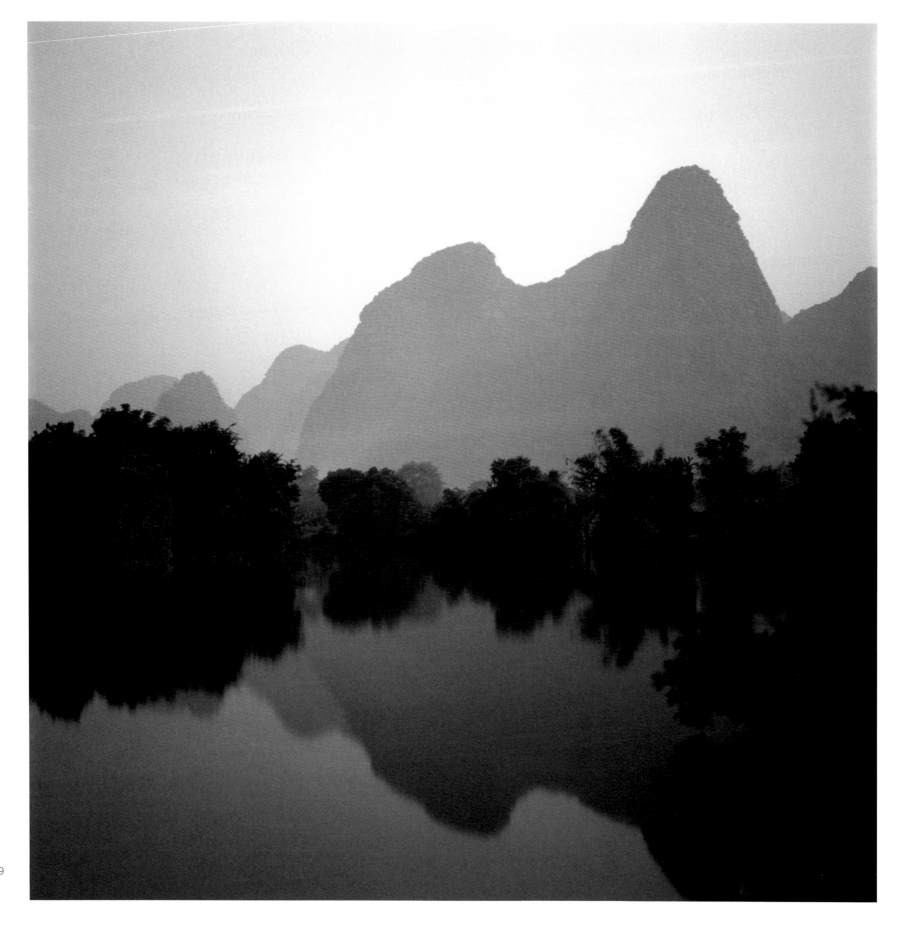

↗ **Fullmoon@Guilin**, 2009
C-Print
74 × 74 cm

↖ **System Drawing – Vertical Projection**, 2014
Acrylic on handmade silkscreen paper
190 × 100 cm

1 Darren Almond in conversation with the author in March 2009 in Berlin.

The sculptures, installations, films, photographs and works on paper created by British artist Darren Almond (b. 1971) often transport the viewer to remote locations. In his *Bus Stop* installation (1999), for example, discarded bus stops from the Polish town of Oświęcim (formerly Auschwitz) are transformed into eloquent testimonies of time. In the *Night + Fog* series of photographs (2007), he travelled to the Siberian town of Norilsk and to Monchegorsk in northwest Russia. The prisoners in these cities' Gulags were sent to the mines to extract nickel. The landscape is now scarred by dead tree stumps emerging from the polluted ground, although a pristine layer of snow conveys a peaceful atmosphere. A personal memory led Almond to China in 2008, a trip that inspired the series of photographs *Fullmoon@Huangshan – Infrared* (2009). For these and other works in the long-term project *Fullmoon* (ongoing since 1999) the artist has used the technique of long exposure to convey the passing of time. The abstract-looking panels in *System Drawings* (2014) give no direct indication that he was originally inspired by the colourful, starlit skies of Patagonia. Instead, the drawings are more reminiscent of constellation maps and thus expand the concept of space and time to include light years. We see what no longer exists in this constellation.

'For me, this journey to China was a type of return,' explains the artist. 'When I was fourteen or fifteen, I suddenly found myself standing in the New York Metropolitan Museum of Art in front of one of those long scrolls with an ink drawing of the legendary Huangshan mountain range. I could not believe that such a landscape really existed!' When Almond reached the Yellow Mountain (Huangshan), a location contemplated by Chinese landscape artists and depicted in ink drawings for centuries, the first thing he had to do was to wait: 'When taking the photographs, I didn't just have to wait for the snow, I also had to wait for the few moments when the mist unveiled the mountain formations and the delicate branches of the trees.'[1]

On his travels through southern Patagonia, Almond also photographed a variety of landscapes under a full moon (*Fullmoon@Argentinian Patagonia*, 2013). The unpolluted air in this region causes the stars to seem clearer and larger, and to appear in an extraordinary spectrum of colour. The search for the scientific basis for this natural drama led Almond to the *magnum opus* of the Austrian mathematician and physicist Christian Doppler (1803–1853). In a paper published in 1842, *On the Coloured Light of Double Stars and Certain Other Stars of the Heavens*, Doppler had attempted to convince astronomers of that time that the different colours of the stars were due to the change in distance. His hypothesis was considered untenable even then. To this day, differences in temperature between the stars are assumed to be the actual cause of the phenomenon.

The celestial maps in the *Star Charts* series depict the artist's fascination with the sky, but in the medium of drawing rather than photography. Almond explains the back story to the paintings: 'The original star charts began in tandem with a sculpture called *Meantime*. From 2000 onwards, an oversized clock travelled the globe via train, truck and boat, over land and sea, while the sculpture's mechanism was beating disdainfully to the rhythm of mechanised time within a digital age.' As an analogy for the mechanically operated clock, Almond selected an artistic method that was based on uniform movement:

with clockwork-like equanimity, he placed hundreds of coloured dots in the interstices of a lattice pattern, which covers the black, handmade paper. Here, technical precision and an individual creative spirit become as one. After all, this is an artist who, godlike, shapes the firmament as he wishes. The impression of the huge distance from the earth is further enhanced by the broad black mount in the square paintings. In *System Drawing – Vertical Projection* (2014), Almond reduces the distance between the drawing and the frame to a minimum and opts for a portrait format in order to reflect his visual experience in Patagonia: 'The vertical format happened because, after returning from Patagonia, I essentially spliced two separate hemispheres together.' The stars hinted at in this version seem to be much closer than those in the *Star Charts*.

When the Russian literary scholar, philosopher and art theorist Mikhail Bakhtin (1895–1975) introduced the term 'chronotope', based on the Greek *chrónos* (time) and *tópos* (place), into narrative theory, he characterised the relationship between location and the passing of time of an action. Like the real historic world, space and time also form an indivisible unit in aesthetic narrative contexts. In other words, temporal relationships must be translated into spatial relationships in order to be experienced. The space therefore becomes the aesthetic representation of time.[2] Darren Almond's works depict the chronotope as a 'form/content category' in a wide variety of media. The narratives that it prompts can, for example, be traced back to Europe's catastrophic history or the mythologically charged landscapes of China. Alternatively, they can allow us to imaginatively take part in the almost infinite time-space of the starlit sky.[3] **U.M.**

2 Mikhail M. Bakhtin, 'Forms of Time and of the Chronotope in the Novel: Notes toward a Historical Poetics', in Mikhail M. Bakhtin, *The Dialogic Imagination: Four Essays*, ed. Michael Holquist, trans. Caryl Emerson and Michael Holquist, Austin, 1990.
3 I am grateful to my colleague Michael Ostheimer for the information on the subject of the chronotope. In this regard, see: Ines Detmers, Michael Ostheimer, *Das temporale Imaginäre. Zum Chronotopos als Paradigma literaturästhetischer Eigenzeiten*, Hanover, 2016.

↗ **Fullmoon@The Sea
of Clouds**, 2008
C-Print
180 × 180 cm

TEMPORAL LANDSCAPES

ZHANG DALI

Landscapes with a Brownian Influence

↗ **Dialogue 199595**, 1995
C-Print on aluminium
100 × 150 cm

When Zhang Dali (b. 1963) returned home from Italy to his native city of Beijing in 1993, the Chinese capital was already in the throes of an accelerated modernisation process to which the alleyways, courtyard houses and other characterising features of old Beijing were falling victim. In revolt against this loss of authenticity and to lend a voice to those who were being violently torn from their trusted neighbourhood network, the artist began his graffiti campaign in 1995. Over the following years, he sprayed his alter ego – a bald head in side profile – more than 2,000 times onto what was left of the walls of buildings after the demolition crews had left. The photographs show landscapes of ruins which, just days or even hours later, no longer existed.

Zhang Dali initially studied painting at the Central Academy of Fine Arts in Beijing. In 1989, he went to Italy, where the street art scene left a lasting impression on him. In China, he is considered to be a pioneer of graffiti. Other than propaganda, artistic interventions in the public space were hard to imagine before his appearance on the art scene. He used the abbreviation 'AK-47' as a pseudonym, thus referencing a notorious Soviet weapon and alluding to the brutality with which the Chinese government acts against its own people. Another pseudonym ('18K' – short for the gold alloy 18 carat) refers to the new prosperity in China, which, however, only benefits a small number of people.

Zhang Dali gives his photographs of these scenes of destruction the title *Dialogue*. The online response that he receives to this invitation to communicate is testament to the great interest evoked by his work. In the frames that he selects, the homes that have been reduced to rubble are so close to high-profile buildings constructed in the traditional style and post-Mao era skyscrapers that they seem to communicate and interact with them. The spray-painted collective of heads in *Dialogue 199942* (1999) plays a special role in this series because it symbolises the clash between the established and the free-art scenes. Zhang Dali's own spray-painted alter ego takes on the role of the 'pointer', a familiar motif in European history painting, here imported into a modern Asian context.

It was 1998 before the police caught up with Zhang Dali and enquired as to the motivation for his activities. No further action was taken against him. That the spray-painted symbols were not really considered a threat to the public order is illustrated by the more time-consuming counterpart to *Dialogue* to which the artist gives the (less conciliatory) name of *Demolition*. In these works, he turns the graffiti-bearing buildings inside out, directing our gaze to what lies behind them. Using this method in *Demolition, Forbidden City, Beijing* (1998), for example, the rooftops of the Forbidden City appear as the inner life of a courtyard wall that now only exists as a relic. While the residential areas of old Beijing are being forced to give way to progress, the former Emperor's Palace shines forth in eternal splendour.

City landscape? Landscape of ruins? Political landscape? Destroyed landscape? Mood landscape? If we look back in Western cultural studies and art history at the terms that were and are constantly used to try to appropriately redefine the phenomenon of landscape again and again in accordance with changing real-world circumstances and artistic visualisations,[1] we get our answer to the question of whether Zhang Dali's works in the *Dialogue and Demolition* series of photographs (1995–1999) are really about landscapes. 'Landscape is not simply a detail of nature that is looked at but it is rather

[1] See Hilmar Frank, Eckhard Lobsien, 'Landschaft', in *Ästhetische Grundbegriffe*, Vol. 3, Stuttgart/Weimar, 2001, pp. 617–669.

↑ **Demolition, Forbidden City, Beijing**, 1998
C-Print on aluminium
74 × 104 cm

→ **Dialogue 199942**, 1999
C-Print on aluminium
72 × 100 cm

→ **Dialogue 199795**, 1997
C-Print
100 × 150 cm

2 Ibid., pp. 619–620.

3 Ibid., p. 620.
4 Matthias Müller, 'Thousands made homeless in Beijing overnight' ('Tausende sind in Peking von heute auf morgen ohne Dach über dem Kopf') in *Neue Zürcher Zeitung, International*, 04.12.2017, p. 6.

the living space that is looked at and is usually composed – since the term was coined – of natural phenomena and human activity; untouched nature on the one hand and the industrial or war space, which is completely devoid of nature, on the other hand are just the two extreme poles of the mixture that landscape consists of,[2] according to the art theorists Hilmar Frank and Eckhard Lobsien. They believe that it is not the act of viewing in itself that manifests the viewed object as a landscape but the meaningfulness of the selected detail. Landscape shows more than what is immediately visible; it is a 'superordinate whole in itself'.[3]

What do we see when we look at Zhang Dali's stone witnesses of the past? In some photographs, trees protrude from mountains of rubble; clumps of grass suggest that green spaces or small gardens were once located between the courtyard houses; there are few signs of people moving around through the remnants of what was 'home' only a short time beforehand. We thus see only fragments of the settlements of traditional courtyard houses which, before they were destroyed, were architecturally structured, everyday communities. People knew one another, helped one another, fought, shared outhouses and washing facilities. Impoverished circumstances, certainly, but also the antithesis of high-rise anonymity, which for many is unaffordable. Zhang Dali does not show us a 'living space that is looked at' but rather the memory of a living space that no longer exists. These photographs are political because they denounce an injustice that continues to be practised and goes unpunished. 'Thousands made homeless in Beijing overnight', ran a headline in the *Neue Zürcher Zeitung* on 4 December 2017. The subheading elaborated: 'In the Chinese capital, hundreds of residents are currently being

evicted – migrant workers are particularly affected.'[4] In this case, therefore, it is not the old Beijing residents who are being driven out of the city centre and a district with a relaxed pace of life which is being lost to a facelessness that turns its back on history. Instead, the victims are those who are building 'the new China' through their manual labour. Zhang Dali also dedicates a memorial to these people. In the installation *Chinese Offspring* (2003–2005), he made casts of the bodies of dozens of migrant workers and hung them upside down from the ceiling of the exhibition space. The construction of *Brownian Motion* (2011–2017) is reminiscent of the scaffolds commonly seen in China. Less subtly, the steel posts bore through casts of people – a reference to the many dead and injured in each building constructed in China. The English biologist Robert Brown (1773–1858), after whom the installation was named, had examined pollen under a microscope in 1827 and in this way discovered the irregular movement of dust particles. The dynamic movement is caused by atoms and molecules, which cannot be seen under the microscope and which push and thrust the grains of pollen back and forth. The analogy is obvious but the impact and shear forces are clearly identifiable in the case of the migrant workers.

Zhang Dali's photographs and installations lament the destruction of historical city landscapes, they show landscapes of ruins which – as they are being imprinted with his signature – become mood landscapes, i.e. landscapes of sadness and rage. Of course, new city landscapes also emerge through all the changes lamented here, although they offer their occupants very little potential to identify with them. U.M.

ANDREAS MÜHE

Every Mountain, Every Valley and Even the Sea

↗ **Prora Wiek**, 2004
Fine Art Print auf Museo Silver Rag
110 × 140 cm

← **Am Berghof**, 2011
C-Print
110 × 140 cm

Born in Karl-Marx-Stadt (now renamed Chemnitz), Berlin-based photographer Andreas Mühe (b. 1979) traces the footsteps of German history – not just in his *Olympisches Dorf* [Olympic Village] (2009) series, but also in other works such as the *Obersalzberg* series (2010–2013), which he set in Hitler's former holiday residence and second seat of government. By contrast, the natural scenarios photographed on the island of Rügen and on the Baltic coast refer back to an era that, from an art-historical perspective, is firmly anchored in the collective visual memory. The German Romantics – Caspar David Friedrich in particular – cherished this rugged landscape. Mühe shares this bond.

Anyone who is familiar with the small forest between the unassuming Baltic Sea holiday resorts of Nienhagen and Börgerende may perhaps wonder at its name. In 2015, Mühe chose the part of Nienhagen Forest known locally as *Gespensterwald* (Ghost Forest) as a motif for his work. He focuses his analogue large-format camera on the sparse scattering of meagre trees, some of which are already dead, standing at the edge of the steep coastline. Photographed at night and with an almost ideally typical full moon as the light source, the setting would be picture-postcard perfect were it not for one disturbing factor – the tiny male figure illuminated by the moonlight. In the *Obersalzberg* series, the artist worked with extras in SS uniforms posing stiffly amidst the landscape. In the photographs taken at the Baltic Sea, he takes on this role himself – naked as he strikes a narcissistic pose. The myth of the German forest as a place clouded in mystery; the hiker proceeding gradually

through it, not to reach a destination but in order to find himself or herself; the protagonist's gaze directed towards the sea and horizon in a search for meaning – in Mühe's work, this experimental arrangement becomes a pastiche.

Mönchsgut (2014) also plays with this convulsion of Romanticism. Mühe photographed the peninsula on Rügen alluded to in the title, famous for its view and its rugged, collapsing chalk cliffs, at the 'blue hour' relentlessly eulogised by the Romantics in their poetry – that brief window of time before sunset when the sky seems to glow from within. Only a small corner of the shoreline extends from the right into the photograph; the vastness of the pictorial space is filled by the play of the waves and the clouds. In this photograph as well, the artist, tiny and naked, can be found at the dividing line between land and sea. An art-historical genre, reduced to kitsch by repeated iterations, is rejuvenated by Mühe's solipsistic refraction. Appropriately enough, he calls this series *Neue Romantik* [New Romantic].

According to Mühe, his 'home land' is a 'stretch of land ... somewhere between the Uckermark and the Ore Mountains'.[1] After hesitating briefly, he elaborates further: 'Actually, it is really just the Uckermark, where my grandfather lived, and the Ore Mountains, where I spent the first years of my life.' He associates 'vastness and the rustling of leaves' with these regions. The Baltic Sea is also firmly engrained in his childhood memories; even today it is one of his 'favourite places'.[2] In Mühe's staged landscape photographs, these

1 See also the film portrait, which was shown in 2016 as part of the exhibition *Der dritte Blick. Fotografische Positionen einer Umbruchsituation* in the Stadtgalerie Kiel, online: http://der-dritte-blick.de/portfolio/andreas-muehe/ (accessed on 12.07.2019).
2 Ibid.

↗ **Mooslahnerkopf**, 2010
C-Print
110 × 140 cm

↑ **SA-Mann am Mooslahnerkopf**, 2011
C-Print
140 × 110 cm

↗ **Soldat am Obersee**, 2012
C-Print
140 × 110 cm

positive experiences only resonate indirectly with these places. In his works, landscapes are always also an echo chamber for German history, which he has lived through himself or learned about from his parents and grandparents. It seems that all of Mühe's landscapes have a story to tell. Perhaps there is also such a landscape specifically for those who do not want to hear the stories that they hold.

Mühe's intentional connection between Berchtesgadener Land, neighbouring Obersalzberg and the *Wandlitz* series of works (2011) is not immediately clear to the viewer. During the days of the GDR, high-ranking SED politicians, among them Erich Honecker and Erich Mielke, lived in the houses in the Brandenburg *Waldsiedlung* of the same name. Mühe contends that both Wandlitz and Obersalzberg were 'places shielded from the public eye'.[3] His photographs remove this dramatic status from them, which was assigned to them retrospectively and has survived to this day. The aesthetic of the sublime, which the Nazis considered analogous with the presumption that their position of power could not be questioned, thus flows through the landscapes in the *Obersalzberg* series. At the same time, Mühe overrides this energy field with a commentary that denies respect. For example, by showing miniature male figures in SS uniforms, who can only be identified on closer inspection of the dense forest, urinating against trees, he shows Hitler's henchmen as human beings with equally human needs. Their deeds do not appear less inhuman as a result. All that it does is suppress the comforting divide – based on

their demonisation – between them and us, the following generations. Political responsibility becomes the mandate of the present day. The facades of the houses in the Wandlitz settlement also develop a similar game of deception involving power and banality. Mühe emphasises their architectural uniformity by photographing them from an identical perspective and at night. Parochial and dull, there is no indication that those who sleep there make life-and-death decisions about people when they wake.

Pathos als Distanz [Pathos as Distance] was the title of the survey exhibition of Mühe's works at the House of Photography in Hamburg's Deichtorhallen (2017). Alluding to Friedrich Nietzsche's feeling of aristocratic superiority, for which he coined the expression 'pathos of distance',[4] Mühe's series of photographs get to the heart of the indifference in dealing with German history. For example, how can we be inspired by a landscape that is overshadowed by the memory of murderous abuse of power without having to accuse ourselves of a lack of historical conscience? Iconic mountain ranges, forests and views of the sea, together with exponents of political power and the buildings that accommodated them – the photographer includes them all. At the same time, his sober approach ensures that he distances himself from an ideological loading of the subject. In this way, landscapes are demystified and individuals are stripped of their heroic trappings; Andreas Mühe opens a door towards a post-mythical and post-heroic age. U.M.

3 Ibid.
4 I would like to thank my colleague Michael Ostheimer for the reference to Nietzsche's coining of the phrase 'pathos of distance'. See Sven Brömsel, 'Pathos der Distanz', in Henning Ottmann (ed.), *Nietzsche-Handbuch. Leben, Werk, Wirkung*, Stuttgart/ Weimar, 2000, p. 299.

↖ **Mönchsgut**, 2014
C-Print
220 × 175 cm

↗ **Gespensterwald**, 2015
C-Print
220 × 175 cm

HONG LEI

Aura of Former Glory

About memory I, 2006
C-Print
46 × 100 cm

About memory II, 2006
C-Print
46 × 100 cm

About memory III, 2006
C-Print
46 × 100 cm

Both the palace and private gardens of imperial China continue to fascinate today thanks to their harmonious marriage of architecture, art and greenery. They tell stories of a spiritual, intellectual and aesthetic golden age. In his painterly and in some cases digitally reworked photographs, Hong Lei (b. 1960) visualises the presence of the past and the sadness of irretrievable loss.

In probably his most famous series of photographs, *Autumn in the Forbidden City* (1997), Hong Lei stages a farewell to the former grandeur of the Chinese culture with a sense of drama worthy of the Mannerists. A dead bird lies on the ground of the courtyard in the Forbidden City. A chain of pearls is looped around its body. Hong Lei focuses on this symbol of mourning in the foreground of the photograph. The imposing complex of the former ruler's palace, built as a demonstration of power, is seen as a sprawling blur in the background. Numerous scratches on the surface of the photograph emphasise the emotional component of the work.

Hong Lei studied painting at the Art Academy in Nanjing until 1987; he then moved to the printmaking department at the Central Academy of Fine Arts in Beijing. The artist says that traditional Chinese literature and art are a source of inspiration for his photographs.[1] His own drawings form the basis for his pictorial compositions. Ever since his youth, he has been researching his family history and in particular regrets the destruction of many books and other belongings imbued with memories which occurred during the Cultural Revolution. His dreams lead him back to this formative time in his life. Whatever remains in his mind's eye when he wakens is transferred to his art, for example in the staged photograph *I Dreamt that I Was Hung Upside Down to Listen to Huizong Play the Zither with Chairman Mao* (2004).

Landscapes, plants, trees and animals are among the recurring themes in Hong Lei's works, which he unequivocally uses to pay homage to the various genres in traditional Chinese academic painting. He chooses a round format for the *After a Song Painting* series, which he started in 1998 and in which he reinterprets famous paintings. Branches, flowers and dead birds are placed in front of a monochrome background.[2] In this series, the artist generally omits any other pictorial elements, thus emphasising how little is needed to produce an entire compendium of classical masterpieces in the mind's eye of the Chinese viewer.

1 I would like to take this opportunity to thank Sabine Wang, who translated the author's questions into Chinese and put them to the artist in a personal conversation with him in his Beijing studio in October 2012.

2 Examples of works in this series include *After Zhao Ji's Song Dynasty Painting of Loquats and Wild Birds* and *Painting of Autumn Chrysanthemums and Quails (after The Song Painting by Li Anzhong)*, both from 1998. In the photograph on the left-hand side of the diptych *Peony Pavilion & Lotus from the Water* (2000), he extended his visual repertoire to include an open, burning pavilion. Such pavilions are frequently also found in traditional *shan shui* painting. The depiction is often accompanied by a meditating monk or a classical scholar.

Earlier in his career, the painted and altered photographs in the series *Chinese Landscape – Zhuozheng Garden in Suzhou* (1998) had already taken Hong Lei back to the Classical Gardens of Suzhou, which were listed as cultural heritage sites between 1997 and 2000 and whose oldest parts can be traced back to the foundation of the city in the 6th century BCE. 'The gardens have been a subject of my photographic work for many years now,' says Hong Lei, recalling the atmosphere that prevailed during a return visit there: 'It was already approaching dusk when I took the pictures in the well-known Zhuozheng Garden (Garden of the Humble Politician) with a wide-angle Hasselblad for the About Memory series.'[3]

In the reasons for their inclusion in the list of the UNESCO world heritage sites, the Gardens of Suzhou (11th to 19th century CE) are described as miniatures of real Chinese landscapes and, on the other hand, as gardens modelled on traditional *shan shui* painting, which emphasises the ideal character of the grounds. The gardens reflect the desire of the old Chinese scholars both to live in harmony with nature and to cultivate it.[4] Hong Lei can assume that a Chinese viewer has this knowledge. In the *About Memory* series (2006), therefore, only the roofs of the pagodas of individual buildings in the park can be seen.

His photographs open up a window on time, allowing us to look back from the present to classical China: 'Back then, people paid a great deal of attention to the natural landscape. At the same time, they wanted to bring the natural landscape into their own gardens at home,'[5] he explains.

By adding light-spot formations, which form a diamond-shaped outline and a kind of gateway to the heavenly sphere, to his reworked black-and-white photographs, Hong Lei makes the metaphysical dimension of *shan shui* painting visible. Drawing on the writings of scholar Han Zhuo, who was active between 1095 and 1125, the sinologist Mathias Obert describes the meaningful function of Chinese landscape painting as follows: 'The "power of heaven and earth" [...] describes the transformation of the entire reality of the world. Once reflected in painting, this can be "uninhibited and continuous" [...], as painting is thus a "continuous connection" [...].'[6] Hong Lei directs the viewer's gaze towards the sky. Even if we only see the roofs of the summer houses instead of the traditional arrangements of mountains and water, anyone who is familiar with this genre is still free to enter into this realm in his or her imagination and to return from this journey of the spirit as another person. U.M.

3 Hong Lei, 2012 (see note 1).
4 See UNESCO, 'World Heritage List – Classical Gardens of Suzhou', https://whc.unesco.org/en/list/813 (accessed 26 July 2019).
5 Hong Lei, 2012 (see note 1).
6 Mathias Obert, *Welt als Bild. Die theoretische Grundlegung der chinesischen Berg-Wasser-Malerei zwischen dem 5. und dem 12. Jahrhundert*, Munich, 2007, p. 395.

MASBEDO

Togetherness in Front of an Icelandic Landscape

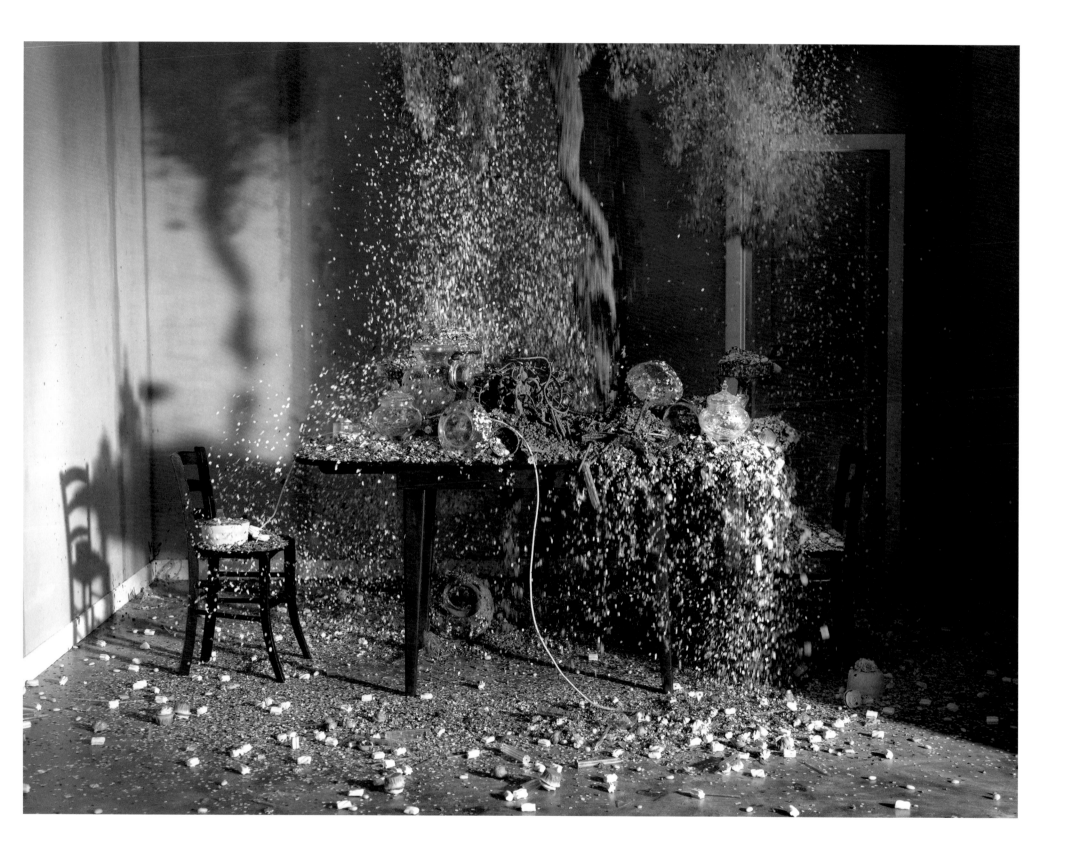

↗ Ionesco Suite #2, 2013
Inkjet print on Hahnemühle paper
110 × 140

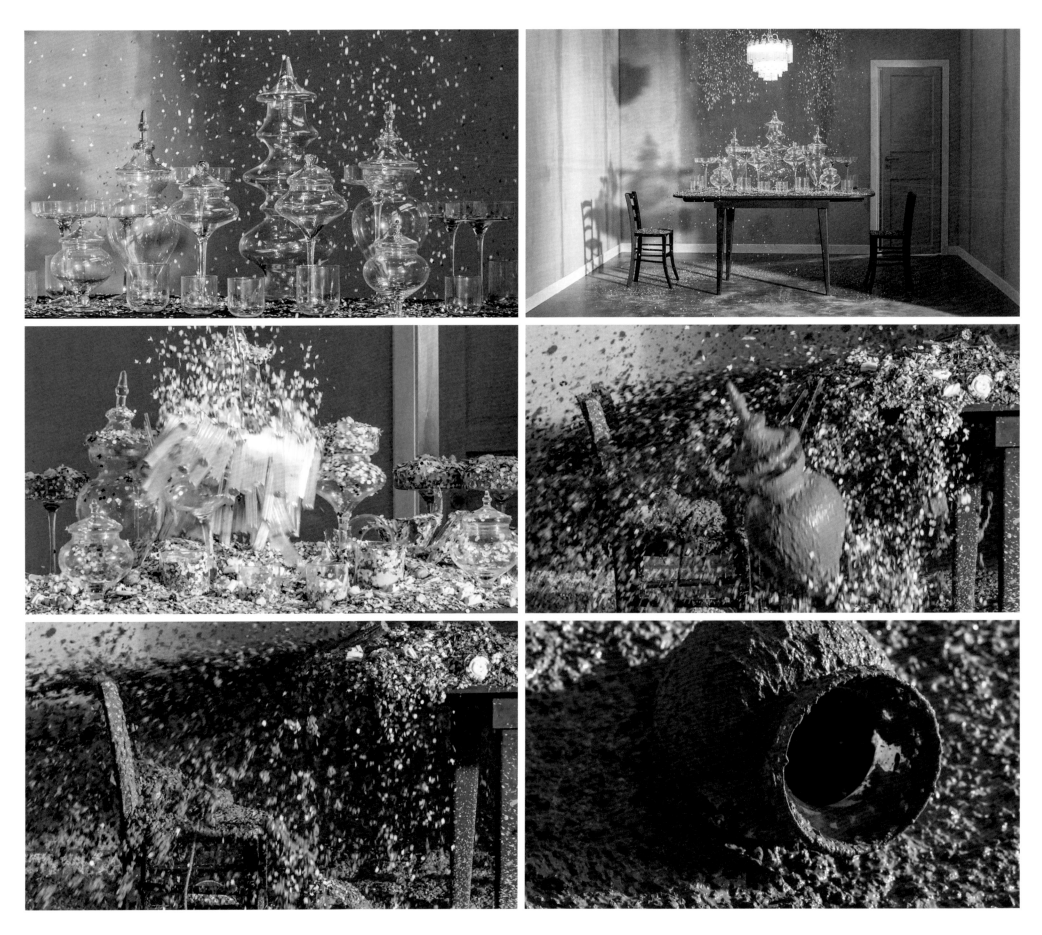

Ionesco Suite, 2013
2-channel video, transferred onto HD
16:55 min.

The Italian artist duo Masbedo, whose name is composed of the first letters of the surnames of Nicolò Massazza (b. 1973) and Iacopo Bedogni (b. 1970), contrasts art and nature as two polar protagonists in the video works *Teorema di incompletezza* (2008) and *Ionesco Suite* (2013): art in the form of a calculated arrangement of objects that suggests the solidifying existence of human togetherness, and nature in its extreme of the raw Icelandic landscape that has an eminent aesthetic power.

Teorema di incompletezza, [Incompleteness Theorem]. The title could scarcely be any more abstract. Is it one that points to a scientific context? If we investigate this further, we encounter mathematical logic – and indeed the incompleteness theorem formulated by the Austrian mathematician Kurt Gödel. Gödel explored the derivability of statements in formal systems and demonstrated the limitations in every formal axiomatic system. He proved that there must be statements not able to be either proved or refuted in axiomatic, consistent systems such as arithmetic. Gödel's incompleteness theorem highlights a fundamental limitation in mathematics: not every mathematical proposition can be formally derived or refuted from the axioms of a mathematical field, such as arithmetic, geometry or algebra. In other words, sophisticated formal systems can never be complete.

What does this high-profile theorem of modern logic have to do with Masbedo's *Teorema di incompletezza*? Whoever asks that question must somehow be on the lookout for a transposition, as Masbedo is not dealing with any mathematical system. So what is there to see? The background consists of a mountain landscape partially covered in snow, backed by a grey sky; the middle ground is a brightly shining sea surface (the video is in black and white). A wide wooden table stands directly on the shoreline. A large number of glass containers in different shapes and sizes are piled up on the table. Two chairs stand on the left and the right of the table. The camera is positioned in the middle, roughly at the same height as the tabletop. From outside the frame, continuous shots are fired at this arrangement, constantly rattling the glassware and causing the table and chairs to break up, piece by piece. The long shot is interspersed occasionally by close-ups that provide visually powerful illustrations of the dynamic nature of destruction. The man-made functional objects are gradually reduced to pieces of wood or shards of glass. Rendered unusable, they appear like miserable waste products of civilisation, abandoned by humans in a monumental landscape.

The table, the two chairs and the glass containers point to an everyday culture of togetherness, to an intimate closeness that is breaking down. And what might the shots represent? Forms of communication that destroy rather than strengthen the intimacy in a relationship? And is this because love, the 'fiery nucleus of togetherness', cannot be communicated? If we transition smoothly to Gödel's incompleteness theorem, it could be suggested that love is a complex system that cannot be derived from other utterances. What's more, like shots from a gun, the medium of language can even tear apart an intimate relationship.

→ **Teorema di incompletezza**, 2008
Single-channel video
5:38 Min.

Teorema di incompletezza is a psychodrama of visual opulence and symbolic intensity. It drives the escalating spiral of destruction to a point at which the remaining shards of glass look like lumps of ice that could change their aggregate state and be absorbed by the sea at any moment. The dishes, effectively the 'everyday implicit contractual basis for a romantic relationship' seem to be liquefying. In this way, the fragments of intimacy can be reconnected to the 'big picture', reintegrating the history of a relationship into the cycle of nature.

A long shot of the Icelandic landscape appears again at the beginning of *Ionesco Suite*: in the background a dull and overcast sky; below it, an anthracite-coloured, partially snow-covered mountain range. In the foreground, a wintry brown meadow with patches of firn. A two-storey, dove-grey building with a gable roof is visible in the middle, at the edge of the meadow, separated from the mountains by a wide body of water. Cut. An enclosed room with two empty chairs at each end of a table on which glass bowls and carafes are piled. The arrangement of the objects, which suggests a cultish experimental setting – with the table as a secularised altar – is very similar to the setting in *Teorema di incompletezza*.

Ionesco Suite is also devoid of any human presence. Instead, objects falling from the ceiling effectively act as actors. Their visual force draws the viewer into the event. Against a backdrop of mellow piano and bass tones, the shower of confetti is followed by a cascade of biscuits and confectionery (including lollipops, boiled sweets and gingerbread), until the glass ceiling lamp collapses. Finally, a violent flow of cement, accompanied by a raucous, electronically generated sound, begins to cover all the objects on the table, gradually burying them, only to then overflow and pour out onto the floor. By the end, the entire room is coated with a thick layer of concrete from which individual glass vessels protrude like archaeological remnants of a past era.

Do the various sequences of falling objects represent the different stages of an intimate relationship? Is Masbedo using symbolic means to illustrate how the world of a couple whose feelings are gradually wearing thin ends in a slowly hardening concrete crypt? Is the artistic duo staging partnership as a counterpart to a volcanic eruption in whose wake everything is flooded with lava and consequently dies?

The film concludes with auratic landscape images of the volcanic island of Iceland, which connote in particular the start of the global financial crisis in 2007. In a concentric link to the start of the video, the same house appears, this time in its entirety. Viewing it from another perspective, we now realise that it is located at the mouth of a fjord. We see and hear the seawater washing against the nearby shore. Landscape becomes the projection surface that allows little or no separation between the internal, mental landscape and the external. When measured against the violence of the dissolution process shown in *Teorema die Incompletezza* and *Ionesco Suite*, there is also some consolation to be found.　　　　　　　　　　　　　　　　　　　　　M.O.

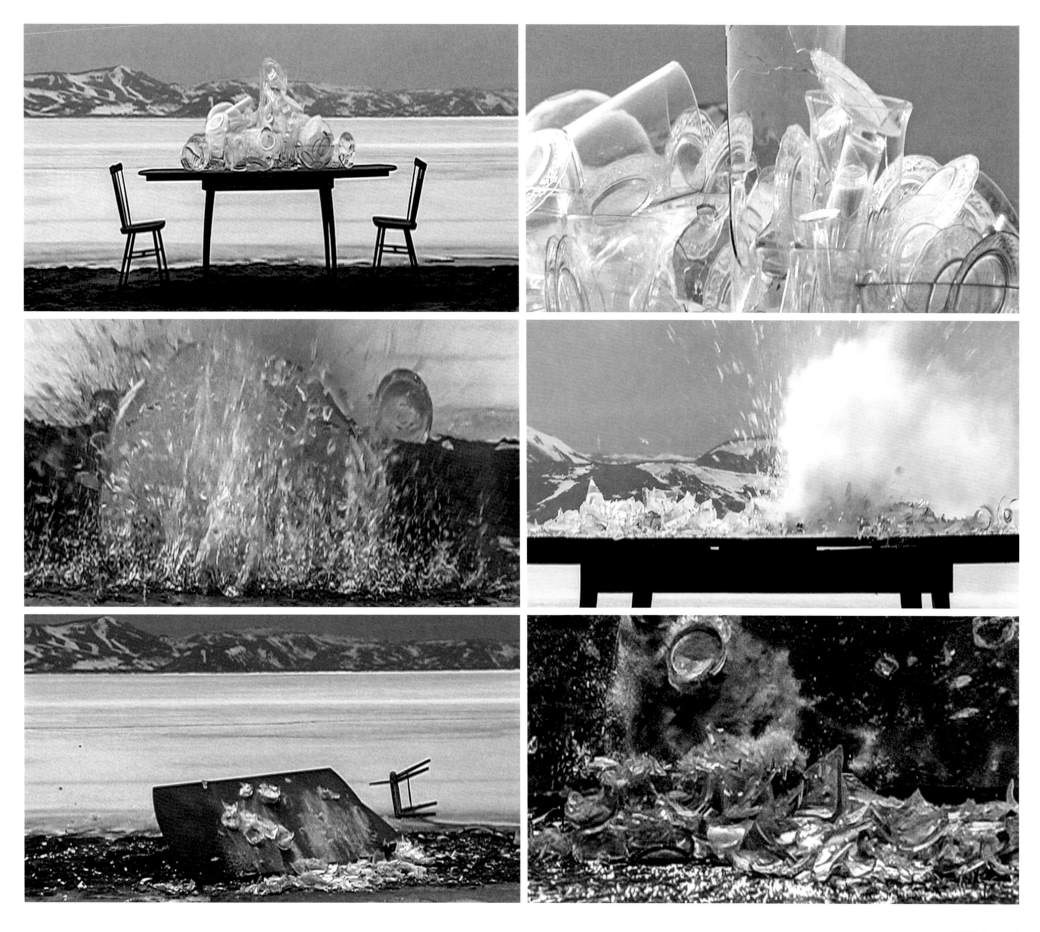

JULIAN CHARRIÈRE

Dystopian Beauty

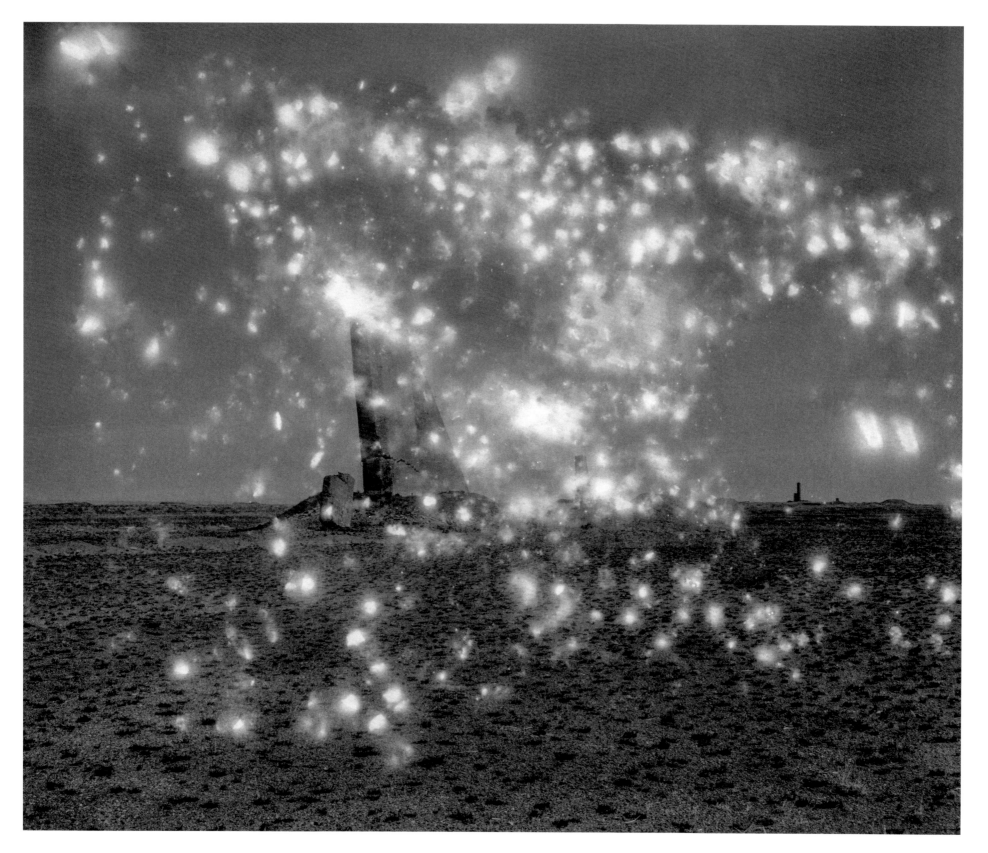

↗ **Polygon XXIX**, 2014
Double exposure through radioactive radiation
on Hahnemühle Rag Baryta paper
183 × 153 cm

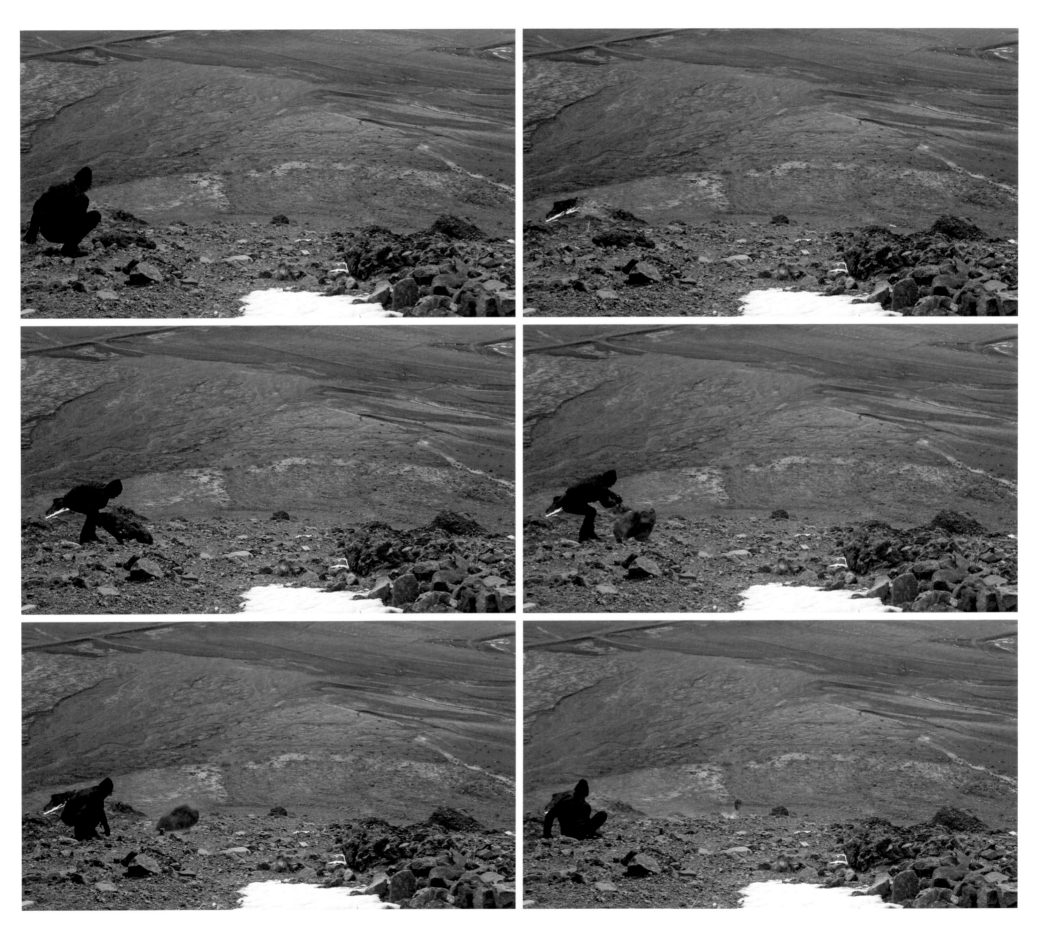

← **And the Post-Modern Collapse of Time and Space**, 2013
Single-channel video
1:55 Min.

1 'Julian Charrière', in *Kunst-sammlung der Mobiliar*, online: https://kunst.mobiliar.ch/kuenstler-in/julian-charriere (last accessed 10 October 2019).

2 *Julian Charrière: As We Used to Float*, GASAG Art Prize 2018, Berlinische Galerie – Landesmuseum für Moderne Kunst, Fotografie und Architektur, Berlin, 27.09.2018–08.04.2019.

Berlin-based artist Julian Charrière (b. 1987) makes his way to the most remote places on earth for his videos, photographs, sculptures and installations. As an 'explorer with an artistic intention', he investigates 'subject areas like geology, physics, biology and cultural history'.[1] For example, the series of photographs entitled *The Blue Fossil Entropic Stories* (2013) shows him holding a blowtorch to an iceberg in the Arctic Ocean. *And The Post-Modern Collapse of Time and Space* (2013) is a video set in an Icelandic rocky landscape and alludes both to the myth of Sisyphus and the phenomenon of the butterfly effect. Seventy years after the first American nuclear weapons tests on the Bikini Atoll, the lasting radiation exposure means that the former inhabitants of the Marshall Islands have not yet been able to return there. Another reason for Charrière to travel to this part of the world. The multimedia installation *As We Used to Float* (2018)[2] shows the legacy of the bomb tests – including what has happened below sea level.

Just two years before Charrière's trip to the Marshall Islands, he travelled to the Semipalatinsk Test Site in Kazakhstan, where nuclear weapons had been tested by the former Soviet Union. The particles that glisten so enchantingly in the black-and-white photograph *Polygon XXIV* (2014) are actually radioactively contaminated particles of soil that the artist scattered onto his photographs when developing them. The landscape itself appears in stark contrast to this superficial sheen. Almost 500 nuclear warheads were detonated there between 1949 and 1989. While Semipalatinsk is still considered to be a no-go area due to extremely high radiation levels, in practice it is easily accessible. A post-apocalyptic landscape is rendered by the polygon-shaped concrete piers extending skywards from the dusty, lifeless soil. The verbalisation of this dystopically beautiful scene gives rise to strange expressions, such as 'glistening sadness', 'hostile expanse' or 'self-destructive perfection of technical progress'.

In his projects, Charrière addresses, on the one hand, the ambivalence of the aesthetic appeal of the photographed landscape and, on the other hand, the knowledge that the balance of nature has been destroyed, primarily by human activity. Charrière does not need to show either victims or accompanying texts to convey his pessimistic prediction of the future, according to which humankind will ultimately succumb in the struggle between nature and humanity. The absence of a human presence, the non-existence of everyday life and the dilapidated buildings and disintegrated shipwrecks that have been usurped by vegetation demonstrate that nature will in fact continue to exist even if humankind has wilfully ruined its own basis of existence. The impression given by Charrière's works is that what follows will most probably be in no way less perfect than creation in its original state. It is surprising how quickly flora and fauna adapt to a fundamentally changed environment and how easily they can

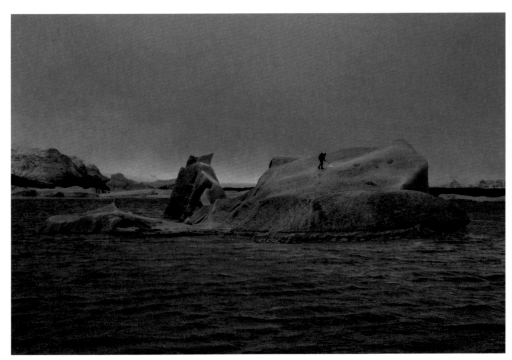 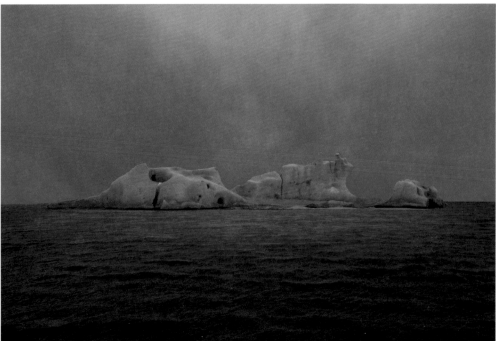

assimilate remnants of human progress and materials like concrete or steel. In the installation *As We Used to Float*, for example, we see a ship's propeller. Coated completely by a layer of algae, with a vibrating surface in the flowing water, its velvety beauty prevails over its uselessness to human beings. The coconuts on the ground in the exhibition space are still slightly radioactive and the artist has them encased in lead. Charrière was immediately fascinated by their altered form as a result of the radiation. One cynical conclusion that could be drawn is that the consequences of the nuclear weapons tests have even stimulated nature's creativity.

Casper David Friedrich communicated with the viewers of his paintings through rear-view figures who gaze into the landscape. Charrière himself frequently appears in his own videos and photographs. However, he does not reveal his identity, which allows him to be a neutral protagonist with the potential for the viewer to identify with him. One example of such a work is the above-mentioned video *And the Post-Modern Collapse of Time and Space*. 'A mountainside appears, varying in colour between dark grey and reddish brown, extending far into the spatial depth. An expanse of snow extends into the middle of the foreground; to the right and left of it lie rocks of different sizes. We see a desert location that resembles a moon sculpture, barren and austere. Whirlwinds dance across the landscape; one can imagine the smell of

dust and bare rock lingering in the air.'[3] This is how the literary scholar Michael Ostheimer describes the landscape presented by the artist. We find ourselves in an Icelandic rock garden. A man dressed in black appears, and tries to move a boulder. When he fails to do so using the power of his legs, he stands up, seizes the colossus and pushes it down the mountain. Rolling into the depths, the huge stone gathers speed and in doing so brings other small stones in its wake. The myth of Sisyphus immediately comes to mind. However, in that case, the protagonist was engaged in a futile attempt to push a heavy piece of granite rock up to the top of a mountain. Charrière, on the other hand, is more concerned with a symbolic butterfly effect, as his action does not pose a real avalanche risk or other specific threat.

This is precisely where the meaningfulness of the performance, which is also displayed in the artist's other projects, is revealed. After all, the destruction of the environment (palm oil plantations in *Tambora – An invitation to disappear*, 2018), climate change (*The Blue Fossil Entropic Stories*) and nuclear testing are just some of the elements that are destroying humanity's quality of life and even its basis for life. What these stones that have been set in motion will trigger in the longer term is unfortunately less unlikely than one would like to hope. U.M.

3 Michael Ostheimer, 'Anti-Sisyphus. Julian Charrière: *And the Post-Modern Collapse of Time and Space* (2012)', in *Sichtspiele. Films and Video Art from the Wemhöner Collection*, Berlin, 2018, pp. 22–25, here p. 23.

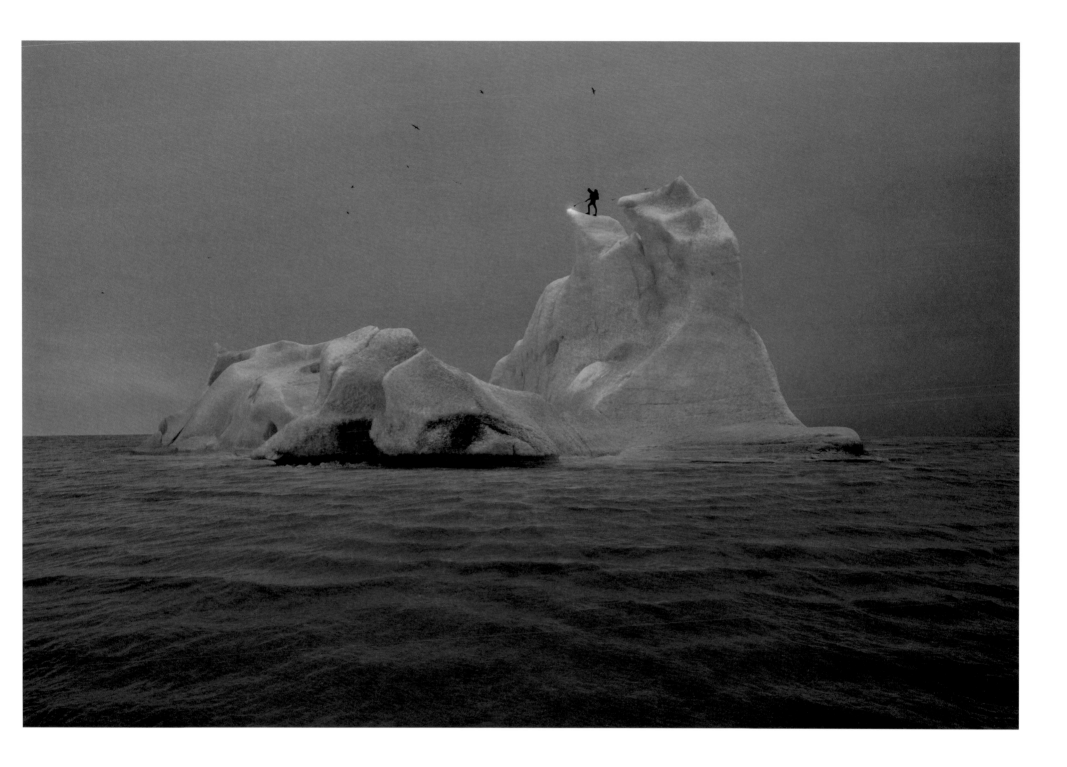

← **The Blue Fossil Entropic Stories I**, 2013
Fine art print on Hahnemühle paper
100 × 150 cm

↖ **The Blue Fossil Entropic Stories II**, 2013
Fine art print on Hahnemühle paper
100 × 150 cm

↗ **The Blue Fossil Entropic Stories III**, 2013
Fine art print on Hahnemühle paper
100 × 150 cm

SHEN FAN

The Silenced Voice of the Mountain Range

↗ **Punctuation – Dwelling in the Mountains**, 2014
Mixed media and newspaper on wood
154 × 600 cm

At the 2006 Shanghai Biennale, Shen Fan (b. 1952) presented a five-by-fifteen-metre light installation: an homage to the traditional landscape painter Huang Binhong (1864–1955). In this work, 2,500 glowing calligraphic neon tubes, attached to a wall-like structure, respond in a choreographed rhythm to soothing music composed by Shen Fan himself. The five paintings in the polyptych *Punctuation – Dwelling in the Mountains* (2014) are also abstract landscapes. Graphic characters from the pages of a Chinese newspaper, overpainted in black and white felt-tip pen, form surreal-looking pointed mountain ranges.

During the Cultural Revolution, Shen Fan was sent to the countryside where he tilled fields with the farmers. Back in Shanghai he studied at the Shanghai Light Industry Institute. The search for an authentic artistic expression led him to abstract painting in 1982. Since the late 1980s, he has been exhibiting internationally. In some of these works, individual brushstrokes form a decorative design; in other works, the brushstrokes boisterously overlap. The diversity of Shen Fan's compositions arises from, among other things, the varied length of the strokes. The black arcs in *1995-P-23* (1995), for example, sweep in large arcs into the picture, whereas the short strokes and curves in *Landscape-C-11* (2006) are kept completely separate. Shen has a preference for primary colours. For example, *White Landscape* (2001) and the triptych *98-99-5* (1994) are painted in nothing but pure white, on rice paper that is a warm natural shade of white, while *95-P-43* (1995) and *River Landscape-C-06* (2006) flicker in bright red.

Survey exhibitions of works dating back to the 1990s demonstrate the various phases of Shen Fan's conceptual refocusing. One change that had a fundamental effect on his works is that, up until early 2000, he worked consistently in oil on rice paper, but since then has painted on canvas. Shen Fan's titles also reflect a new attitude to his own work. While he expressly emphasised in earlier interviews that he did not want to raise any figurative associations and therefore preferred a simple numbering system, this statement was no longer relevant once he abandoned rice paper as a painting surface. Now, he uses the words *landscape*, *river* or *garden* in his titles. In addition to a number of square or rectangular pictures, he has continued to favour primarily the extreme landscape format of the traditional scroll, which might be interpreted as an expression of his affinity with Chinese aesthetics.

1 All the information on the technique used in *Punctuation – Dwelling in the Mountains* (2015) and on the artist's self-assessment is taken from email correspondence between the author and the ShanghART Gallery in Shanghai.

Even today, Shen Fan is described as a leading exponent of Chinese abstraction – an assumption that is only partly true if his more recent works and their narrative titles are considered. The light installation mentioned at the beginning of this essay, *Landscape: A Tribute to Huang Binhong* (2006), underlines his artistic approach. Even though, strictly speaking, we do not see a landscape, the artist presents a meditative reflection of nature by arranging the brushstroke-like neon lights in such a way that they resemble hills or waves. The polyptych *Punctuation – Dwelling in the Mountains* is characterised by a similar ambiguity between the abstract and the figurative. Five landscape canvases hang side by side, with no gaps between them, but at different heights. The effect of the up-and-down movement produced by the work brings to mind a mountain range. Similarly, in the individual pictures abstracted, white mountains rise up from a vibrating black surface. The overall effect is quite prosaic and the viewer might think that the paintings were generated on a computer. Yet anyone who is familiar with Shen Fan's earlier painting will not trust this initial impression. Viewed at close range, the grid actually turns out to be a piece of delicate handicraft. Not a bare or primed canvas but rather several accurately arranged newspaper pages cover the stretcher frame. According to the artist, it was part of the concept that the pages used do not feature any images.[1] For the viewer of the polyptych, however, the printed text is no longer even vaguely perceptible because a felt-tip pen has been used to paint over every single character; a black pen has been used to depict the background and a white one for the mountain ranges. Only the punctuation marks and the spaces between the words are spared. An additional rhythm is produced by the columns of text.

Following a phase of abstraction during which Shen Fan used only calligraphy, in *Punctuation – Dwelling in the Mountains* he once again addresses landscape painting, though he adopts a completely different mode of practice that he himself describes as Concept Art. In more recent pictures, a correspondence with ink painting becomes apparent in the reduction to black-and-white contrasts. While the influence of Shen Fan's engagement with Western Minimalism and American Action Painting cannot be ignored and the artist himself alludes to it, the joy of experimentation of classical Chinese scholars and in particular *shan shui* painting remain his sources of inspiration to this day.

U.M.

TANG GUO

Order of Things in the Flow of Time

↗ **Stone (G)**, 2012
Ink on handmade paper
32 × 70 cm

↑ **Happy (K)**, 2012
Ink on handmade paper
32 × 70 cm

Second Opium War, October 1860. As a retribution for the murder of their compatriots by Emperor Xianfeng, British troops destroyed and ransacked the Old Summer Palace in Beijing. Even today, an aura of erstwhile splendour pervades the few remaining ruins. In the exhibition entitled *The Rhyme of Ruins* (2013), the Nanjing-based artist and photographer Tang Guo (b. 1955) presented a jumble of ink-drawn ruined traditional buildings and everyday objects, some of them destroyed, some still intact. However, the artist does not associate his catastrophic landscapes with any historical event, but rather with a memory from his youth.

For some time now, ideas about China have been linked with the concept of acceleration. But Tang Guo manages to avoid this external speed thanks to the methods he uses in his art practice. He makes his own paper in an extremely complex procedure that follows traditional techniques. This process can take up to six months. In some of his works, Tang Guo uses the handmade paper without further treatment, thus directing the viewer's attention to the fine grasses and wood fibres that have been worked into the paper and

the natural brown or ochre colouring of the sheet, evoking associations with landscapes.

Tang Guo made his way into abstraction in stages. For example, while the painted works in his 2001 *Blue Combination* series still retain clear references to calligraphy, the characters have been distorted to such an extent that the meaning they convey is no longer to the fore. Instead, the beauty of the stroke is of primary importance. At first glance, the works in the monochrome *Landscape* series (2004–2010) seem completely detached from traditional prototypes. The watery, blurred colour gradations in royal blue or green and the translucence of the paint applied are completely in keeping with the aesthetics of Chinese ink painting.

The flow of water, its perpetually changing surface and colour, the way in which it reflects both land and sky, its life-giving but also destructive powers, are all key elements of the Taoist philosophy. Since the beginning of his career as an artist, Tang Guo has been inspired by the essence of water. In addition to the spiritual and intellectual dimension, however, there is one incident that

↗ **Pillow (I)**, 2012
Ink on handmade paper
32 × 70 cm

lingers in his memory and coalesces with the theme of water; it goes back to the time of the Cultural Revolution. Like many of his peers, Tang Guo was sent to the countryside as a young adult. As in his case it was a beautiful place near Nanjing, he found the experience to be more of an adventure than an 'educational' measure'. In 1973, his first year there, a dam broke, leading to extensive flooding. Since 2012, his fine-ink drawings have referred directly to this experience. They formed part of his *The Rhyme of Ruins* exhibition, which also included a video of the same name.

After almost forty years, the devastation caused by the deluge of water has vanished. What is left are the images living on in his memory. As an act that retrospectively establishes peace following the traumatic experience and nevertheless illustrates its constant presence, Tang Guo arranges still lifes in ink on handmade paper. In works that are clear and sharply outlined, formerly useful or decorative objects – some in fragments, others still intact – nestle up to one another in *Mirror (A)*, *Happy (K)* and *Pillow (I)* (all 2012). Other works in the series feature buildings or architectural details such as pillars or parts of pedestals. The works are devoid of any human or animal presence; nor do we see any plants, just some bamboo shoots lying on the ground. An 'order of things' prevails. At the same time, the hill-like arrangements evoke associations with landscapes, but not with a *shan shui* ensemble of waterways, mountains and greenery. That which is human-made is divested of its intended functionality and reorganised by the power of nature. This serene world view is entirely logical from a Buddhist and Taoist perspective. The water that surges up over the banks or breaks through a dam is only recapturing its original flow. The ink drawing *Pit* (2013) takes this point of view one step further. The material legacies of the person gradually dissolve here and disappear into the inky shadows. Dividing the work into two sections, a bright lower half and a dark upper half, enhances the spiritual dimension of the work. While Tang Guo's longitudinal landscapes in *The Rhyme of Ruins* series set the material and the transient in the flow of passing time, the consistent use of the portrait format for *Pit* focuses on the relationship between the earthly and the metaphysical. **U.M.**

↑ **Mirror (A)**, 2012
Ink on handmade paper
32 × 70 cm

→ **Pit**, 2013
Ink on handmade paper
114,5 × 69 cm

QIU ZHIJIE

Measuring the World

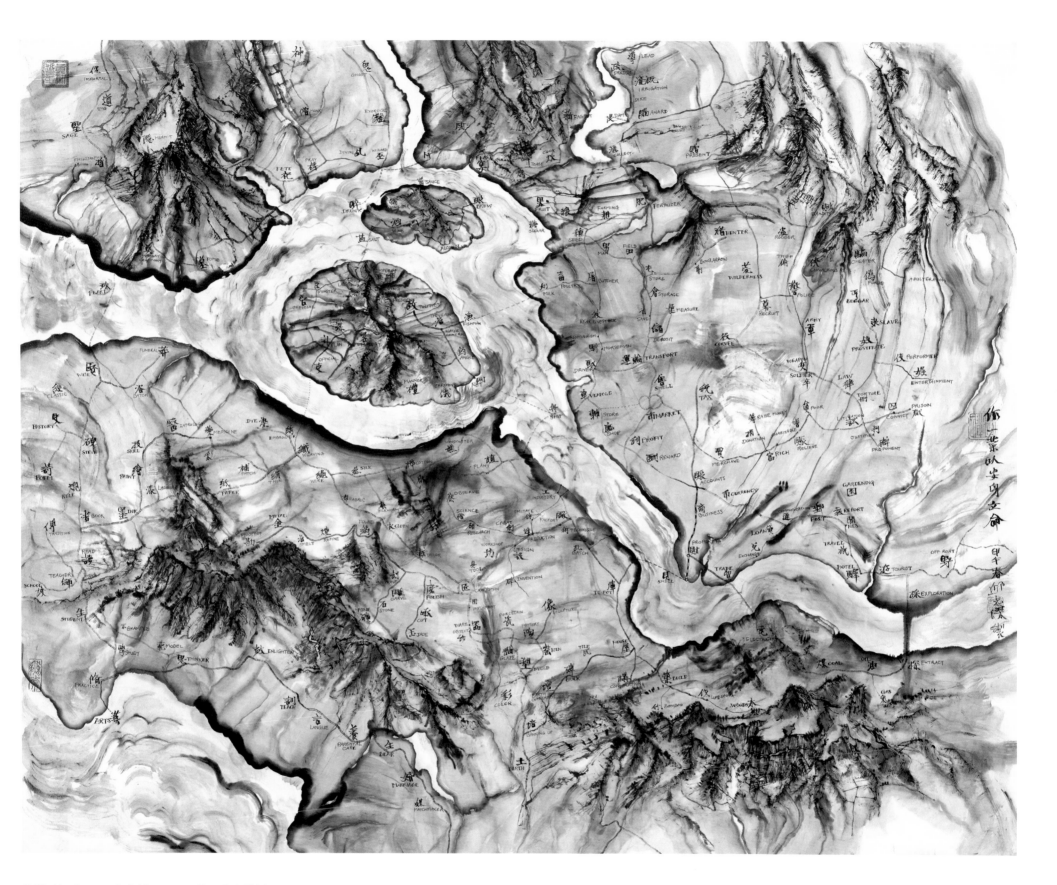

↗ **Working in a certain field gets oneself settled**, 2014
Ink on paper on canvas
145 × 183 cm

'Total art for me is art as cultural research': this is how Beijing-based artist Qiu Zhijie (b. 1969) describes the objective of his multimedia and interdisciplinary works. He abandoned his ambition to be an archaeologist when he saw an exhibition by the now legendary art group Xiamen Dada in 1986. His ink paintings, photograph, installations and performances, as well as his social engagement, are still shaped by a researcher's perspective.

Qiu Zhijie varies the materials and techniques he uses from work to work. In 2006, he started to work on a long-term project entitled *A Suicidology of the Nanjing Yangtze River Bridge*. In addition to the compilation of a steadily growing archive, this project also investigates, at both a theoretical and practical level, a phenomenon peculiar to the Yangtze Bridge: since its completion in the eastern Chinese city of Nanjing in 1968, more than 2,000 people have chosen it as a place to die by suicide. Qiu Zhijie outlines the reason for the sad notoriety associated with Mao Zedong's architectural flagship project: 'Like the Golden Gate Bridge in San Francisco, the bridge is often shrouded in fog. Fog attracts potential suicides. Such a renowned place also lends a certain grandeur to one's death.'[1] Qiu Zhijie's installations for this project follow the traces of history. He does not focus on the cold facts but rather on the fates of individual people, who either died at the bridge or wanted to die but survived. A therapy centre that he has established to help treat those at risk of suicide and those who are bereaved by suicide forms the basis for his research. These individuals are offered opportunities to talk about their experiences and are also invited to take part in Qiu Zhijie's art projects related to the issue of suicide.

A series of exhibitions that toured internationally shows the visionary power with which Qiu Zhijie pursues his objectives. The fourth part of his Suicidology project, entitled *Götzendämmerung* [Twilight of the Idols] (2009/2010), transformed Berlin's Haus der Kulturen der Welt into a materialised nightmare: plaster cast women's and men's shoes balance on steel arches, a clock ticks back towards the present day from the year 5000, mirror cutouts of crows cast their shadows. Opened books simulate the outlines of the Yangtze Bridge in Nanjing and pages flutter in the draught of quietly humming fans. In contrast, a shadow puppet play solidifies into an immobilised image. If a person dies of his or her own volition, he or she frustrates the plan of creation.

The artist's mapmaking paintings of recent years represent another form of 'cultural research'. The tradition of the medium in which he works dates back to pre-Christian millennia in China and in the West. It is said that the legendary Emperor Yu of the Xia dynasty (ca. 2,200–1,800 BCE) had images of the part of the country that he governed – including rivers, mountains, animals and plants – incorporated into ritual bronze vessels. Anaximander of Miletus (ca. 610–547 BCE), an early philosopher in the Western tradition, is believed to be the first person to have attempted to produce a map on the basis of geographical data. Qiu Zhijie's abstract landscapes, on the other hand, do not show regions that can be precisely located. With the calligraphic artistry of the Old Masters, he creates works not only on paper but also directly on the walls of an exhibition space. For his exhibition *The Unicorn and the Dragon*, for example, which formed part of the 55th Venice Biennale (2013), he drew large-scale, fanciful topographies that, across cultural boundaries, trace the history of mythological traditions and images of unicorns and dragons. Walking through the palace that is the home of the Fondazione Querini Stampalia was a virtual journey through time.

Qiu Zhijie also chose the medium of cartography for his work *Bird's Eye* (2013), which consisted of 26 scrolls and extended to almost 20 metres in length. The themes addressed in this work highlight the artist's intrinsic values. *The Isles of Yesterday*, *The River Discovered Roads Before Mankind Did*, *The Desert is the World's Last Ruler* – even the titles of the individual parts of the work refer to the bird's eye perspective that is adopted for the view of what we call 'the world'. The microcosmic and actually verifiable phenomena are less relevant. Instead, the importance of humankind to the existence of the planet is put into perspective and reference is made to the self-destructive behaviour of humans when it comes to our natural resources. In *This Water is Certainly Not Free*, gaudily coloured rivers wind their way through a hilly landscape painted in black ink – unfortunately this is not a dystopia but rather an increasingly dangerous reality in China.

Unlike in *Bird's Eye View*, Qiu Zhijie adopts a self-reflexive perspective in *Working in a certain field gets oneself settled* (2014). In order to facilitate individual interpretations, he does not provide any clues that would allow the viewer to locate the hilly landscape, which is rendered in shades of grey. Quite plausibly, it is the coordinates of one's own life that determine the course of the rivers and the land in the map the artist has drawn. Given the fact that, beyond consumption and profit, the scope of development for people in China is massively restricted, this work acquires a sociopolitical significance. After all, it is precisely where the freedom of the individual is limited by external forces that creative and/or humanistically oriented forms of self-realisation are of fundamental importance to guard against an unstable, meaningless and homeless existence. U.M.

1 Qiu Zhijie in conversation with the literary scholar Li Shuangzhi, quoted in Ulrike Münter and Li Shuangzhi, 'Kunst als kulturelle Recherche', Goethe Institut China, December 2009, https://www.goethe.de/ins/cn/de/kul/mag/20719454.html (last accessed on 29.05.2019).

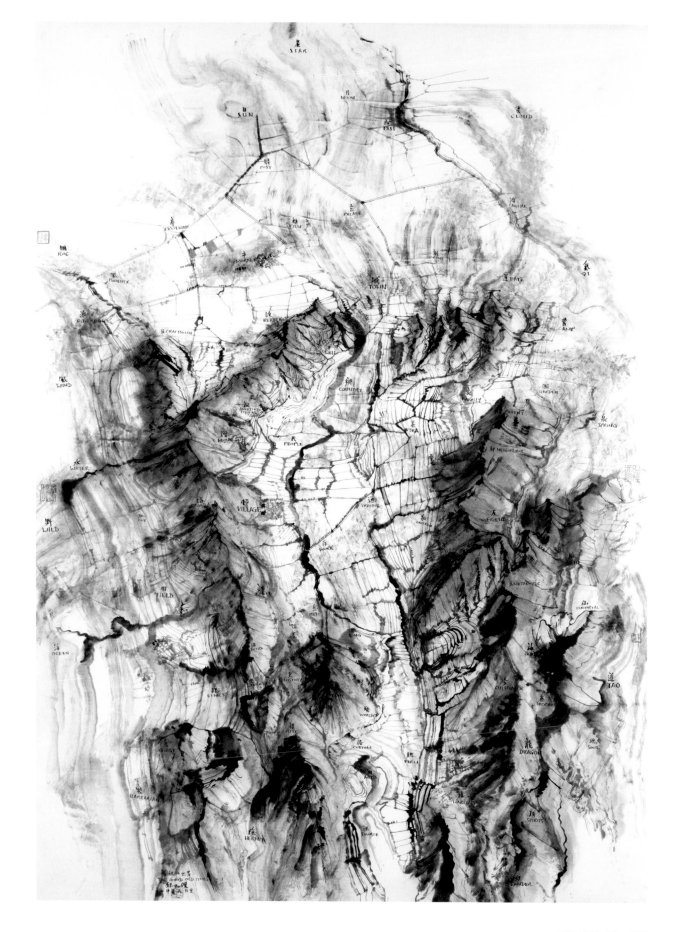

↗ **The world before**, 2016
Ink on paper on canvas
200 × 145 cm

BRIGITTE WALDACH

Dialogue with Mountains, Trees, Stars, Phlox and Clover

Desideratum, 2015
Gouache, graphite on
handmade paper
146 × 140 cm

← **Exhausted Clichés**, 2017
Gouache, graphite, carbon pencil on
handmade-paper diptych
190 × 380 cm

Ever since the Romantic era and the time of Grimm's fairy tales, the German forest has been seen in European culture as both a symbol of the search for meaning and a dangerous place. Gloomy and shrouded in mist, painted or described, this mystical place is no longer accessible to rational logic. For Berlin-based artist Brigitte Waldach (b. 1966), even the title of her diptych *Exhausted Clichés* (2017), a drawing in graphite, gouache and pigment pen on hand-made paper, suggests that she is not interested in reviving this 'exhausted', i. e. stereotypical, attribution. Instead, her oeuvre reflects an approach also favoured by the Romantics – to create work that is fragmentary, unfinished and therefore open to interpretation.

Brigitte Waldach's academic background was initially in German studies but she subsequently decided against a career in the humanities and moved to the Hochschule der Künste Berlin (now Universität der Künste Berlin), where she was a *Meisterschülerin* (master student) under Georg Baselitz. Given the very different aesthetic of the two artists, their conceptual point of intersection may not immediately be apparent. A glance at their respective sources of inspiration is enlightening in this regard. We see that neither Baselitz's nor Waldach's art practice takes place in an ahistorical space. With the responsibility of the contemporary witness, both perceive the repercussions of past events as part and parcel of the present day and see their work as a sociopolitical echo

chamber. Waldach's affinity with literature and philosophy is also evident in her studio in the Wedding district of Berlin. Books that are referenced in her works are filled with sheets of paper and pencilled comments and lie close at hand. Her vibrant, flowing handwriting defines the action space of the figures in her pictures as a historical sphere that is shaped by their own history. Quotations from and references to biographies, dramas, musical scores and narratives cause the surfaces of her large-scale drawings to vibrate eloquently. The air is infused with sentences, the waves of the sea or the trees are phenomena formed by writing. Waldach says that she takes one of two routes to the particular work: 'When I read, I see images, and when I draw, sentences appear. I cannot think of one aspect without the other.'[1]

Waldach often relocates the place where the action unfolds – or more frequently where time seems to stand still – to lofty or even oxygen-deficient heights, to lonely mountain formations that are no longer assigned to a specific time. Figures gaze from an indeterminable location into the starfilled sky. Philosophically, the question if there is a higher order is an open question. It is no coincidence that the triptych *Space* (2015) features quotes from Friedrich Nietzsche's *Thus spoke Zarathustra* (1883). In this work as well, the black infinity of the universe stretches across an icy white mountain panorama. A vague topographic note is inserted through elisions into the cosmic darkness in the

1 Brigitte Waldach in conversation with the author in spring 2016 and autumn 2017 in her Berlin studio.

↗ **Space**, 2015
Gouache, graphite, carbon pencil
on handmade-paper triptych
185 × 420 cm

upper left corner of the work: '6 000 Fuss jenseits von Ort und Zeit' (6,000 feet beyond space and time). But according to the artist, it was not Nietzsche's rejection of the idea of a God of creation that was the primary inspiration for *Space*, but rather Stanley Kubrick's cult film 2001: *A Space Odyssey* (1968). However, while Kubrick staged the philosopher's ideas as a cold prediction of the future, Richard Strauss had been inspired first and foremost by the Dionysian mood of the text in his 1896 *Zarathustra* composition. A world without an all-knowing and all-powerful ruler was for him synonymous with a way out from the shackles of Christianity. In order to transfer this aspect also into her triptych, Waldach's constellation of stars lights up in the same arrangement as the first two pages of Strauss's score. A timeless space for reflection opens up, offering neither promises of salvation nor apocalyptic scenes.

'What can we hope for?' is the third core philosophical question in Immanuel Kant's *Critique of Pure Reason* (1781). His strict separation of knowledge and faith leaves all responsibility for people's actions up to themselves, but does not in any way deny them the hope of a divine relatedness (*Weltzusammenhang*). Waldach's drawing *Desideratum* (2015) shows a girl or a young woman lifting up her hand to the sky. Stunning, black, cross-hatched, cloud-like structures, fraying at the edges, accumulate above her head. 'I would like to interpret more broadly Nietzsche's use of the term "Desideratum" in this drawing, to use it in the original sense of the word,' says Waldach, commenting on her work. Something 'desired from heaven' to describe a 'yearning, perhaps even a utopia'.[2] The undefined dimension of this look into the future is reflected in the traces of words like 'natural', 'unconscious' and 'desire', which waft around the expectant protagonist. Even if heaven doesn't promise anything, it still allows for the hope that her yearnings will be fulfilled.

Back to *Exhausted Clichés*. Seen through the rear view of a figure – the work of Caspar David Friedrich comes to mind – the viewer enters a forest. A handwritten text extends across the body of the person, who cannot be identified as a man or woman. Individual words, sentence fragments or overlapping passages of text also hover over the roots of the trees and into the treetops. Waldach refers to one of David Foster Wallace's *Brief Interviews with Hideous Men* as a source of inspiration for this work.[3] In this particular short story, the narrator, an unlikeable, macho egocentric, describes an encounter with a young woman that decisively changed how he relates to himself and the world. It is not the incident related by the nameless characters that throws the audience off track, but rather the fact that the young woman's 'needle-sharp focus'[4] enables her to maintain the upper hand over what she has experienced.

In her drawing *Exhausted Clichés*, Waldach refers to a key scene in the story, which takes place in the outskirts of a forest.[5] The olfactory intensity with which Wallace's female protagonist perceives nature allows us to experience the landscape as a space for the imagination. The narrator recounts how, face down in the gravel, his strong-willed chance acquaintance 'could distinguish lilac and shattercane's scents from phlox and lambs'-quarter, the watery mint of first-growth clover'.[6] As in Wallace's case, Waldach's drawing does not relate to a specific forest. Trees dissolve into delicate contours or are turned into word diagrams at the outer edges of the work. Jigsaw-like areas in the dense foliage reinforce the impression that this work is not a complete narrative in itself but rather just one sequence or the beginning of something. Interestingly, the figure that we see from the back enters the forest counter to the European reading direction, namely from the right. Interpreted in terms of time, someone is moving into the past here. Seen from this perspective, the symbol of the red, five-pointed star, which also appears in other works by the artist,[7] acquires significance and refers to the 'German Autumn', the name given to the wave of terror perpetrated by the Red Army Faction (RAF) in October 1977. Functioning as a landscape of remembrance, the forest changes, depending on who is walking through it.

U.M.

2 Ibid.
3 David Foster Wallace, *Brief Interviews with Hideous Men*, New York 1999.
4 Ibid.
5 Ibid.
6 Ibid.
7 Brigitte Waldach dedicated a multimedia series of works to this theme. See also: Dieter Scholz, 'Rote Sterne und Textwolken. Brigitte Waldachs Raumzeichnungen zur RAF', in *Brigitte Waldach. Sturz/Fall*, exh. cat., Kunsthalle Emden, Heidelberg 2010, pp. 88–101.

↗ **Horizon**, 2016
Gouache, carbon pencil on
handmade-paper triptych
170 × 420 cm

BIRDHEAD

Dissolution of Time into Eternity

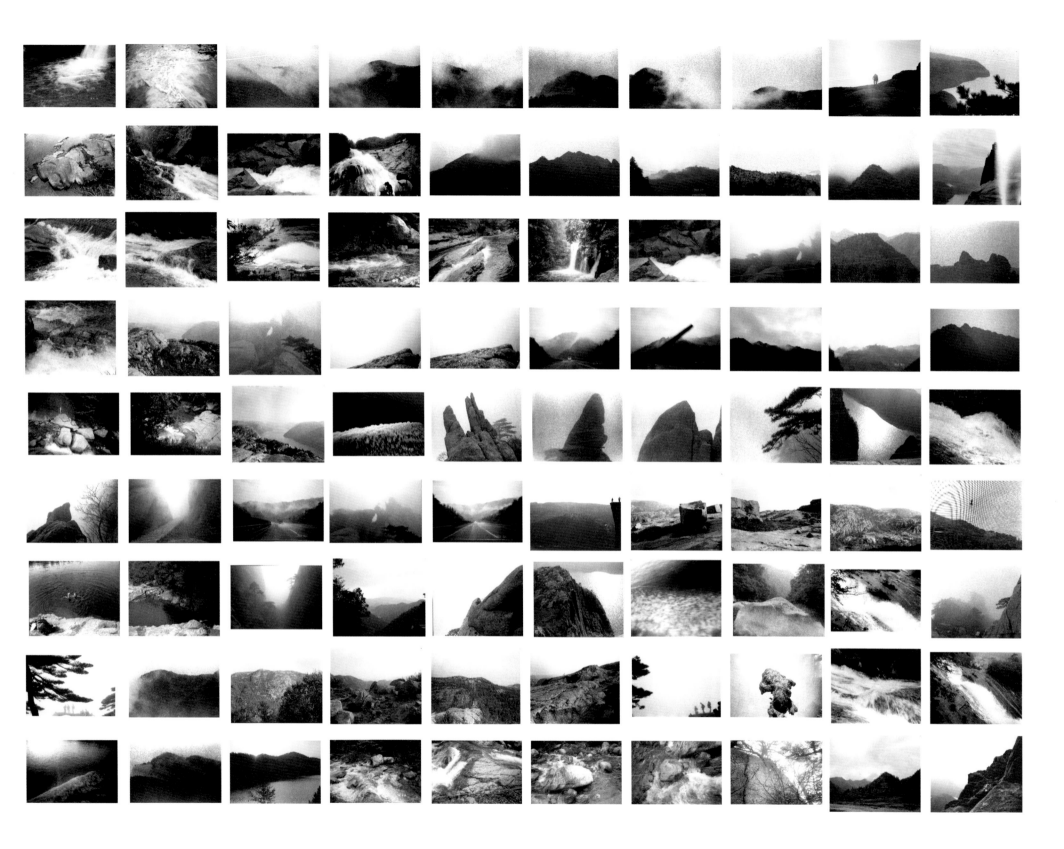

↗ **Welcome to Birdhead World Again, Shanghai**, 2015
C-Prints
90 parts, each ca. 50 x 60 cm

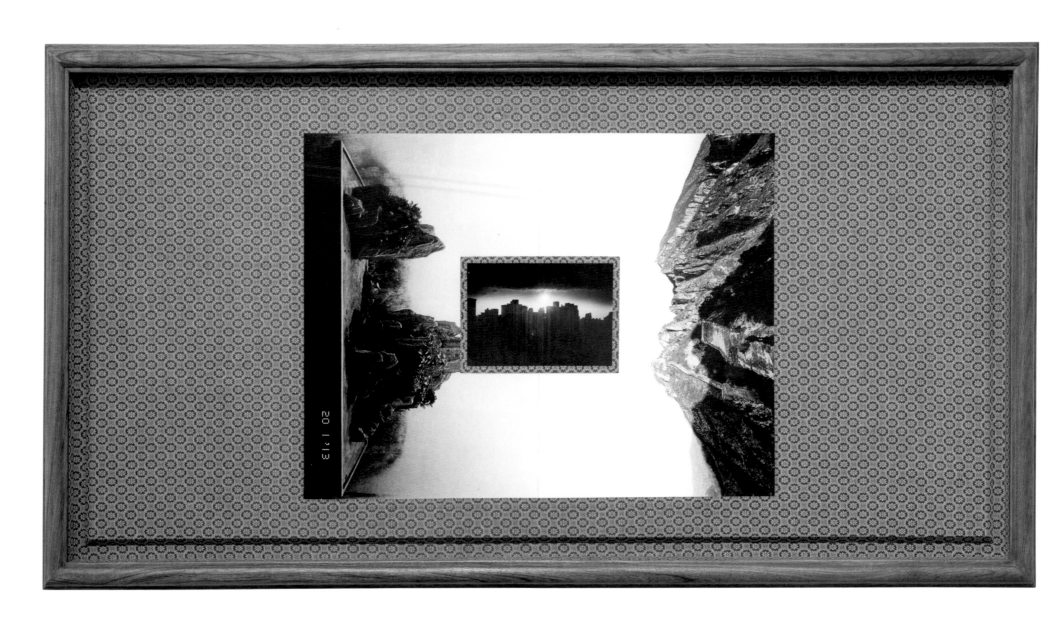

↗ **The Light of Eternity:**
Two Peaks Piercing the Clouds –
Third Time For Dayi, 2013
C-Print, textile, wood
84 × 158 × 5 cm

1 See, for example: *Welcome to Birdhead's World – Venice Project*, 54th Venice Biennale, 2011, or *Welcome to Birdhead World Again*, ShanghART H Space, Shanghai, 2015.
2 Michael Young, 'Steampunks Birdhead', in ArtAsiaPacific, November/December 2013, online: http://artasiapacific.com/Magazine/86/Birdhead (last accessed on 17.07.2019).
3 Ibid.
4 Ibid.

Artists Ji Weiyu (b. 1980) and Song Tao (b. 1979), both of whom were born in Shanghai and still live there today, got to know each other while studying at the Shanghai Arts and Crafts School. Since 2004, they have been working together under the collective name Birdhead. Their photographic oeuvre consists of thousands of snapshots of people (both famous and unknown), city landscapes and nature scenes. The level of blurring in the photographs frequently prevents the viewer from being able to identify exactly who or what is depicted. Camera shots range from extreme close-ups to aerial shots. The duo exhibits in China and abroad, frequently under the title *Welcome to Birdhead World Again*.[1] The repeated use of the same exhibition title, together with their many self-portraits, emphasises the autobiographical nature of the sequences of images. According to their statements, they are less concerned with the meaningfulness of individual shots than with presenting their photographs as a narrative flow, the notes of a melody.

The name 'Birdhead' is an incidental by-product, Ji Weiyu and Song Tao tell columnist Michael Young.[2] While the artists were struggling with their computer, the characters for bird and head randomly appeared on the screen and appealed to them straight away. When strolling through Shanghai or Beijing, Kyoto or Tokyo, London, Moscow, Stavanger in Norway, or hiking in the legendary Huangshan mountains in the province of Anhui, anything that attracts their attention is worthy of photographing. But this approach does not in any way devalue the individual images. The artists of Birdhead still work with analogue technology and develop the negatives themselves. In the darkroom, the hand movements and the slowness with which the once unwitting subjects captured by the lens now reappear on the gelatine paper seem almost anachronistic. It seems equally 'old-fashioned'[3] that the two artists don't have a website. The Birdhead artists' charming lack of modernity suits the retro aesthetic of their countless self-portraits and their preference for black-and-white photographs. The sporadic presence of colour photographs among the sequences of images brings the viewer back to the present day.

Classical Chinese poetry repeatedly makes an appearance in Birdhead's photographic installations. For example, the artists refer to the poems of the Han Dynasty's Cao Cao as a source of inspiration, or quote songs from the Tang Dynasty.[4] The titles of many of their photographs have a poetic ring to them. One such work is *The Song of Early Spring* (2012), which consists of fifteen square snapshots, including a close-up of a bonsai tree, views of treetops and the sky, a Qigong practitioner and a man sleeping on a bench. Everyday observations are stylised into a rhythmic arrangement, a visual lyric

→ **For a Bigger Photo 15**, 2015
Silver gelatine print mounted on linden wood, traditional Chinese enamel
200 × 100 × 5 cm

↘ **For a Bigger Photo 5**, 2015
Epson-UltraGiclee print on durable photographic paper, mounted on wood, traditional Chinese enamel
250 × 120 × 5 cm

that exists outside the ivory tower. The image-in-an-image arrangement in *The Light of Eternity. Two Peaks Piercing the Clouds – Third Time For Dayi* (2013) is consistent with this trend of grounding what is usually found at loftier heights. Instead of a religious or Buddhist promise of an afterlife, the Birdhead artists cast a spell on the light of the rising or setting sun above the roofs of the city, which consequently becomes for them a symbol of the dissolution of time into eternity. A more explicit counterargument to workaday Chinese pragmatism is hard to imagine.

Xincun (2005–2007) is undoubtedly one of Birdhead's most famous series. In the run-up to Expo 2010 in Shanghai, Ji Weiyu and Song Tao spent a year constantly roaming their old neighbourhood of Xueye Sancun, which was located on the grounds of the World Expo and had been earmarked for demolition to make way for the exhibition. Arranged chronologically, in order of season, the photographs of the neighbourhood appeared in a publication that, even on the date it was printed, represented a farewell to the artists' childhood home.[5] Even after the expulsion of its residents, Xueye Sancun was still known by its nickname *xin cun* (new estate), which it had been given when the newly constructed buildings were occupied. Birdhead's photographs show grey and dusty scenes of destruction and deserted playgrounds in the middle of winter; crumbling plaster that reveals a rainbow underneath; and defiantly blooming shrubs in springtime. Cats and dogs repeatedly make an appearance, holding onto their territory to the bitter end. The book ends with New Year fireworks over the roofs of the disappearing architectural repositories of memories. 'The world of Xincun will be wiped out as history (…). The photo album of Birdhead is the memory that could only be kept by those who truly experienced the world of Xincun,'[6] states Birdhead confidante Lin Yu in her introductory words in the publication. At the end of the book, Ji Weiyu and Song Tao remember the croaking of frogs that was once heard in Xincun. As they would to a friend, they bid farewell to the cool concrete walls of their former home: 'Our 6-storey buildings and your fresh smells of cement.'[7]

While the individual photographs, arranged meticulously in a grid of horizontal and vertical lines in the various exhibitions, may initially appear random, their meaningfulness becomes apparent when they are assembled en masse. With intuitive certainty, Birdhead succeeds in achieving what the traditional landscape artists sought to accomplish: 'directly [opening up] an active relationship with the world by seeing'.[8] U.M.

5 Lin Yu, 'Xin Cun. Birdhead', in *Xin Cun. Birdhead*, Shanghai, 2006, n.p.
6 Ibid.
7 Ibid.
8 Mathias Obert, *Welt als Bild. Die theoretische Grundlegung der chinesischen Berg-Wasser-Malerei zwischen dem 5. und dem 12. Jahrhundert*, Freiburg, 2007, p. 2.

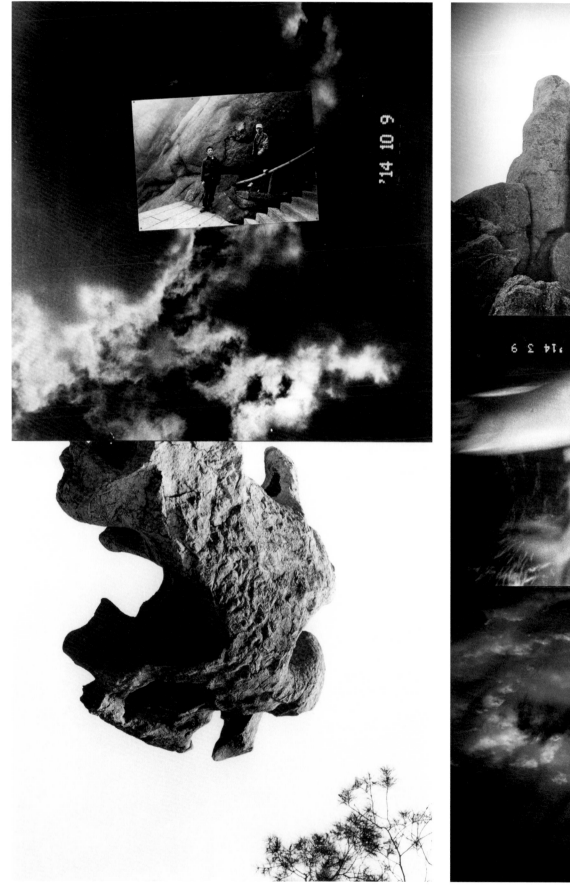

ARTIFICIAL LANDSCAPES

YANG YONGLIANG

Tradition as an Intercultural Visual Education

↗ **Greece No. IV**, 2010
Epson-UltraGiclee-Print
70 × 64 cm

↗ **Greece No. II**, 2010
Epson-UltraGiclee-Print
70 × 64 cm

1 Katja Lenz, 'Yang Yongliang', in Peter Fischer (ed.), *Shanshui. Poetry without Sound? Landscape in Chinese Contemporary Art*, exh. cat. Kunstmuseum Luzern, Ostfildern, 2011, p. 204

Regardless of where a journey takes us, what we see is always shaped by our own history. Needless to say, this history changes according to everything that we experience, read, hear and dream. Being able to see through the eyes of another person – 'with borrowed eyes' – thus remains a yearning, an experimental arrangement. The photographic works of Shanghai-based artist Yang Yongliang (b. 1980) translate the vision of an ability to see beyond temporal and cultural boundaries into long panoramic scrolls, often several metres in length. Mountain and water scenes are brought to life in videos, and indeed to a life in the here and now. The artist merges multiple photographed views of his home town or places he has visited using the composition rules of Chinese ink painting. Even at a technical level, this results in a symbiosis of two temporal spheres. The synergy of historical tradition and the present day continues at the thematic level. Instead of a *shan shui* idyll, the mist-shrouded, humpbacked mountains are composed of groups of skyscrapers, multi-lane roads and a maze of construction sites. Where poets and artists once found inspiration for their works in a place of meditative contemplation, a tumultuous, profit-seeking frenzy of activity now prevails, which not only threatens the order of nature and thus the foundations of human existence, but also makes forms of self-reflection extremely difficult. In *View of Tide* (2008), Yang Yongliang escalates this process of acceleration in his depiction of a huge flood wave crashing onto a mountain, spoilt by monotonous new buildings and scaffolding. Nature is no longer well-disposed towards humankind and reacts destructively to the devastation wrought by the human race.

The *Greece* series of photographs (2010) is confusing. What prompts a Chinese artist to take photographs of fragments of ancient Greek columns? There is a biographical twist to the answer. In 2009, Yang Yongliang participated in an artist-in-residence programme organised to mark the Second Thessaloniki Biennale. As part of an exhibition entitled *PRAXIS: Art in Times of Uncertainty*, the curators had invited artists from around the world, who explore social upheaval but also the cultural memory of buildings and everyday objects. Against the backdrop of the rapid changes occurring in China, which affect almost every aspect of everyday life there, Yang Yongliang transferred his artistic concept to foreign surroundings. Two of the oldest but also fundamentally different cultures – Greek and Chinese – blend together in the artist's intellectual archive. Yet he is fully aware that the foreign can only be appropriated to a limited extent. The reason is that the many years that he spent studying traditional Chinese calligraphy and ink painting have proved to have a particularly formative influence on this work. 'My mode of expression, it is entirely founded on the shanshui tradition. [...] My way of thinking, viewing, and perceiving are infiltrated by the literati ethos,'[1] he says, summing up his philosophy.

Even if he appreciates the technical possibilities offered by image processing, this does not change anything about his connection with the pioneers of Chinese landscape painting, who withdrew into the mountains to escape the influence of the court. Peace and calm prevailed in the seclusion there, allowing them to explore new territory in their experimental treatment of the surviving aesthetics in word and image. This historically informed spiritual freedom is also the hallmark of Yang Yongliang's *Greece* series. It is only logical that relics of Greek architecture, and not mountains and waterways, serve as the bearers of tradition in these works. While temples and statues were built to honour deities in ancient Greece, in China creative powers were attributed to the sky. Landscape painting and poetry bear witness to this culture.

Inspired by his explorations in Thessaloniki and other Greek cities, Yang Yongliang inserts miniature tourist attractions and low-cost housing into the broken edges of ornamentally carved fragments of columns. The left edge of *Greece No. IV* features the port city's trademark, the 'White Tower'. Constructed following the Ottoman conquest of Thessaloniki in 1430 by Sultan Murad II as part of a fortification, it was initially used as a prison. Today, it accommodates a museum. Further to the right, where part of the column is missing, a field of burial crosses nestles up to the rugged stone. The reversed order of magnitude gives the ensemble the appearance of a rocky landscape. The photographic template for this scene is the Zeitenlik military cemetery in which are buried the human remains of more than 20,000 fallen Russian, French, Italian and Serbian soldiers who fought with the Allies against the Turks near Thessaloniki in World War I.

For a Chinese artist, whose education led him to internalise history as a continuum of events, Greece and its artefacts from Roman, Byzantine and Ottoman eras must seem like a temporary vibration space. Even wars in other countries, mediated via the Zeitenlik cemetery, remain present in the memory of the city landscape. These present-day traces of the past are supplemented by the effects of political mismanagement and corruption in recent history. While the luxury yachts of the wealthy few lie in the harbours, the number of those who can barely afford the absolute essentials increases. While the harshness of this reality is a relatively new phenomenon in Greece, it is part of normal life in China, albeit in a different political climate. The *Greece* series could thus be described as evidence of an empathic way of seeing.

U.M.

MICHAEL NAJJAR

High-altitude Flights to Artificial Landscapes

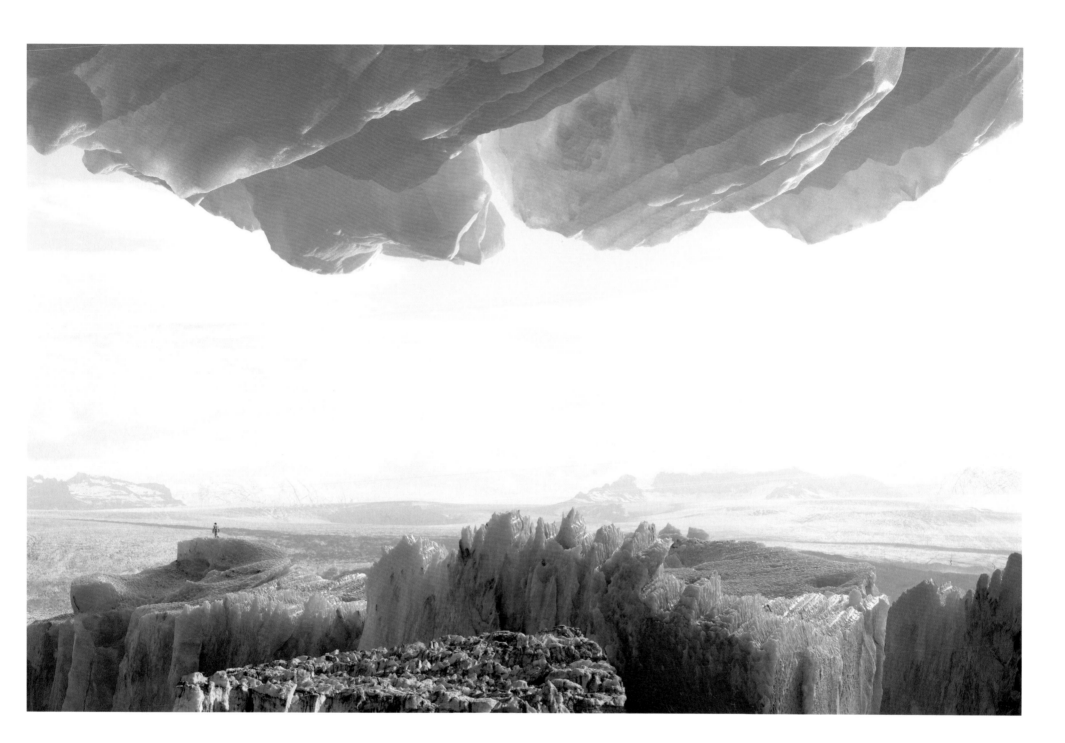

↗ **europa**, 2016
Hybrid photography, Lightjet print on
Alu-Dibond, Diasec, aluminium frame
132 × 202 cm

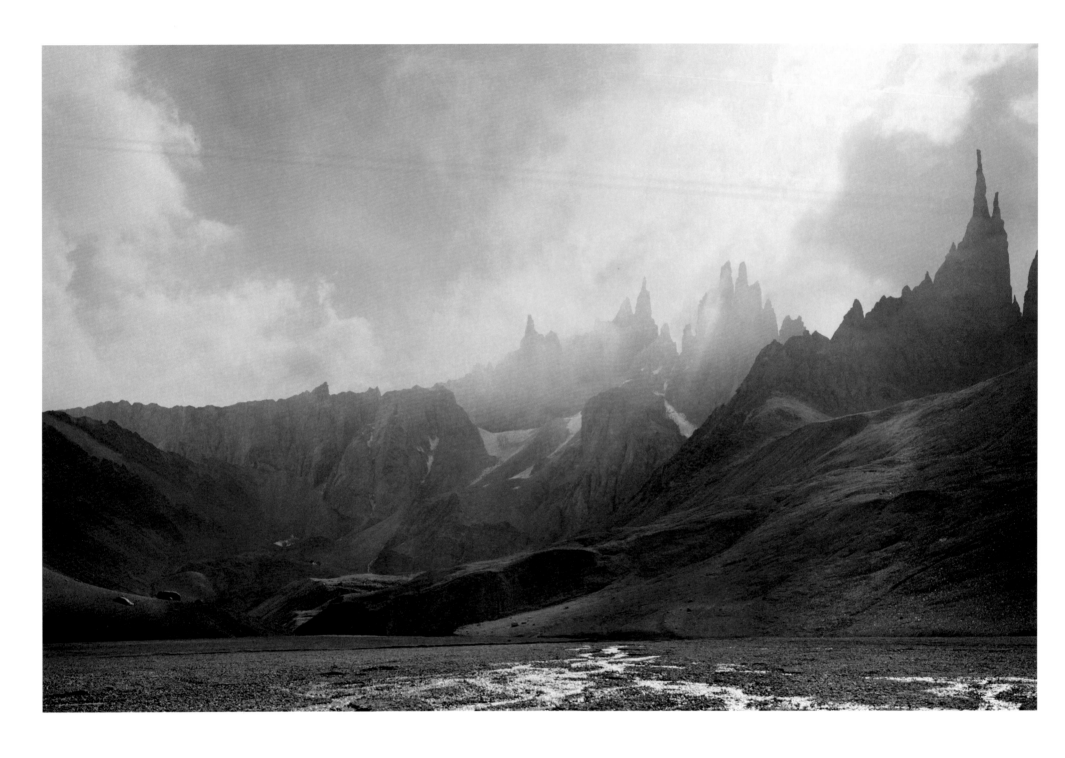

↗ **hangseng_80-09**, 2009
Hybrid photography, Lightjet print on
Alu-Dibond, Diasec, aluminium frame
132 × 202 cm

The photographer and video artist Michael Najjar (b. 1966) is a modern-day Icarus. He is constantly moving upwards: into skyscrapers (in the *netropolis* series), high into the mountains (in the *high altitude* works), and even into space (in the *outer space* series). Icarus, consumed with hubris, flew too close to the sun, whereupon he plunged into the sea and drowned. Unlike his mythical predecessor, however, Najjar exercises great care. It does not occur to him to rise up against his mentors as Icarus once rebelled against his father Daedalus. Najjar trusts the synergy of technology, science and the experts who accompany him (the mountain guide on an expedition high in the mountains, the jet pilot on a stratospheric flight or the tandem master during a HALO jump[1]). He needs this trust in order to be able to pursue his artistic ambitions: firstly, to go beyond the horizon of the known in his photographic or videographic documentation; and secondly, to critically view, select and possibly digitally process the resulting visual material in his own studio.

Michael Najjar describes his 'hybrid photographs' as 'images that merge analogue and digital components'.[2] Using the computer as a composition tool, technically reproduced reality is digitally processed in such a way that it results in amalgamations of nature, culture and art. By analogy with Najjar's use of the term 'hybrid photography', which accentuates the production aesthetic, we could refer to the aesthetically alienated fabricated landscapes as 'hybrid landscapes'. Najjar's method expands not only the spectrum of possible motifs in art but also the understanding of landscape by means of a huge range of phenomena, perspectives and possibilities for projection.

In the *netropolis* series (2003–2006 and since 2016), Najjar made his way to the top floors of skyscrapers, which he used as a vantage point to study contemporary megacities. By digitally superimposing several panoramic shots taken from different angles, the artist produces palimpsest-like entanglements of architectural heritage – abstract-looking, black-and-white urban landscapes. The acceleration of the urban world in the 20th century has given way to an approximate digital simultaneity in the globalised space of the 21st century. Meanwhile, a critique of progress based on the increasing acceleration is largely obsolete. For example, while the director Godfrey Reggio *spatialised* time in his experimental film *Koyaanisqatsi* (1982) by visualising traffic flows at dusk in a large city as luminous lines, Najjar *temporalises* the urban landscape space into an equally abstract and diffuse netlike structure. The compression of time culminates in spatial interconnectivity. The space shrinks to the architectural silhouettes of the people, simultaneously connected to one another in a honeycomb-like structure. Cities become spaces of network time, urban landscapes of simultaneity. The resulting effect is the structural similarity of the various representations of digital urbanity in Najjar's *netropolis* series: the important thing is not where one is – whether that is in New York, Beijing or Shanghai – all that matters is that one is globally connected there.

Najjar's *high altitude* series (2008–2010) also addresses processes in the digital world. However, this is only revealed to the viewer on closer inspection. Initially, we seem to be confronted with photographs of mountain peaks in the Andes. However, the rugged fragmentation of the mountain peaks raises doubts as to whether their appearance is due solely to the interaction of tectonic mountain-building processes and erosion. Titles like *nasdaq_80-09*, *dax_80-09* and *dow jones_80-09* provide clues to the interventions made in the

1 Abbreviation for high altitude – low opening. The skydiver jumps at a high altitude and manually opens their parachute at a low altitude.

2 Camilla Péus, 'A Chronicler of Future Time – A Conversation with Michael Najjar', in: *Michael Najjar. outer space*, Berlin, 2014, pp. 40–43, here p. 43.

natural diversity of forms. So where do the rugged rocky landscapes actually come from? By layering events in nature with movements on the financial market. To do this, Najjar used a process of metonymic substitution: he digitally manipulated the relevant geological summit in such a way that its jointing traced the development of stock market indices between 1980 and 2009. The geological records of natural history are reshaped by algorithm-based financial market processes.

In this way, Najjar's hybrid photography blends the material reality of mountain landscapes with the digital reality of the financial world to present a technology-based grandeur that oscillates between beauty and terror. Like the bizarre jaggedness in Caspar David Friedrich's *The Sea of Ice* (1823), the merging of the natural mountain range with artificial landscapes may astonish the viewer and give the impression of overwhelming magnitude. There is, however, a foreboding downside: what happens if the number of cultural landscapes, which have been increasing since the 20th century, suddenly lead to a loss of the planet's material basis? If modernity, which was shaped by humanity's growing desire to dominate nature, is followed by an era when humankind loses control over the consequences of this quest for domination? If the human being as a determining factor in the biophysical transformation of planet Earth is outwitted by computer processes? If human impotence is confronted with the power of computer-based algorithms, which were created by humans but have now taken on a life of their own and can have massive implications for the appearance of the earth's surface? Then, the scenario visualized in Najjar's *high altitude* series appears as an extreme consequence of the information age: the landscapes pulsating in sync with the Anthropocene.

When Najjar climbed the Aconcagua – at 6,962 metres high, the highest mountain in South America – as part of his high altitude project, he was inspired to break through the Earth's atmosphere. Since then, Najjar has been enthralled by the idea of being the first artist in space. His yearning finds aesthetic expression in his *outer space* series, which he began in 2011. Driven by humankind's fascination with a potential future in space – for which the American literary scholar De Witt Douglas Kilgore coined the phrase 'astrofuturism'[3] – Najjar creates astrofuturist landscapes.

Viewed in terms of production aesthetics, the landscape composition *europa* (2016) consists of ice and mountain landscapes, some of which were photographed in Iceland, some of which are based on photographs taken by the space probe Galileo of Europa, one of the moons orbiting Jupiter. Europa is considered to be a potential location for life beyond planet Earth thanks to an ocean, about 100 kilometres deep, located under its icy surface. In the middle of the left half of the image, Najjar projects the rear view of a small figure dressed in a space suit into this extra-terrestrial space fantasy. The result is a variant of space art in which two iconographic traditions intersect. One is the science fiction tradition, which draws on the 2013 film *Europa Report*, directed by Sebastián Cordero, to make the surface of the Jupiter moon accessible to astronauts by means of digitally reworked photographs. The other is the tradition of Romantic landscape painting, as expressed paradigmatically in Caspar David Friedrich's *Wanderer over the Sea of Fog* (1818). However, while Friedrich's wanderer is completely absorbed in the contemplative vision, Najjar's space traveller courageously explores the *terra incognita*. M.O.

3 See De Witt Douglas Kilgore, *Astrofuturism: Science, Race, and Visions of Utopia in Space*, Philadelphia 2003.

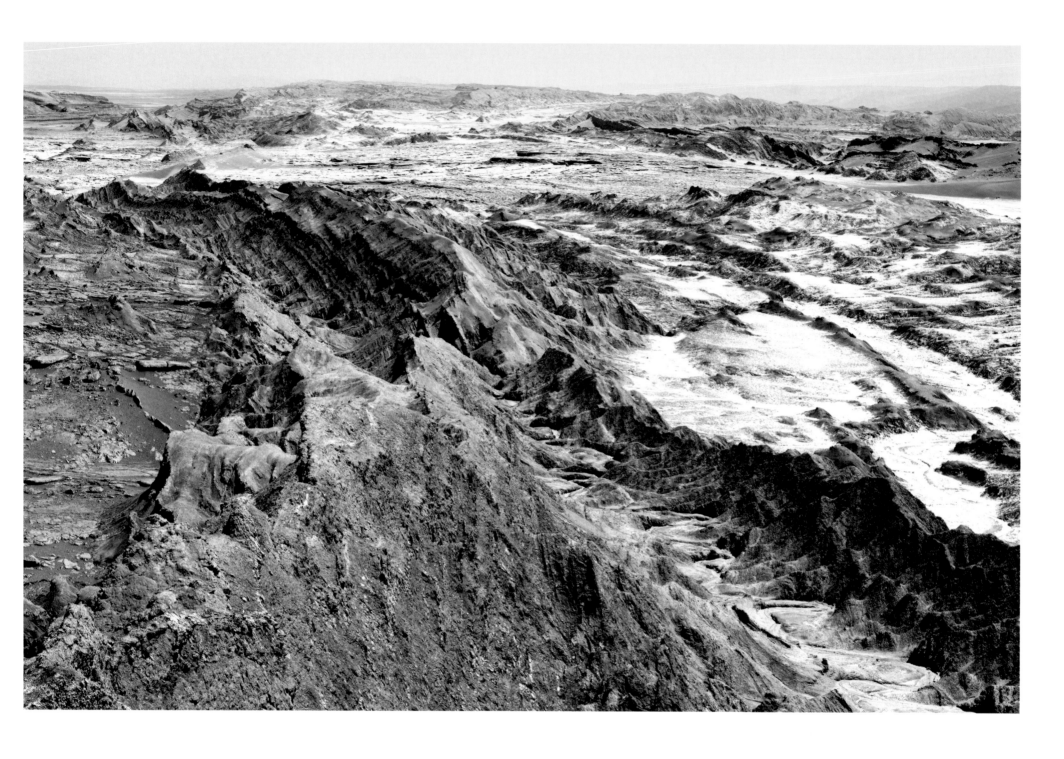

↗ **interplanetary landscape**, 2014
Hybrid photography, Lightjet print on
Alu-Dibond, Diasec, aluminium frame
132 × 202 cm

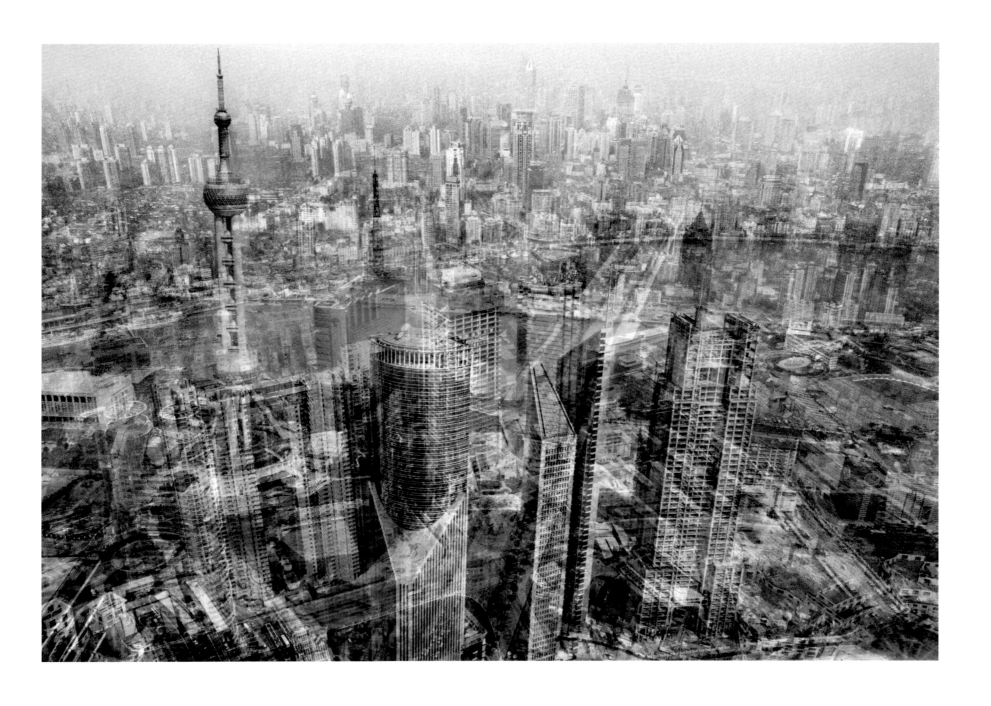

↗ **netropolis, shanghai II**, 2007
Hybrid photography, Lightjet print
on Alu-Dibond, Diasec
120 × 180 cm

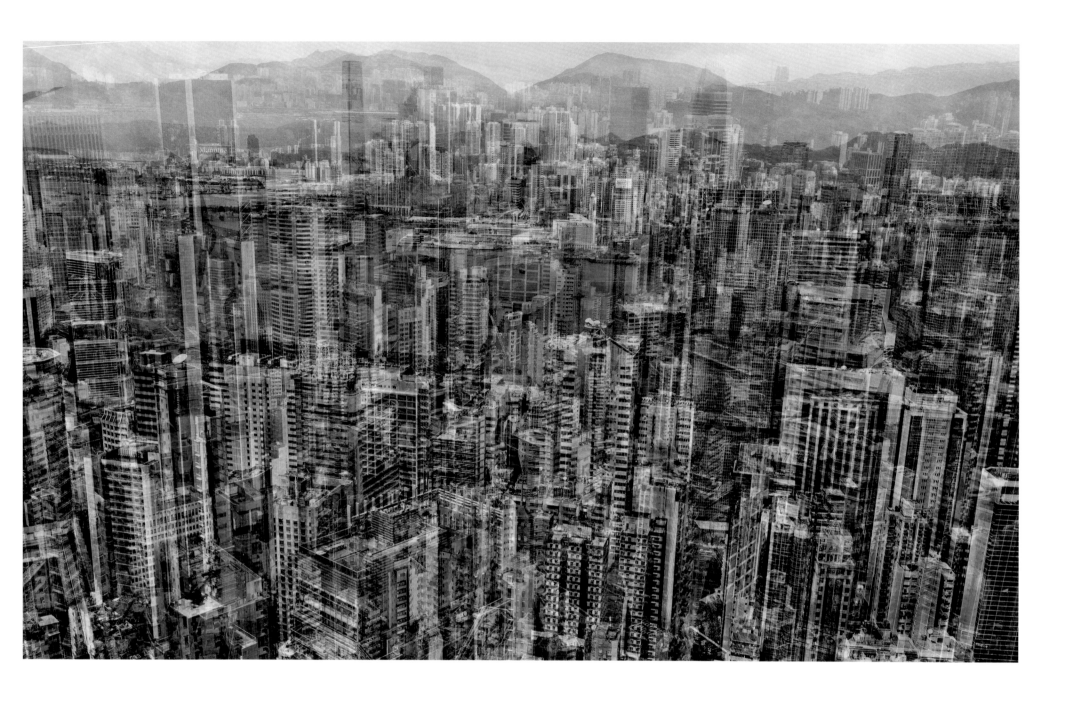

↗ **netropolis, hong kong**, 2018
Hybrid photography, Lightjet print
on Alu-Dibond, Diasec
180 × 300 cm

SERSE

Light and Shadow

A layer of graphite coats the sheet of paper. A flat darkness and shadowy greys are the defining characteristics of the image. Then, using a variety of erasers, the Italian artist Serse (b. 1952) more or less peels away the finely granulated mineral, revealing wave and cloud formations, mountain landscapes, drastically enlarged drops of water, stems and blades of grass. Dim lighting suggests timelessness. Without further information, viewers of these works might initially think that they were looking at reworked black-and-white photographs or even images generated entirely on a computer. However, the fact that visitors to the museum spend an unusually long time in front of the etchings suggests that viewers realise pretty well that this initial impression is fallacious.

Overviews and retrospectives of Serse's extensive oeuvre date back to the 1990s. Even without knowing more about the artist, it very quickly becomes clear that he consistently explores far below the surface of his themes. In his 1998 work, *Vedo doppio*, for example, we see a duplicated drop of water. It's as if we are playing a film backwards and the scenes are dissolving into one another – we see how the water seems to spring from the middle of concentric circles and form a transparent ball in the air. Art becomes the magical continuation of the real spectacle of nature, a no-less miraculous phenomenon. Pioneers of this type of concentrated focus can be found among the photographers working in the constructive and concrete tradition in pre- and post-war Europe. Serse references in particular the German graphic designer, photographer and painter Anton Stankowski (1906–1998), who used the technique of multiple exposure in his black-and-white photograph *Interference* (1953). Stankowski's photograph shows several drops of water forming intertwining circles of ripples on the surface of a lake.[1] The three 'erasures' in the *Studio dal vero* (2013) series, for example, illustrate the many different ways in which a natural phenomenon can be staged. Here we see a single drop of water, shown slightly from below in one work, whereas in the second we are looking down on the falling drop and the water that is swirling up. The basic mood of the pictures changes according to the choice of darker or lighter background and the various shadows that are cast. Our inability to pinpoint the sources of the light adds to the theatrical tension.

But what value is added by Serse's extremely elaborate technique, with which he ultimately achieves a quite similar effect to that obtained by Stankowski and photography in general? The answer to this question is provided, among other things, by the drawings featured in the 2006 series *Ritratti in punta di pennello*, in which Serse presents his thoughts on production aesthetics based on the subject matter of the image. In this collection of twenty-six

1 See *Serse: La Natura Del Disegno*, exh. cat., De Garage, ruimte voor actuele kunst, Mechelen, 2006/2007, Trieste 2006.

portraits, with titles like *Giotto*, *Picasso*, *Bacon*, *Rothko*, *Ad Reinhardt*, *Kiefer*, *de Kooning* and *Polke*, he 'erases' the brushes that were used by the famous artists and show corresponding signs of wear and tear. Through his precise and minimalist depiction of their bristles of varying thickness, of the specific way in which the wooden handle and broad brush are connected and, above all, of the traces of usage, these things acquire a significance beyond their mere utility value. The use of light and shadow elevates them to a mythical level and imbues them with a radiant charisma. The artists are both absent and present at the same time. It is precisely this high regard for the actual art practice, the production process, the way in which an artist translates an idea into a work, which differentiates a photograph from a drawing. Serse's technique produces graphite dust and rubber shavings; it is a technique that requires extreme meticulousness and patience but also great physical strength. This form of creative work is thus profoundly different from the aseptic perfection of a photographer. This intensity transfers to the viewer who encounters Serse's works directly.

This heightened awareness has an impact on how we look at Serse's cloud and wave studies and his mountain landscapes. Like the artist Giorgio Morandi (1890–1964), famous for his still lifes of bottles, vases and bowls,

Serse shuns spectacular effects. The viewer's attention is therefore largely drawn to the 'how' of the representation and relies on his or her imagination. It is also not surprising that the work *Astratto naturale* (2001) directs our gaze to a number of stems jutting out of a calm body of water. In an interview, the artist classifies his practice as part of the classical Italian art tradition and describes his works as a 'window on the world'.[2] At the same time, however, another perspective lends itself to his oeuvre. Reflecting the premise formulated by the Chinese scholar Lao-Tzu on the potential of emptiness, Serse reverses the artistic practice of Asian ink painting. To this day, ink is highly regarded in the Eastern tradition, as it can be used to generate an entire palette of blacks and greys within one brushstroke. By contrast, however, Serse meticulously fills the emptiness that is characteristic of ink painting with the grey of the graphite. Only in the next step does he partially remove the 'colour', allowing the picture to 'breathe'. The eraser replaces the brush. The fact that the artist actually works in ink in the four prints in *Nero di China* (2004) emphasises his spiritual closeness to this art practice. In the *Argento adottivo* series (2006), the ink arcs that we saw in the *Nero di China* series reappear. This time they are rendered as light-phenomena, behind which grey-black branches appear to be reflected on a calm water surface.
U.M.

LU SONG

Hinterland

↗ **Milk Beach**, 2014
Oil on canvas
160 × 120 cm

↗ **Sleepwalker**, 2010
Oil on canvas
120 × 200 cm

Unlike many other Chinese artists, Beijing-based artist Lu Song (b. 1982) does not generally make any obvious reference in his works to the reality of life in his homeland. His works do not allude to the frenetic everyday routine in a large city. Even a reference to traditional landscape painting is not immediately discernible. It is certainly worth noting here that Lu Song completed his studies in the UK, namely at the University of Wolverhampton and the Wimbledon College of Art in London. It is clear from the more recent past that foreign stays or a life in exile for artists from previous generations – Zao Wou-Ki (1921–2013), Xu Bing (b. 1955) and Qin Yufen (b. 1954) are a few that come to mind – tend to strengthen rather than weaken their connection with tradition. No generalisations can be made about the themes and techniques adopted by the post-Mao generation – globalisation has taken effect here.

Lu Song cites German Romanticism and the Symbolist artists of the 19th century as two of his sources of inspiration. This is less surprising than it may seem at first glance.[1] After all, as early as the end of the Qing Dynasty, around 1900, the first texts by 18th-century European authors were being translated and read in China.[2] The first highlight is considered to be the May Fourth Movement of 1919. Authors like Guo Moruo, Yu Dafu and Xu Zhimo were inspired by this literature; the resulting works are to this day described as 'Chinese Romanticism'. Conversely, in the West, the 1920s and 1930s saw increased interest in Chinese literature and landscape painting, although even before that Johann Wolfgang von Goethe had been an enthusiast.

East and West share a very positive outlook on solitude in literature and art – a yearning for a place where the gaze can be turned inward. In *New City of Light* (2010), painted in oil on canvas, the emptiness of the foreground and middle ground swim towards the viewer. Cracks, streaks and dissolving contours create a mystical mood. The gloomy ground floor of a high-rise building hovers, adrift, in the watery pictorial space. Doors and windows are only recognisable as gaping voids. An abandoned, unfinished building? The red, yellow and blue balloon-like shapes on the walls appear like a rebellious protest against this architectural dreariness. Lu Song recalls the backstory to *New City of Light*. He was visiting friends, artists, whose studios were located on the outskirts of Beijing. The daubs of colour in his painting are identical to those he saw on a facade there. By the artist's own account, details like these, observations, impressions, sounds or dreams inspire him to begin work on a painting. What the result will be on the canvas is unclear. 'I never make notes and I don't work with drawings,' says Lu Song. 'If I did that, the tension, the excitement, would be gone and there'd no longer be any need to paint the picture.'[3] The titles are only added afterwards as well. In *New City of Light*, for example, he had Charlie Chaplin's *City Lights* (1931) in mind.

1 The author conducted the interview with the artist in Berlin in spring 2014.
2 I am grateful to the literary scholar Dr. Li Shuangzhi (University of Nanjing) for the information about the reception of Romanticism in China.
3 Interview with Lu Song (see note 1).

← **New City of Light**, 2010
Oil on canvas
49 × 60 cm

The lights are already extinguished in the suburban apartment blocks in *Sleepwalker* (2010). Everyone is sleeping. Except for the man in the foreground of the painting – he is extremely animated and for some reason is digging a hole, lit by the beam of a car's headlights. The title could therefore refer to the nocturnally active protagonist. The sleepwalking aspect, however, could equally apply to the moment the picture was conceived, during a sequence in a dream that the artist once had. A fantastical ensemble of bushes, which seem to glow from within, remained in his memory for a long time after waking.

Lu Song describes his painting technique as a process over which he only has limited control. It is instead the paint's own momentum that fundamentally shapes his works. Applied in extremely thin layers, the pigment forms puddles or spreads like a semi-transparent veil of colour over the canvas. Streaks running from top to bottom leave the pictorial space, indicating that the canvas was raised during the painting process. Another method that he deploys to reinforce the underlying ephemeral mood that he is aiming for is his use of clear silicone. The entire surface is then coated with a layer of paint. Once the silicone has dried and is removed, individual elements like leaves, bushes or parts of the sky or water are revealed as blank, empty shapes. They are weightless and intangible but nevertheless present.

Lu Song's painting leads to the *Hinterland*,[4] to the *Hills Beyond the Backdrop*.[5] His protagonists are sleepless (*New City of Light*) or make their way into nature at daybreak (*Sunrise*, 2013). *Milk Beach* (2014) also shows a location outside the centre of the city, which is only suggested and identifiable at some distance. In dream or memory images that are executed in fractured, earthy and dusky tonalities and a range of faded pastel colours, the viewer follows those that require peace and tranquillity and for whom the everyday economy of purpose is much too restrictive. Often only traces – sometimes not even these – indicate the possible presence of a person.

The impact of Western culture on the artist, alluded to at the beginning of this text, is qualified by the above-mentioned themes and techniques that he favours in his painting. Like the scholars of earlier dynasties, Lu Song's protagonists at times elude the context of social behaviour and norms. However, they do not ramble into the mountains or bamboo groves but are satisfied with the outskirts of the urban space. In aesthetic terms, there is also a definite connecting link to classical Chinese artists: blurred outlines and spaces are reminiscent of the 'boneless painting', still practised today, the purpose of which has always been to convey the viewer's meditative contemplation towards a mountain and water setting. Above all, Lu Song repeatedly works with empty spaces in the application of paint and thus complies with one of the most fundamental principles of traditional landscape painting: the principle that a background completely covered in colour cannot breathe and prohibits an exchange of energy between the work and the viewer. U.M.

4 Title of his solo exhibition in Galerie Huit, Hong Kong (2015).
5 Title of his solo exhibition in the Alexander Ochs Galleries, Berlin (2014).

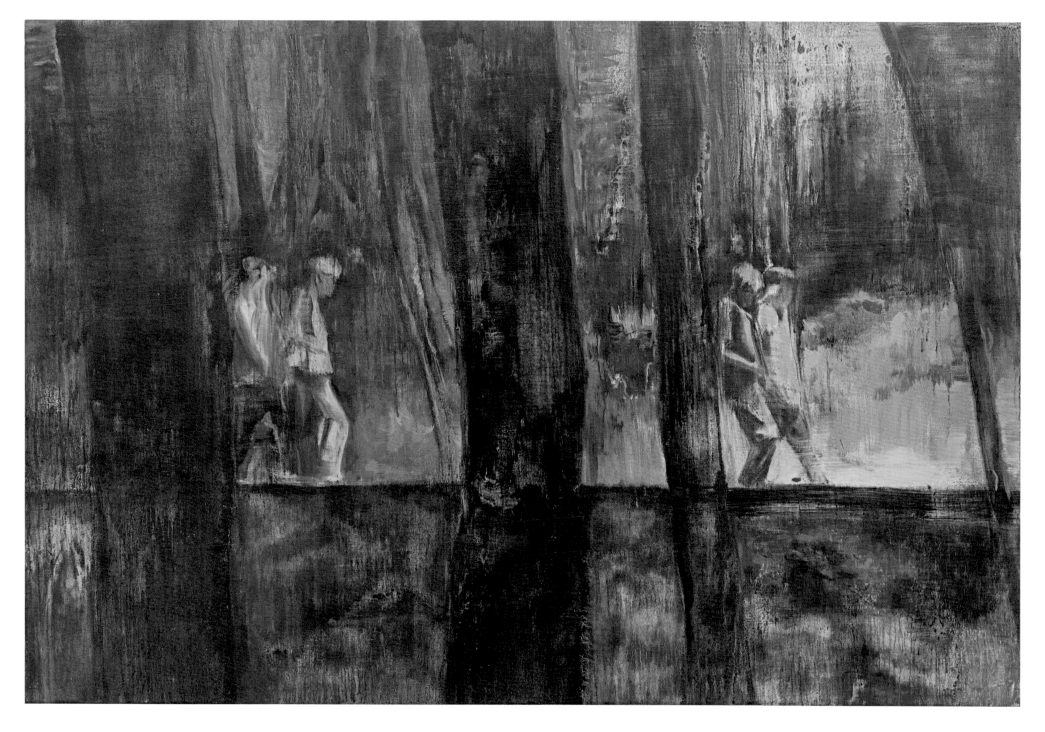

SUN XUN

Both Elemental and Contemporary

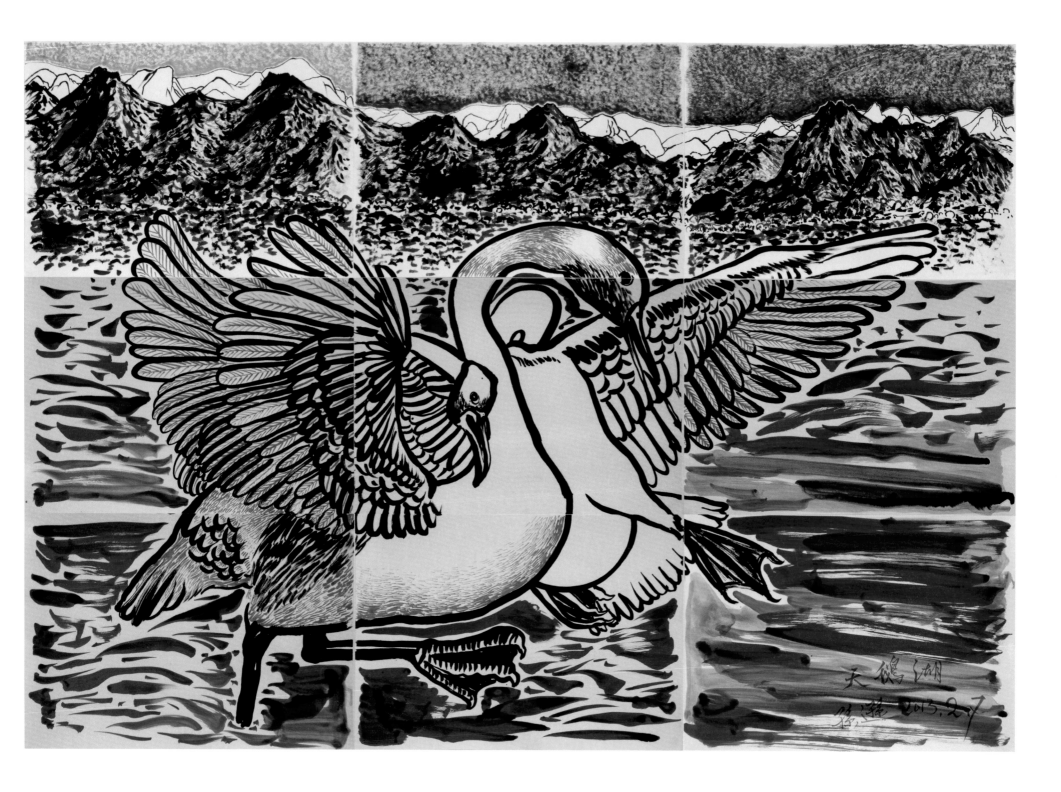

↗ **Theatre of the Imagination, Swan Lake**, 2013
Mixed media on paper
99 × 145 cm

With a lofty beat of its wings, a two-headed swan-like creature rises from the undulating flow of the river; a hilly landscape with a deep-blue sky stretches out in the background – *Theatre of the Imagination, Swan Lake* (2013). Beijing-based artist Sun Xun (b. 1980) is a brilliant calligrapher, graphic artist and painter, but also a master of the traditional Chinese craft of wood-cutting. He does not confine himself to specific formats; he works directly on the walls of the exhibition space or on huge scrolls; he arranges framed details into a landscape or animates his creations on the computer so that their movements also exist outside of the imagination.

Sun Xun studied printmaking at the China Academy of Arts in Hangzhou. Being awarded a professorship at this same institute upon completing his studies did not impede his development as a visual artist. As early as 2006, he had founded his own animation studio called π (Pi). In 2009, he relocated the studio to Beijing, the centre of the Chinese art scene. It is hard to believe that we are looking at a relatively young artist when we consider his international career fueled by a manic creative urge. A look behind the scenes confirms our suspicions: Sun Xun now works with a team of more than a dozen assistants. However, this does not in any way impair the quality of his oeuvre, which at this stage is difficult to keep track of. His brushwork is unmistakable, his fictitious figures are magnificent. The accusation frequently levelled at contemporary Chinese artists – of producing art for a quick sale – is nipped in the bud when we see the technical brilliance and originality of Sun Xun's work and the passion that he displays in his practice. His international exhibitions (including those in China, South Korea, Japan, Germany, Switzerland, Italy, the USA, Australia, Brazil and Iran) and the art prizes he has been awarded – e.g. Chinese Contemporary Art Award (Best Young Artist) and Taiwan Contemporary Art Link (Young Art Award), both in 2010 – are testaments to this outstanding achievement.

Sun Xun's stunning microcosms turn art into a physical experience. He uses lighting to create his own temporality. His pictorial worlds are inspired by events from China's past and present, literary works, mythological traditions, folk tunes and his own experiences and memories. He treats animals,

people, landscapes and objects with the same panache. Entire spaces are transformed into visions that the viewer can literally walk into. The content in the installation *Coal Spell* (2008), for example, refers to Sun Xun's hometown, Fuxin, a town in the province of Liaoning in northeast China. The hard lives experienced by the coalminers there did not change even under Deng Xiaoping's economic reforms. An integral feature of the daily routine was the propaganda that heralded the achievements and guiding principles of the 'new China' and rang out from the omnipresent loudspeakers. *Coal Spell* shows us the dust, the greasy pieces of coal, the smoking chimneys, the machines, the railway lines and the tunnel that leads us back to the light. But it also shows us the people who are ruining their health and risking their lives. Sun Xun populates the imagined, nightmare-like yet also magical scenes from his father's stories with large and threatening dragonflies. Animated ink drawings help to bring this landscape of memories to life. Refusing to misrepresent or romanticise history, Sun Xun creates a fictitious reality.

Huge animal figures and insects appear again and again in Sun Xun's works, for example in *Insects Archaeology* (2005), a series of works painted in ink on lightboxes; *Animals: People's Republic of Zoo* (2009), an installation consisting of animations and drawings; and *The New China* (2008), a large-scale and highly dramatic installation. Another key figure is that of the magician, whom the artist describes as 'the only legal liar' in an interview with art critic and curator Barbara Pollak (*The New York Times*, 27 November 2013), illustrating his ironically and stunningly punctuated distance from the themes that he touches upon. The artist refuses to categorise his works as 'political' in the narrow sense of the word. 'You may or may not believe what I tell you. But it doesn't matter, because this is my art,' he says, specifying the scope for the reception of his works. While *Some Actions Which Haven't Been Defined Yet in the Cultural Revolution* (2011) refer to his father's stories about this dark chapter in Chinese history, works such as *Theatre of the Imagination, Swan Lake* lead into the parallel universe of the imagination, free of the cares of real events.

U.M.

ALEXANDRA RANNER

Variations of Homelessness

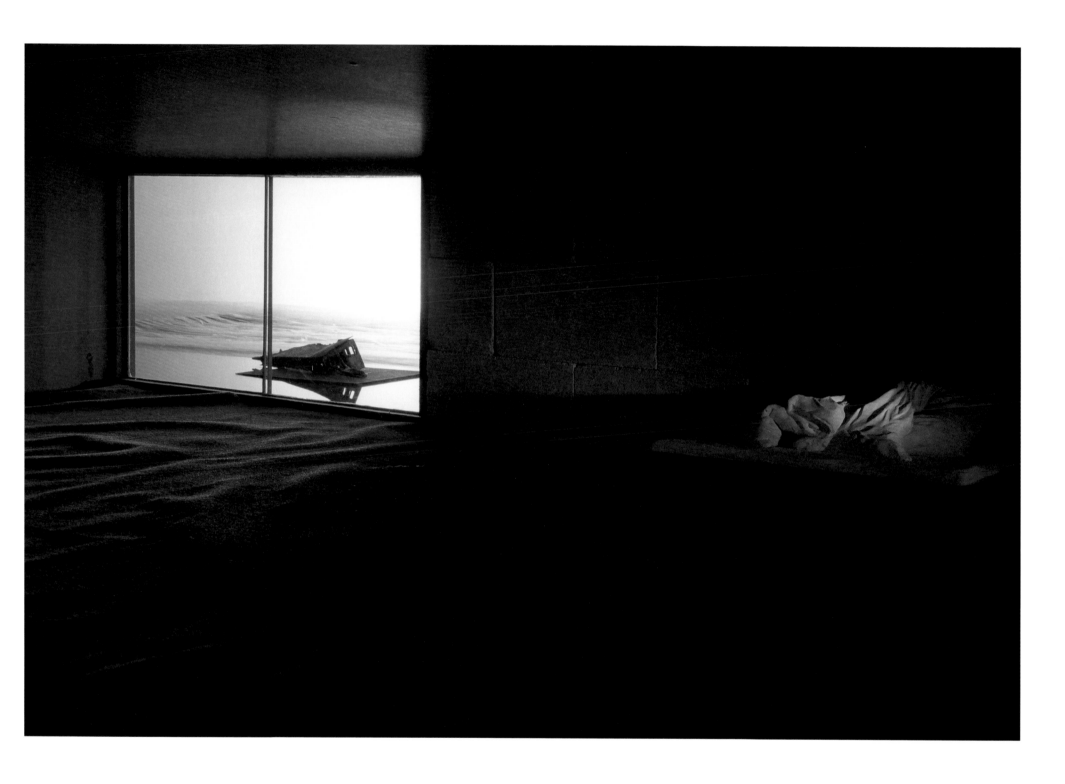

↗ **Studie für Raum III**, 2010
C-Print
45 × 58 cm

The places created by Alexandra Ranner (b. 1967) are anything but cosy. And when a disembodied head, adrift in a murky body of water, starts to sing Johann Sebastian Bach's cantata *Ich habe genug* [I have enough] (1727), who would think of the Christian promise of a life after death? Consolation lies elsewhere. Nothing that we see in the Berlin-based artist's walk-through, large-scale sculptures, three-dimensional models, installations, videos or photographs has actually taken place; everything that looks true to life has been fashioned with the utmost precision in her studio. Rumpled duvets and pillows, which on closer inspection are revealed to be artistically carved blocks of foam, are reminiscent of hilly landscapes. Entire rooms become sculptural structures and lead into a parallel reality.

In *Studie für Raum III* [Study for Space III] (2010), for example, we look into an almost empty room with large windows. Dim light and an extremely uneven carpet exude an unsettling atmosphere. A box-like flat bed stands by a bare stone wall next to the window. The white bed linen has been methodically concertinaed. The view outside shows a mocked-up body of water on which a shrunken wooden house appears to float. Bed and flotsam echo each other in their apparent agitation. The interior and exterior seem to engage in a dialogue with one another. 'There is something ephemeral, angelic about this bed linen,' says Alexandra Ranner during a conversation in her studio in Kreuzberg, Berlin. Her description reinforces the impression that her works

take us into a sphere beyond anything that can be understood on a pragmatic level. Everything seems to be frozen in the moment, like an image from a dream that has been retrieved during the day.[1]

Several variations of the video installation Ich habe genug were executed between 2005 and 2017: in 2005, it was realised as a standalone building (Palast der Republik, Berlin); in 2006, it materialised initially as a rough wooden shed (Kunstverein Ruhr, Essen) and later that year as part of a shroud for a fountain (Kunsthalle Rathausgalerie, Munich). Nine years after the first version, the Wemhöner Collection sponsored the construction of a weatherproof house which has been located in Herford since 2015. The installation returned temporarily to Berlin in 2016 as part of the *Karmakollaps* [Karma Collapse] exhibition in the Georg Kolbe Museum.[2] Hideous, grey-green roughcast rendering can be associated with camouflage colour. The shutter in front of one of the three hatch-like windows opens and closes in a defined rhythm and reveals a video loop, almost eleven minutes in length, presented via a projector in the interior. Lured by the classical singing of a man with a winsomely beautiful bass voice, the viewer – '[t]hrust into a somewhat voyeuristic position'[3] – sees a man's severed head floating on the surface of a narrow river. Misconception: on closer examination, it emerges that the water itself is not floating but rather that an artificially created, uninhabited landscape passes by the stagnant water. 'While the camera tracks the movement of the

1 The author first visited the artist's studio in autumn 2012; additional visits followed in subsequent years. The quotes are taken from conversations with the artist.

2 The installation *Ich habe genug* was executed there as a standalone building in the garden; it subsequently found its permanent home (for now) in the public space of Herford.

3 Michael Ostheimer, 'Swan Song', in Philipp Bollmann (ed.), *Sichtspiele. Films and Video Art from the Wemhöner Collection*, Berlin, 2018, pp. 170–173, here p. 171.

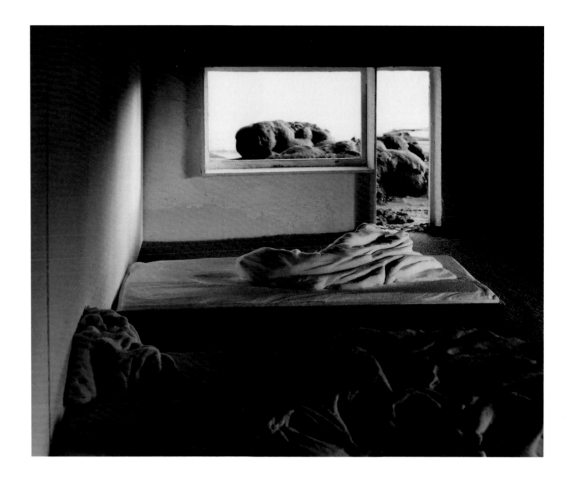

4 Michael Ostheimer, 'Swan Song',
in Philipp Bollmann (ed.), *Sichtspiele.
Films and Video Art from the Wemhöner
Collection*, Berlin, 2018, pp. 170–173,
here p. 171.

head, the view on the opposite bank, which resembles a canal bank, switches between sparse greenery (grass, shrubs, bushes and puny, stunted trees)', and 'various buildings (neglected ruins and modest dwellings). Among these buildings, as if seen in a mirror, is a little house, by all appearances identical to the one into which the viewer is currently looking in *Ich habe genug*.'[4] It is unclear where the sound of birdsong and barking dogs emanates from; at times it is drowned out by the loud clatter of a helicopter.

The voice coming from the man's head floating in the plastic tarpaulin water sounds unaffectedly powerful. The Bach cantata that he sings (BWV 82) amidst the barren landscape describes an unnamed person's yearning for death: 'World, I will not remain here any longer, I own no part of you [...].' From a Christian perspective, the end of earthly existence is associated with the idea that life following death will be one with God. 'With joy I would say, world, to you: I have enough.' Ranner's cinematic staging of the cantata blends this promise of transcendence with a Christian and mythological allusion that has meaning for fewer and fewer people today: the severed head. In addition to associations with John the Baptist and the brutish army commander Holofernes, it also brings to mind the story of the singer and poet Orpheus. He was punished for disobedience by Dionysus, who sent maenads to tear him to pieces and to throw these pieces into the river Hebros. However, Orpheus' head is said to have floated out to sea, singing to the end. In Ranner's work, on the other hand, a thirty-metre stretch of landscape passes by a water tank. 'Home-sweet-home' becomes a symbol of isolation, gloom and crisis of meaning in a bleak, apocalyptic atmosphere.

According to the artist, it is precisely 'this ambivalence of simultaneously present beauty and threat' that attracts her. Ultimately, she says, all her works deal with 'landscapes of the soul', the 'peripheries between reality, dream and vision'. In 2013/2014, Ranner created a work consisting of five prints entitled *Randgebiet* [Borderland]. The landscapes staged in this edition can be interpreted as visualised states of being: dilapidated huts in a type of lunar landscape, the remains of buildings at risk of being swallowed by the sea, shacks sunken down at the beach, bulging rough terrain that holds out no hope of a chance of settling there. The similarly inhospitable and alienated landscapes of Caspar David Friedrich could come to mind. The artist's *Crash* series of photographs (2012/2013) leaves no doubt that she has internalised the oeuvre of the Romantic painter as a space of reference. An arrangement of covers piled up to form hills, characteristic of her work, extends across a coldly illuminated space. Behind the violently broken window opening in the wall, sheets of plasterboard slide over one another like layers of frozen ice. Friedrich's *Wanderer above the Sea of Fog* (1818) is absently present.

U.M.

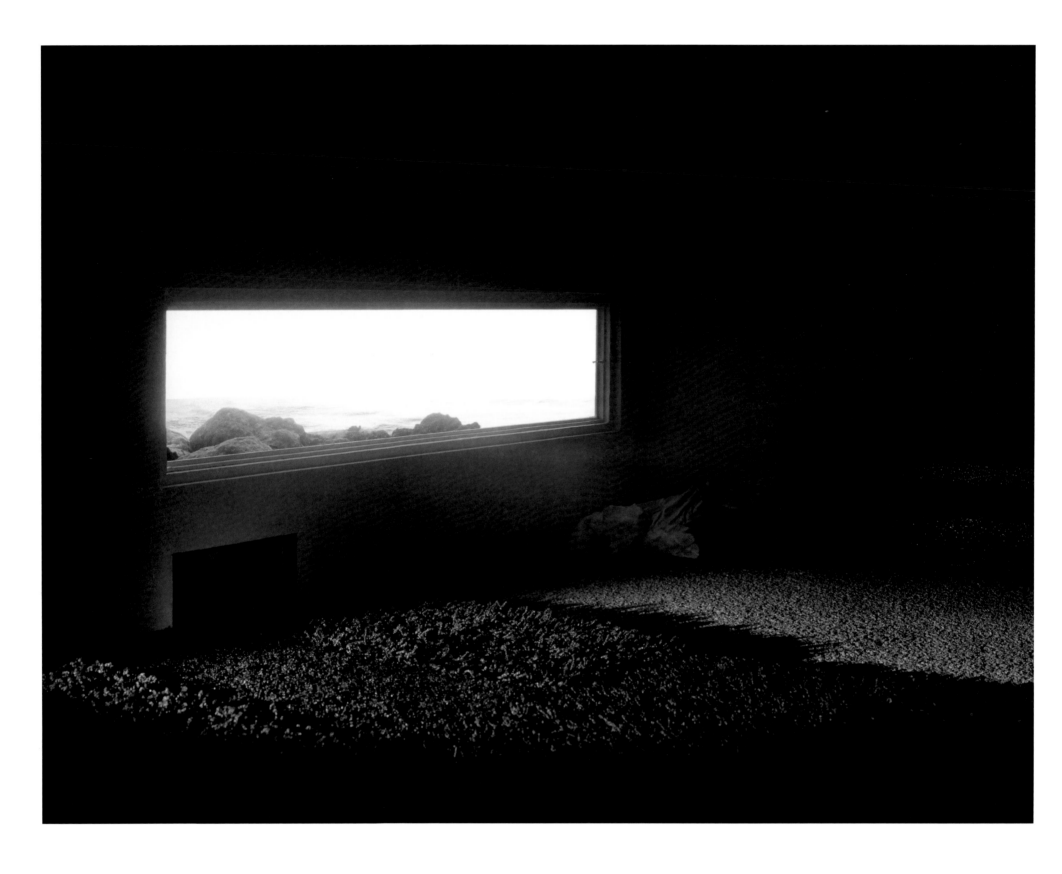

↗ **Raum V**, 2010
Carbon print
100 × 133 cm

→ **Ich habe genug**, 2005
Single-channel video
15:00 Min.

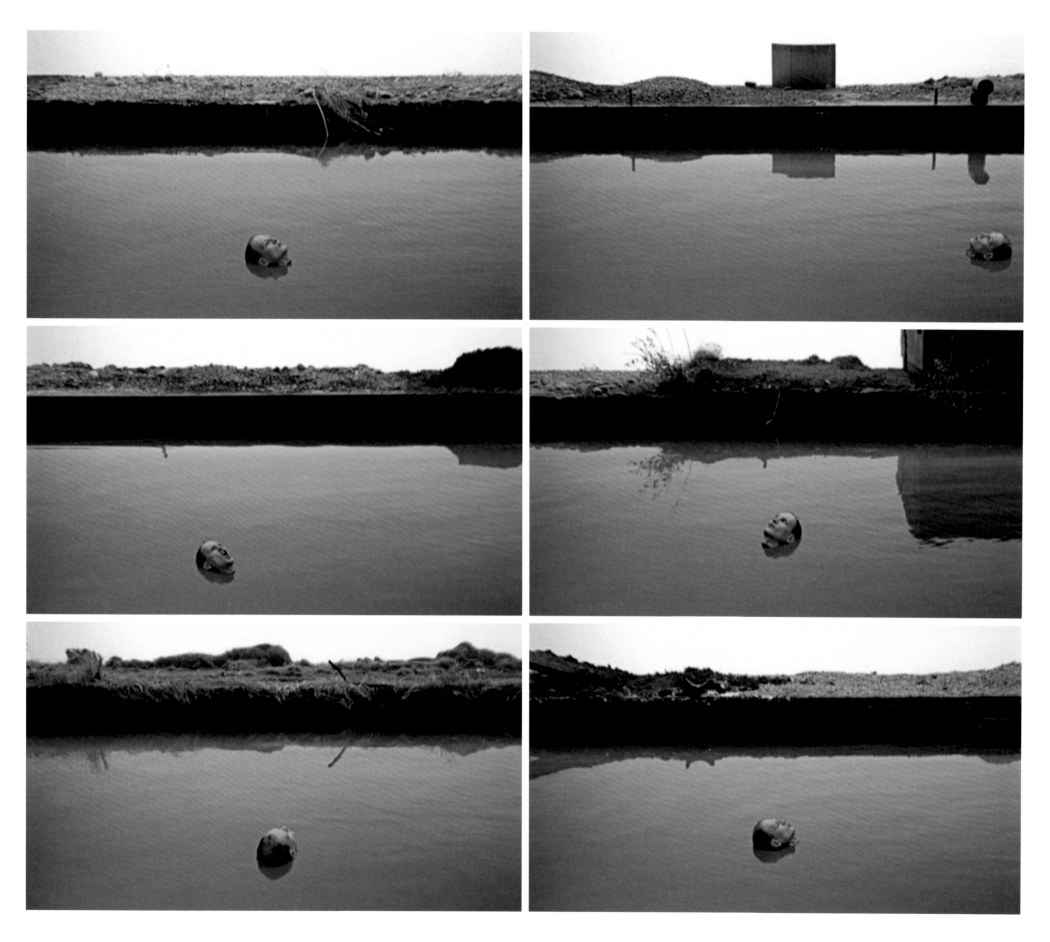

FRANK WIEBE

Mapping the Imaginary

Shifted Mountains IX, 2014
Oil on canvas
230 × 190 cm

↖ **Shifted Mountains IV (Afrika)**, 2014
Oil on canvas
230 × 190 cm

We close our eyes: Africa. Even those who have not visited the continent see pictures of people and landscapes and think about current events there, which gives little cause for optimism. More than twenty percent of the world's land mass and more than one billion people, congealed into one geographic outline. We also recognise this outline in *Shifted Mountains IV (Africa)*, an oil painting on canvas done in 2014. However, artist Frank Wiebe (b. 1961) does not give the viewer any more points of reference.

Frank Wiebe studied painting at the Universität der Künste in Berlin (at that time known as the Hochschule der Künste Berlin) between 1982 and 1988. Today he looks through the window of his studio in a Hamburg suburb at the old pine trees extending skywards. All is quiet, both visually and acoustically. This mood also extends to the conversation in front of the large-scale canvases in the series *The Last Resort* (2012/2013) and *Shifted Mountains* (2014/2015).[1] As the titles of Wiebe's works illustrate, we are not dealing with cool abstraction but rather with informal approximations to existential questions. For example, how does someone imagine his or her 'last resort'? Wiebe atmospherically and energetically transmits his reflections into vertically consecutive and overlapping colour resonances. In *The Last Resort V*, for example, all nuances of red that can possibly be imagined flood the left side of the painting – then

1 The author visited the artist in his studio in summer 2016.

a yellow-green chink of light – and a writhing, cool, light blue and turquoise, from whose depths a darker blue subsequently appears. The right third of the painting oscillates between green and yellow, while a midnight blue takes hold at the outer edge. Failed. How can language describe what has been seen by the mind's eye and now, though only hinted at, appears as an image in the here and now? The last resort defines itself by the borderline experience which we will undergo there: the transition from the earthly to the unknown. *The Last Resort* leads us into the realm of intuition and foreboding.

The pine trees in front of the window, the blue sky, the roofs of the neighbouring houses. In front of us are the paintings *Shifted Mountains I, III, IV* and *VI*. While some of the works in the series have the name of specific places, most are simply numbered consecutively. Therefore our thoughts are not guided to a particular region with which we associate actual events and incidents. Initially, it is the monochrome colour of the background that dominates the atmosphere. The deep black causes the delicate formations of web-like structures and lines, drawn with a disposable syringe, to appear as if they are floating. We see something that is almost weightless, following its own concept of time, which could disappear again in the next moment. And, at the same time, each structure seems as if it can be only this way and no other.

Their outer edges resemble those of a continent but it is also conceivable that we are dealing with extremely enlarged close-ups of tissue or nerve structures in the human body. As there is ultimately no valid assignment, the viewer's awareness of the conceptual differences between the paintings is heightened. Dense white lines, pointillist vibrating planes, waves and circles stand out against the cosmic black. The image could also continue one way or another outside the confines of the painting. Wiebe invigorates the black-and-white contrast of the drawings with mist-like varnishes.

Let's look once again at *Shifted Mountains IV (Africa)*. The fact that a location is named in the title sends us back into the world of our imagination, and the work becomes a projection plane of this world. Yet the *Shifted Mountains*, which are only numbered, initially lead an autonomous existence; a visual narrative only develops through a way of seeing that is descriptive, comparative and contextualising. Thus the mountains start to move. By inviting us to take a microscopic look into the interior of the massifs, Frank Wiebe provides visual evidence of something that, by the end of the 1700s at the latest, had become common scientific knowledge thanks to the founder of modern geology, James Hutton (1726–1797). The history of the earth, hitherto tied to the interpretation of the Bible, is emancipating itself to become the history of strata of stone and earth. Something that resembles a relatively homogeneous structure when viewed from a distance and for a brief period of time accordingly reveals itself to be heterogeneous and changeable.

What is left when the individual is gone? This question is, of course, impossible to answer; but to this day, it has not lost its relevance for every single person, religion or philosophy. Sensitised by viewing *The Last Resort V* and *Shifted Mountains I, III* and *VI*, our view of *Shifted Mountains IV (Africa)* changes. Now the continent becomes an expedition into the realm of the unknown. The catastrophic living conditions of many people there are no longer just headlines, but instead are convulsing the grand scheme of things. A helix spirals destructively into the entrails of the country. In the top part of the painting, the artist has used his fingers to smear on smudges of red. A collection of horizontal lines extends across the habitat with aggressive speed. As in all his other works, the artist also creates a counterweight to this dystopia. A white haze or a wisp of wind seems soothing, comforting, hopeful – for a 'nevertheless', a 'thereafter' or a 'hereafter', perhaps?

Our gaze breaks away from the paintings. The trees in the garden sway in the wind, the blue sky and the green of the meadow dazzle. **U.M.**

↗ **Shifted Mountains II**, 2014
Oil on canvas
230 × 190 cm

ANDREA STAPPERT

'Into the Absolute White'

↗ **Grand Canyon, Arizona,** 2012
Fine art print on Hahnemühle paper
184 × 143 cm

↗ **White Tree, New York**, 2010
Fine art print on Hahnemühle paper
120 × 205 cm

1 Andrea Stappert in conversation. The interviews quoted in this text were conducted by Ulrike Münter in autumn 2011 and summer 2019 in the artist's Berlin studio.
2 Ibid.

Berlin-based artist Andrea Stappert (b. 1958) is famous for her portraits of artists and other personalities in the international art world. After studying painting at the Hochschule für bildende Künste in Hamburg, she moved to Cologne in 1985. It was here that she met Martin Kippenberger, who proved to be instrumental in directing her towards the medium of photography. While her mostly black-and-white photographs include shots of bleary-eyed artists like *Gilbert & George* (Cologne, 1994) and shadowed faces such as that of *Raymond Pettibon* (Berlin, 1998), Stappert's oeuvre also features impressions of nature, usually photographed late at night or very early in the morning, which she has been working on since 2009. 'When I took my first photographs of trees at night on Berlin's Oranienplatz, I did not know then how much this subject would engage me. As I work exclusively in analogue, I often only come across my motifs in the darkroom. It is there that I have also discovered a certain similarity between current works and my earlier photographs.'[1]

For a long time, the artist did not exhibit her photographs of trees or the landscapes that she had traversed: she felt that the difference in theme between the portraits and the nature scenes, some of which look almost abstract, was too great. The positive response to *Grand Canyon, Arizona* (2012), a view of the famous gorge rendered in powdery black, which Stappert presented in a small side room off the studio rooms during the *Ngorongoro* group exhibition (Berlin, 2015), encouraged her to abandon her reservations. As if the eyes need to get used to the dark, the viewer's gaze glides over the canyon, seeking out visual points of reference – the horizon or a source of light perhaps. Deliberate overexposure emphasises the granularity of the photograph's surface, suggesting that we are zooming in on the sandy structure of the massive outcrop of rock. The few bright cliff edges and hollows look like compositional features of a painting and not like a representation of reality. This impression corresponds completely with the artist's mode of practice – she emphasises in interviews that her training as an artist continues to inform her current work. In her landscapes, it is not the seen natural space that is visible, but rather the space that is perceived by all the senses. Anyone who stands in front of her ink-black photograph of the Grand Canyon will forget the sea of warm ochre and copper tones normally associated with this landscape. In Stappert's interpretation, the monumental rock formations are transformed into an experience of black with all its shades of grey. The photograph captures the moment just before complete darkness.

Stappert describes her intention to visit the world's largest salt flat, *Salar de Uyuni* (2016) in southwest Bolivia, as a radical counterpart to *Grand Canyon, Arizona*, namely a journey into the 'absolute white'.[2] Most photographs of the prehistoric, dried-out lake, extending over almost 11,000 square kilometres, emphasise the contrast between the snow-white, honeycomb-shaped

structure of the salt flat and the cold clear blue of the sky. Stappert, on the other hand, consistently evens out this contrast. The pitted and porous brine crust, reminiscent of a lunar landscape, extends across the foreground and middle ground of the photograph. The horizon fades away to a horizontal line separating two adjacent planes rendered in milky shades of white. The sky is revealed as an unending expanse. Stappert sums up her journey as being 'alone in complete whiteness'.

A very different experience of nature is reflected in the photograph *White Tree, New York* (2010). The viewer is immediately struck by the unusual shape of the tree. It is hard to imagine that a tree trimmed in this way can yield new shoots easily. As if swinging its hips, the trunk moves to the right to find its centre again somewhat higher. The branches growing below the edge of the photograph look like shoulders and outstretched arms. Stappert discovered the tree in one of the famous dioramas exhibited in the American Museum of Natural History in New York.

Several photographers, among them Hiroshi Sugimoto, are fascinated by the museum's stuffed animals and the scenes of nature that surround them, a fascination that initially may seem strange. Where is the added value in capturing a landscape setting in a photograph which shows an ideal state of nature that has been largely destroyed by humankind or is about to become a relic of the past? Sugimoto, who visited the museum on four occasions between 1976 and 2012 with his team and an array of sophisticated lighting equipment to gaze through these 'windows into untouched nature',[3] is very aware of his motivation: 'I'm using this diorama to represent my idealistic vision of nature.' Stappert has admired Sugimoto's work for many years; but when she herself stepped in front of the glass cabinets, she did not know that he too had stood here. Their different interests become even clearer when they are compared. Unaccompanied and equipped only with her Leica camera, Stappert allows the tree – and only the tree – in all its individuality to work its magic. The distance created by the reflective glass in the resulting photograph is not minimised by retouching: on the contrary, it is even welcomed. Divested of its natural colour and bathed in a blindingly fantastic light, the tree acquires a timeless and placeless magic.

Andrea Stappert is motivated again and again on her travels not by the representation of what has already been thought or already been imagined, but also by what she finds at the moment the photograph is taken and developed in the darkroom. The same is ultimately true of her portraits. The artist meets people who fascinate her, in the most diverse of locations, spends time with them – and then, suddenly, the mood, the tension, the light or even the darkness is right, giving the signal to take a photograph, which, in a best-case scenario, succeeds in resembling a painting. U.M.

3 See 'Hiroshi Sugimoto: Four Decades of Photographing Dioramas', in *American Museum of Natural History*, https://www.amnh.org/explore/videos/at-the-museum/hiroshi-sugimoto-four-decades-of-photographing-dioramas (accessed on 05.08.2019).

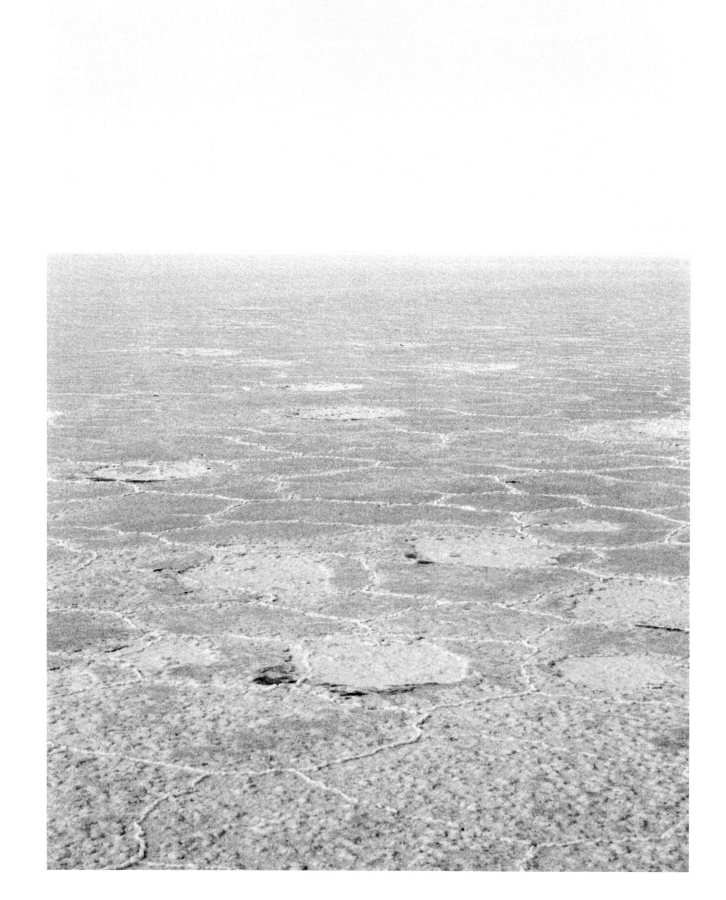

↗ **Salar de Uyuni**, 2016
Fine art print on Hahnemühle paper
210 × 162 cm

Credits

pp. 19, 159, 160, 162, 163: Courtesy Alexander Ochs Private

pp. 23–26, 29: Courtesy Camera Work, Berlin

pp. 31, 32, 35: Courtesy Studio In Sook Kim

pp. 37, 38, 41, 52, 54, 55, 99, 115, 119–123, 135, 136, 13, 165: Courtesy ShanghART Gallery

pp. 43, 47, 49: Courtesy Galerie Krinzinger

pp. 44, 46, 48, 73, 75, 92, 93: Courtesy carlier | gebauer

p. 51: Courtesy Victoria Miro

p. 53: Courtesy Roslyn Oxley9 Gallery

p. 56: Courtesy Galerie Ron Mandos

p. 59: Courtesy Studio Isaac Julien

pp. 61–63, 65: Courtesy Flowers Gallery, London

pp. 67, 68, 71: Courtesy Chambers Fine Art

pp. 77, 78, 81: Courtesy Galerie Max Hetzler, Berlin/Paris/London

pp. 85, 87, 88, 143, 144: Courtesy Shanghai Gallery of Art

p. 91: Courtesy C-Space, Beijing

pp. 91, 94, 109, 110, 112, 113: Courtesy Dittrich & Schlechtriem

pp. 96, 97: Courtesy Studio Andreas Mühe

pp. 103, 104, 107: Courtesy Masbedo

pp. 125, 127, 155: Courtesy Galleria Continua

pp. 129–131: Courtesy Galleri Bo Bjerggaard

pp. 133, 170: Courtesy Galerie Mathias Güntner

pp. 147, 148, 151–153: Courtesy Studio Michael Najjar

pp. 169, 171–173: Courtesy Studio Alexandra Ranner

pp. 175, 176, 179: Courtesy Frank Wiebe

pp. 181, 182, 185: Courtesy Andrea Stappert

Colophon

Editor
Philipp Bollmann

Authors
Ulrike Münter, Michael Ostheimer

Project management
Kristin Rieber, Philipp Bollmann

Design
Delia Keller | Gestaltung Berlin

Translations
Ann Marie Bohan

Copyediting
George Frederick Takis

Project management, Kerber Verlag
Lydia Fuchs

Production, Kerber Verlag
Jens Bartneck

Cover image
Darren Almond, *Fullmoon@Guilin*, 2009

The Deutsche Nationalbibliothek lists this publication in the Deutsche Nationalbibliografie; detailed bibliographic data are available on the Internet at http://dnb.dnb.de.

Printed and published by
Kerber Verlag, Bielefeld
Windelsbleicher Str. 166–170
33659 Bielefeld
Germany

Tel. +49 (0) 5 21/9 50 08-10
Fax +49 (0) 5 21/9 50 08-88
info@kerberverlag.com

Kerber, US Distribution
ARTBOOK | D.A.P.
75 Broad Street, Suite 630
New York, NY 10004

Tel. +1 (212) 627-1999
Fax +1 (212) 627-9484

Kerber publications are available in selected bookstores and museum shops worldwide (distributed in Europe, Asia, South and North America).

ISBN 978-3-7356-0671-6
www.kerberverlag.com

Printed in Germany